PEOPLE WITH AIDS

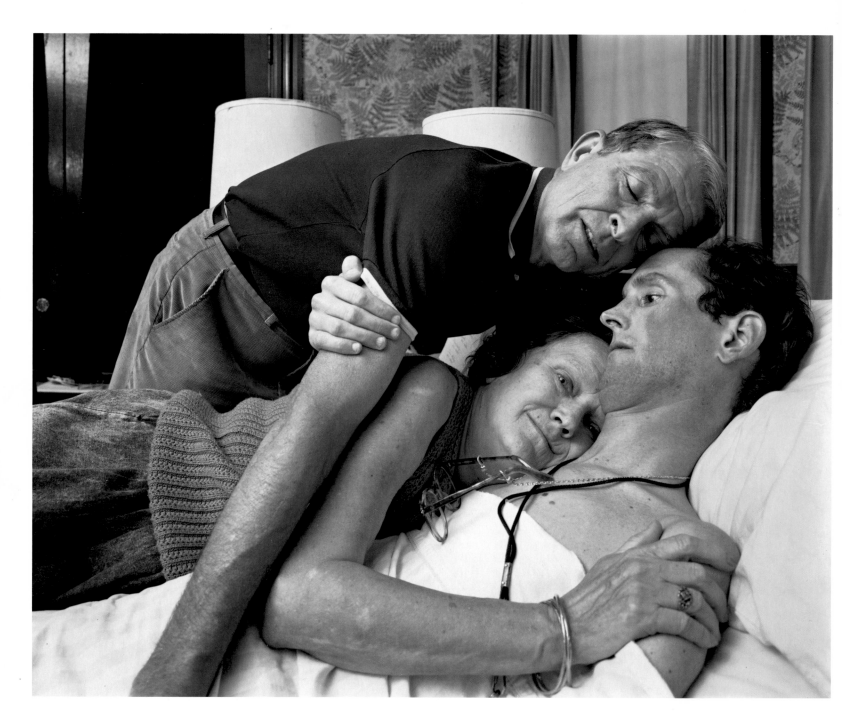

Robert, Ginny, and Bob Sappenfield, Dorchester, Massachusetts, August 1988

PEOPLE WITH AIDS

PHOTOGRAPHS BY NICHOLAS NIXON

TEXT BY BEBE NIXON

DAVID R. GODINE · PUBLISHER

BOSTON

FIRST PUBLISHED IN 1991 BY DAVID R. GODINE, PUBLISHER, INC.

HORTICULTURAL HALL · 300 MASSACHUSETTS AVENUE · BOSTON, MASSACHUSETTS 02115

LIBRARY OF CONGRESS CATALOGING-IN-PUBLICATION DATA

NIXON, NICHOLAS, 1947–

PEOPLE WITH AIDS / PHOTOGRAPHS, NICHOLAS NIXON :

TEXT, BEBE NIXON. — 1ST ED.

P. CM.

ISBN 0-87923-908-5 (HARD COVER) — ISBN 0-87923-886-0 (SOFT COVER)

1. AIDS (DISEASE)—PATIENTS—BIOGRAPHY. 2. AIDS (DISEASE)—

PATIENTS—INTERVIEWS. 3. AIDS (DISEASE)—PATIENTS—PICTORIAL

WORKS. I. NIXON, BEBE. II. TITLE.

RC607.A26N58 1991

362.1'9697'920092—DC20 91-2186 CIP

FIRST EDITION

PRINTED IN THE UNITED STATES OF AMERICA

Contents

Foreword

This is a book about fifteen people. Very little of it is about their everyday lives. Most of it is about their sickness, their dying, and their deaths.

It is about bravery and cowardice and style and weakness, about honesty and self-deception, humor and bitterness. It is about endless patience with the banality of this world, and about the rage that rises as precious time slips away like dreams. It is about what happens to the body and the spirit as a person, a young person, faces the certainty and the unfamiliar hugeness of death. It is about discovering that your family is with you, or that it is not. It is about how different we human beings are from one another, how inconsistent, how contradictory and how unlike characters in literature, whose lives and deaths so often have a harmony about them. Those lives and deaths are imaginary. These are real.

We have no illusions that these words and photographs describe whole lives or complete people, much less the full spectrum of AIDS. These are but fragments selected from hundreds of hours of conversation, dozens of letters, literally thousands of photographs, from the bits and pieces of their lives that fifteen people wanted to show to us. We never knew them when they were well. We only knew them when they were sick, terribly sick, and we knew them only *because* they were sick. They are each, in many ways, profoundly ordinary. Before they became ill, their lives were much like other lives: complicated and unfocused and disappointing, productive and satisfying and full of promise. These individuals were as burdened with trivia and blessed with delight, as vulnerable to ill temper and laughter, as predictable and mysterious as

anyone else. But each of them contracted AIDS, a disease that introduced them to illness and death far earlier than they expected.

Our purpose from the outset of this project was to record with honesty and compassion what it can be to have AIDS; to show what it can do to those who have it, and to their families, lovers, and friends; and to see why it is the most devastating and important social and medical issue of our time.

All of these people, for their own reasons, joined our effort. They knew what we were trying to do, and they believed in it enough to let us bear witness to their dread and suffering, to their courage and joy, to the immense love in some of their lives, and, too often, to their terrible loneliness. For this is AIDS, and those who suffer from it have not always been granted the compassion and human concern that might reasonably be expected for those who wrestle with a painful, debilitating, life-threatening illness. So these fifteen people knew, too, that what we were trying to do was impossible: to record the illness and the dying of ordinary people with so much candor and so little cant that even total strangers might be moved.

When we began the project, we did not know much about illness. We knew almost nothing at all about death. But then came AIDS.

By the winter of 1986, we were both profoundly aware that the world we had inhabited so comfortably for so long had become an unfamiliar place, one which challenged all our notions about what was true, what was safe. Friends, and

friends of friends, were dying of AIDS. Medical confidence had dissolved into despair as the staggering magnitude of the illness became apparent. There was no cure. The human loss was appalling, and sympathy and justice were, unbelievably, nearly absent from the public response.

Though we would not have defined ourselves as political activists, we felt compelled, as a photographer and a science journalist, to make something from our familiarity with pictures and with words, from our own experience of AIDS. We wanted to tell personal stories of people who had AIDS. But we didn't know how to find those people even to begin to talk to. They were hidden, undercover, private. We needed, somehow, to transcend their privacy without violating it.

We wrote and called and cajoled and pleaded with everyone in town who had anything at all to do with AIDS. We finally found Liz Paige at the AIDS Action Committee (AAC), Boston's clearinghouse for AIDS-related services and support. She discussed our project with other AAC leaders. They decided we could print a letter in the AIDS Action Committee newsletter, sent regularly to all of their clients, if we underwent a weekend-long training session. We did so, and in March 1987, our letter appeared in the newsletter, describing our project and asking for volunteers.

Over fifty people contacted us. Some changed their minds about participating when they found out the scope of the project. Others were reluctant to give us permission to photograph and interview them for the duration of their illness. Some dropped out after a few weeks or months. Two moved away. One simply disappeared without a word.

The fifteen in this book stayed. For them, the project was an opportunity to make something constructive out of a disease that had rendered them powerless over their lives in almost every other way. Some did it because, they said half-mockingly, they wanted to become famous. One man wanted not to become famous, but immortal. Many were intent on showing that people could live well with AIDS, not merely die from it. Several wanted to break the silence about alternative therapies and drugs, and open the public's eyes to the healing powers of nontraditional medicine. For others, joining the project was an act of desperation, an attempt to defy the disease itself. One man said it was his only chance not to be nobody in this world. One woman believed that by going public with her illness in this way, by sharing her pain and suffering with others, she could somehow compensate for the sins in her life that otherwise would haunt her in death.

For each, in his or her own private way, participation in the project was an act of profound political significance.

These fifteen people embraced us. They allowed two strangers into their lives who wanted to see and hear the baldest of truths, and who wanted to do this not once, but repeatedly. For them to allow this required exceptional patience, moral courage, and selfless generosity. At the time of this writing, all but one of them has died.

Our hope, and theirs, was always to produce a book of their pictures and their words, and to turn over any profits to AIDS groups in Boston. Because of the subject and nature of the book, David Godine agreed to publish it for cost. The designer, the makers of the half-tone negatives, most of the technical staff, the paper supplier, the printing company, and the binder contributed up to 40 percent of their services. The project became a conspiracy of collaboration.

Even with such cooperation, the book would never have happened at all were it not for our dedicated supporters. Contributions from Dr. David Baltimore and Dr. Alice S. Huang, Mary and David Robinson, Frisch Brandt and Jeffrey Fraenkel, and Agnes Gund, enabled us to fulfill our original vision. Without them, we could never have completed our covenant with those who had given not money, but heart, spirit, and life itself.

If the Hospice at Mission Hill in Boston, which opened in June of 1989, had been in existence even one year earlier, it could have helped many of these fifteen people at the ends of their lives. In their honor, and in their names, all proceeds from this book will be donated to the Hospice.

Bebe Nixon
Nicholas Nixon
April 1991

PEOPLE WITH AIDS

Tom Petchkiss

Tom was the first volunteer. He responded to the AIDS Action Committee newsletter in April 1987. He'd been diagnosed in the early spring of 1986. In March 1987, he moved from New York City to Arlington, a suburb of Boston.

SEPTEMBER 1987

I'm gay, but that's never stopped women from being attracted to me. There was one day, a few summers ago, when I was walking down the street, and I came close to causing two accidents. Both drivers, one a man, the other a woman, were looking at me and not at the road. It really happened.

I still look pretty good. Not like your typical AIDS patient, anyway. I've had pneumonia twice, lost a lot of weight. But I just don't think I fit any preconceived notion of what sick people look like. I'm still physically very active, still look normal and healthy. I'm pretty strong-willed, and I'm trying to make the rest of my life mean something. I think attitude has a lot to do with extending your life. I have choices to make now, just as I always did, but now, they influence not only my life, but also my death. It makes me feel good to know that.

I lived in New York for nine years. I was . . . I *am* an actor. I'm not working now, and sometimes that's a big issue for me. In New York I did acting jobs, and in between I did massage, waiting on tables, things that kept me in the world. I miss that now. But I decided to move here in a kind of flash of intuition. I felt a real strong urge to be near trees again, to watch them change and grow. I have a brother in Somerville, and my mother is in Newburyport, so there were also practical reasons why it made sense.

Having AIDS has reprioritized my life. Things matter now that didn't use to. Before I was sick, I never would have considered a project like this one. Now, I think it matters for me to use my voice, however faint it may be, to speak out against medical insensitivity. To call attention to the lack of what's being done.

I feel cheated, I feel betrayed. And I will die before I'm ready. "Before my time," isn't that what they say?

Tom Petchkiss died six weeks later, on October 12, 1987, at New England Deaconess Hospital. He was thirty-one years old.

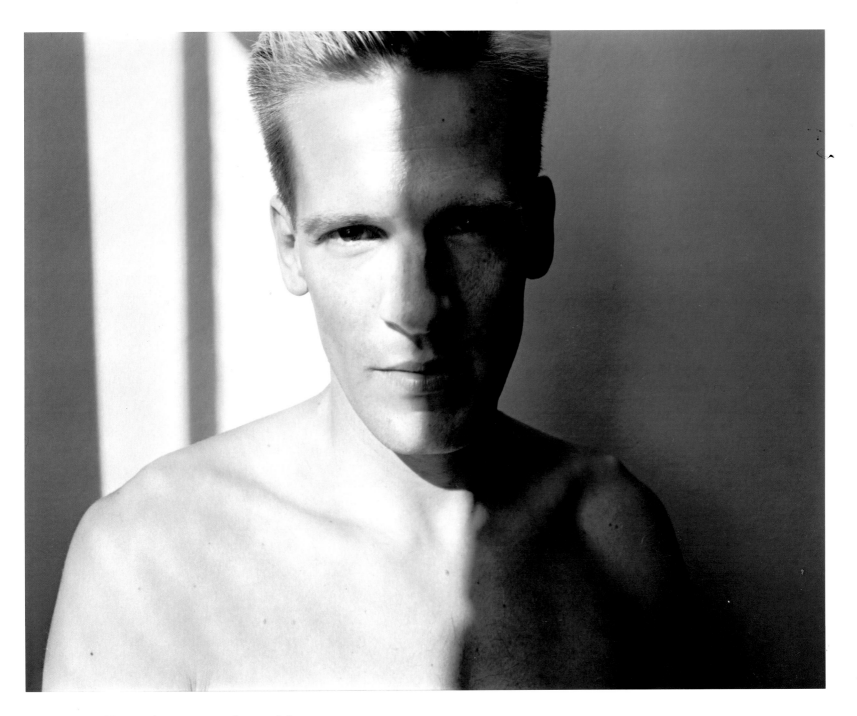

Tom Petchkiss, Arlington, Massachusetts, July 1987 *3*

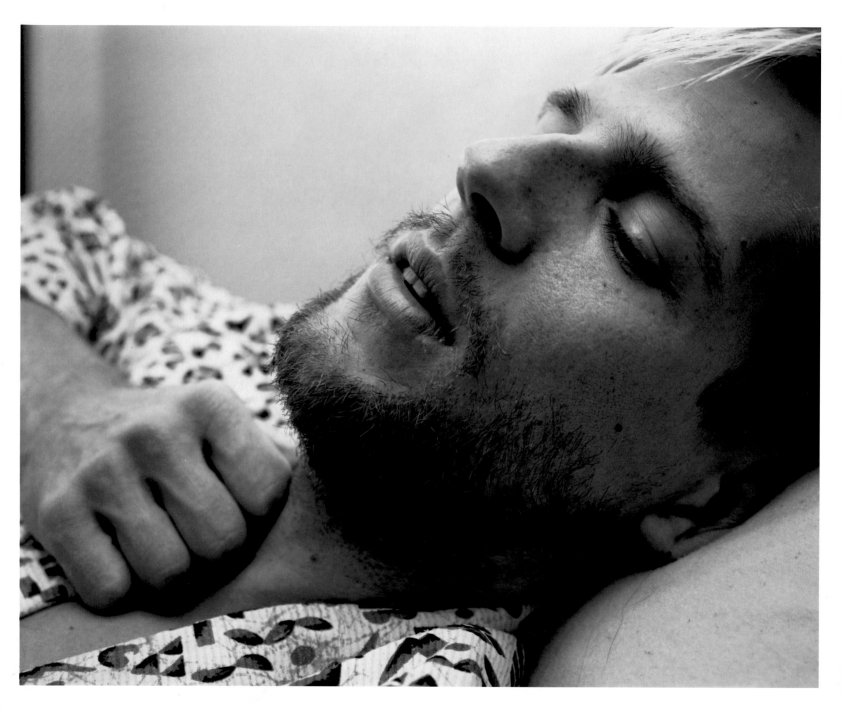

4 *Tom Petchkiss, Arlington, Massachusetts, August 1987*

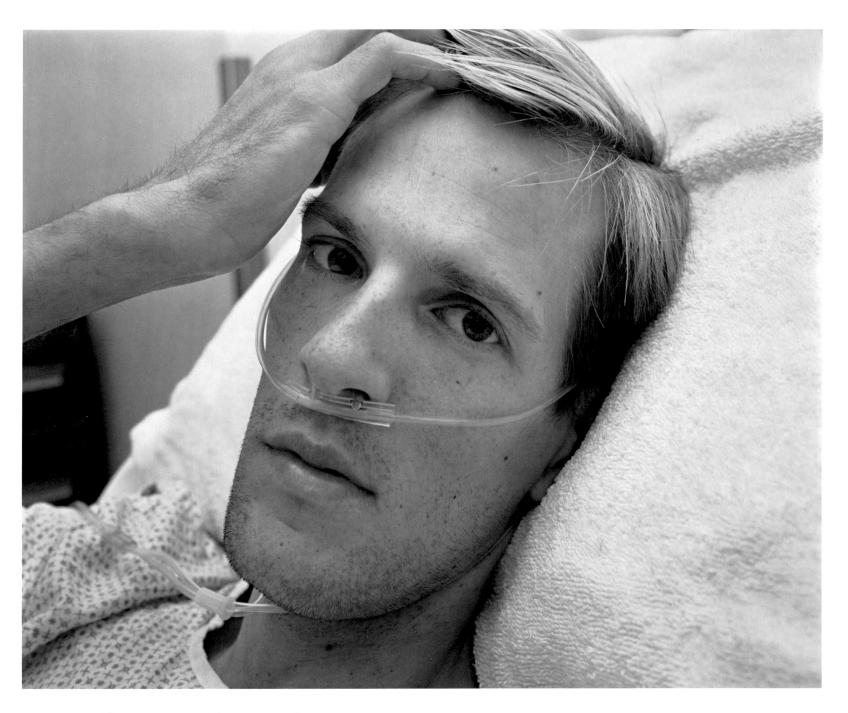

Tom Petchkiss, Boston, Massachusetts, September 1987

Tom Moran

Tom was part of a large Catholic family and grew up in the work-
ing-class suburb of Quincy, outside Boston. He worked at many jobs,
and eventually became a physical therapist. Tom was also an alco-
holic. Every night for more than ten years, he drank until he blacked
out. In the winter of 1986, he developed a nearly fatal case of pneu-
mocystis pneumonia. He landed in the hospital and was diagnosed
with AIDS *almost by chance.*

Tom never discussed how he might have contracted the virus.
He felt it was beneath his dignity, beside the point, and no one else's
business. He recovered from the pneumonia, and left the hospital in
early January 1987.

He took AZT *and continued to work part-time at his job. But*
gradually the recurring infections of AIDS *weakened and debilitated*
him so, that he had to quit. His health was no longer good enough
for him to be on his own. He went to live with his widowed mother
in her house in the Boston suburb of East Braintree.

SUMMER 1987

When they told me I had AIDS, I never doubted it for a min-
ute. I knew I had AIDS when I went into the hospital. I was
pretty sick already. I had all the clinical symptoms, and I had
suspected for many months that I had AIDS. I was suspicious
about what was going on. That's why I didn't go to the doc-
tor. Because I knew that they would start poking around and
start finding things. I wanted to avoid the reality of the diag-
nosis. I knew, but I didn't want to be told. Because it was
such a fearful thing. To be told you have a life-threatening
illness. So I held off.

One of my diagnoses was chronic, obsessive bad-attitude
disease. Nobody could tell me *nothin'*. Nothin', Jack. You're
talkin' Dr. Moran over here. I was just a very arrogant, self-
centered, one-way guy. And very angry. And I was severely
alcoholic. I drank myself drunk, dead drunk, every day, every
single day. And I still functioned on two jobs. It's funny.
Many people knew I drank very heavily. And yet other peo-
ple, who knew me well, didn't know. It was a game with me.
Who knew and who didn't. But I stopped. I am sober today.
And by the grace of almighty God, I hope to stay sober for
the rest of my life.

I needed help to stop the alcohol, but I didn't get it in the
usual way. When I got so terribly sick with AIDS, they put
me in the intensive care unit, and it was 1986. And when I
woke up in the hospital, it was 1987. I had very nearly died.
And I said to myself, "You're here because of AIDS. But
you're here because of alcoholism, too. You have to give up
the drinking. Because if you don't, you might just as well get
a gun and just get it over with, just shoot yourself." Having a
life-threatening illness, with AIDS, and the terrible fierce terror
of the pneumocystis attacks, that was the impetus that slowed
me down from drinking, and forced me to take "the hard
look," as they say in AA. But it also gave me the strength to
put the cork in the bottle. And I truly do believe that I've been
granted new life. I hadn't been sober for so many years that
I'd forgotten what it's like. I'd forgotten that underneath the
alcohol personality is my own personality. Having survived
the hospital experience and having come to sobriety are one
and the same thing to me, because they both represent new life.

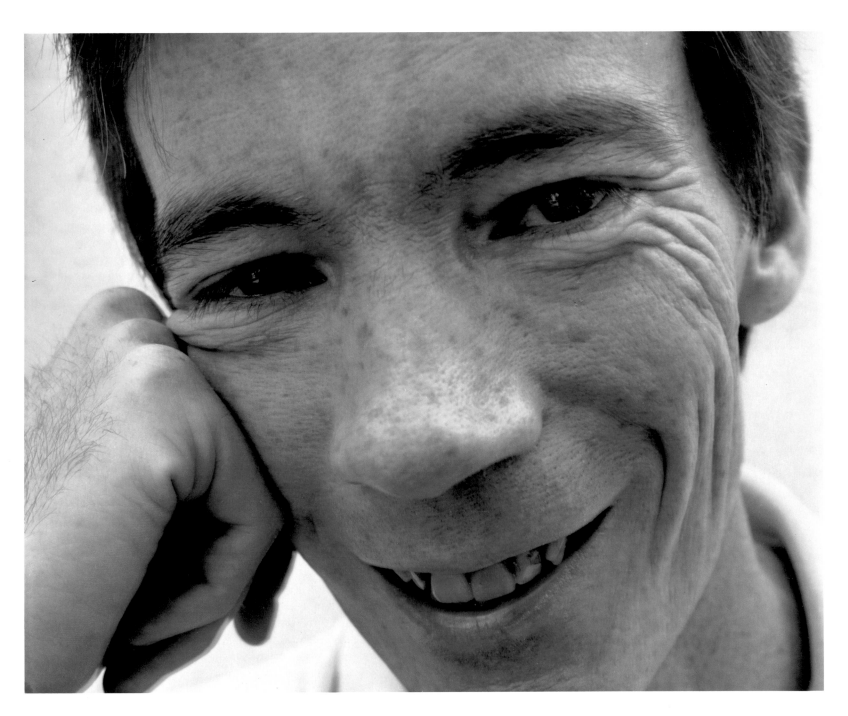

Tom Moran, Quincy, Massachusetts, July 1987

The most important thing to me now is spiritual development, my relationship to God. My personal relationships with my family and friends come right close by it. Then my day to day to day to day trying to deal with the constant threat of death. And deterioration. And all these things that can come from AIDS.

I think the key to turning it all around was the fact that I had a profound spiritual experience while I was lying near death in the hospital. It started out like emergency prayers to God. "Hey God, please save me, please don't let me die. Please save me from AIDS. If I say these prayers, will you save my life?" I was trying to make deals, trying to make contracts for the forgiveness of God. Then this finally settled down to a search for something deeper. I used to call myself a retired Catholic. I realized that you can't quit, because you bear the stamp of your upbringing forever. Since I knew that I couldn't quit, I used to say I was retired. So what I decided to do was go back to the beginning, go back to Catholicism, and look at why I left the church when I was a teenager. I just kind of faded out, it wasn't a radical break. I just got sick of them constantly talking about sin, and the fact that raped women were not supposed to have abortions. I got sick of their politics, and sick of the fact that the churches I went to were extremely parochial, and extremely judgmental of people, and if they didn't like you they wouldn't give you absolution of your sins. They did a lot of hard things to a lot of dedicated Catholics, which bugged the hell out of me.
So I left.

Lately, I've been doing some work with a Catholic priest in the LaSallette movement. He and I have been doing a lot of talking about everything, from questions I have about the structure of the church, to questions like what does God mean to me. As a good Catholic boy, what I was expecting to hear from the priest was, "Well, this is the way it is, Tom. This is the decision of the church." But no way was he falling into that trap. He would present several sides of an argument, or several points of view, and say, "What matters here is your relationship to God, and your interpretation of that." This is very interesting mechanics for Catholics. The priest gave me permission to stretch out my relationship with God in a different way. It must be okay, because Father said it was okay.

I've gone to several Catholic services, and they pushed all the old buttons and pulled all the old strings, and I said, this is not for me. So I went to a Unitarian service in Provincetown one day. Hilarious. Absolutely hilarious. The Unitarians generally are very liberal, but my God, these people are liberal beyond belief. I call it the Unitarian Lesbian Church. They did two things that just bothered me awfully. Number one, there was no period when prayers were offered up to God. None. The second thing was, when I go to a religious service, I expect the minister or the priest to either bless the crowd, or to call down the blessings of God onto the parishioners. And they didn't do that, either. It was kind of like, "Well, thanks for coming, and we'll see you next week." It was very much like a town meeting. Weird. But as a social organization, these people can't be faulted by anybody in America. They run day care, and they run elderly care, and they have bus service for handicapped people, and they give away food, and they give away clothes, and they give away medical care, and they counsel, and they're just really there, in the community. But I felt terribly uncomfortable with the service. I've tried the Episcopalians. You know what an Episcopalian is, don't you? It's a Catholic that flunked Latin. I went to an Episcopalian service that I liked very much. So I'm exploring, to see if there isn't some kind of service someplace that I feel comfortable with.

But the private part of it, the prayer, matters most of all. And as far as prayer goes, you know, the more you pray, the stronger your prayers, and the more fixed your heart and your mind are. And I'm finding that to be very refreshing. And very good. Especially my moments when I despair. And I lose faith. And I lose courage. And I lose hope. What helps me the most then is to pray, like they often do chants in other cultures. They just repeat them and repeat them and repeat them. There's great strength in that, and it really does help me to find centeredness, and the light of God and the strength of God in my life.

When I left the hospital, after I was first diagnosed, and the initial shock of having AIDS began to pass, I realized I couldn't do it alone. I needed to build a support system around myself. My support system is a mile wide and about two miles deep. Hell. I've got two doctors. A chiropractor. This guy who's a professional photographer comes out to my house every once in a while and shoots pictures. Nice guy. A nutritionist. I have a therapist. I have a support group. I'm a member of a hospice. I'm leaving people out here, but I think you get the basic idea.

I've been very lucky. My family did not reject me. My mother wanted me to come live with her, so she could take care of me, help me out. And I didn't have too many choices, so I came to live with her.

I've only told two of my friends that I have AIDS. I have two best friends, a man and a woman, whom I've known for many years. I did not expect them to reject me, and they didn't. But the emotional losses have been substantial. My fiancée left me. I lost my apartment. I lost my jobs. I lost what used to be the image of my body. I lost a big piece of my health. I lost all my money, and I became a public welfare recipient. Remember the Reagan safety net? Well, I'm in it. My checks came yesterday. I nearly vomit every time I get one of these in the mail. A Social Security handout.

FALL 1987

Lately, I haven't felt so good mentally. During my last hospitalization [in September], I learned that I can't take AZT anymore. And there's nothing else I can take. That's it. It's sink or swim on my own, and I think I'm not going to make it. I've tried to take AZT during two different illnesses, once in June, again in September. It worked, but in both cases it also made me extremely ill. This is very rare among people who take AZT. I guess they're going to write me up in a paper, submit it to the JAMA — you know, the *Journal of the American Medical Association*. Great. What a thrill. "Case number 369: The guy who couldn't tolerate the only thing that could save his life."

In the hospital, after the doctors told me I couldn't take the AZT, I lay there and thought, "I want to go home, but what am I going to do? I'll just recuperate for a few weeks, and then what am I going to do?" It wasn't until I got home that it hit me. What they were really saying was that my options are gone now, and there is nothing out there to help me. Nothing. They can try to deal with my infections as I pick them up, which I undoubtedly will do. But there's nothing to help me.

So, if I didn't believe it in the past, I believe it now. I am going to die. This thing is going to come. It's going to hunt me down, it's hunting me down right now. And it's just a matter of time, and energy, and the luck of the draw. But I will die. And I will die of AIDS.

In the hospital I had dreams of calling out to people to save me. And no one would come to save me. I had dreams of anonymous-looking bodies hunting me down and stabbing me in my heart. I went through the whole cornucopia of burial stuff. We all bury ourselves, all of us who know we're dying. Because obviously, if you die, you're not going to be there to mourn your own death, so you mourn it now. I went through a period of mourning. It just got worse and worse and worse and worse, until the point where I was just so emotionally wrung out with it that I couldn't mourn anymore. It's a hell of a feeling to realize that you're totally unprotected. That no one will come to save you, no matter what you do. You can't make a contract with God, because suffering and death is part of life. You're all alone. There's nobody to protect you. I will never again be safe.

I don't know if it's possible to make peace with this thing. I go through periods of stability. I try to live day to day, because I don't know about tomorrow. I could die tomorrow. It's partly the AA philosophy. I try to feel the joy of being alive today. I'm sober. My priorities have changed. I have life left in me. And there is joy in living. Even under the most oppressive circumstances, there is joy in living. Now, joy does not necessarily mean happiness. But I try to maintain a joyful attitude, an appreciation of my blessings.

Another side of trying to make my peace with it, is

acknowledging the fact that I am furious that my life is threatened by AIDS, that I am ragingly mad at the world. Because I don't think I deserved this. I don't think I did anything in my life to deserve this. I wasn't a bank robber, I didn't beat up my girlfriends, I sent my nieces and nephews presents.

The other thing is facing the truth about the future. There's nothing that anyone can do for me. They can't save me. I'm going to die. I mean, that's it. You get AIDS, you die. You die today, you die tomorrow, you die in two years, you die in five years, you DIE. Because there's nothing in the pipeline. My doctors have assured me, unless there's a Perry Mason finish here, where somebody jumps up in the courtroom and admits they did it, there is nothing in the pipeline. Not now. Not five years from now. So it ain't gonna happen. And I have to deal with the enormous sadness, and enormous fear . . . I'm not afraid of death, by the way, but I am afraid of dying. I have to acknowledge all those things, face them alone. Because the alternative is to say "good-bye," and go to bed, and die. And just check out. I understand now why some of the people I meet do that. I have discovered, when I speak to support groups, that it's generally not a good idea to mention any spiritual experiences that I've had. Because the majority of people who have AIDS never go through this process. I would say that 60 to 70 percent of them never have any kind of spiritual or religious experience out of this. They just have sadness and rage. And these are the people I say are just sitting around in God's waiting room, ready to get called. I don't hold that against them, or blame them or anything like that. But for me, I just can't live that way. Not that I haven't been tempted to, lately. But I just can't do that. I. Just. Can't. Do. That.

The ending of my life might be a very slow and painful one. Or then again I might die in a matter of a few hours or a few days. But I Goddamn guarantee you one thing about this. When I'm on my deathbed, I'm gonna be able to say, "These were the best years of my life." These were the years when I came to truly appreciate my family and friends. And I came to stop being a Goddamned drunk. And these were the years when I finally worked out all the life crap, all the baggage.

Got it all straightened out. And found some joy and some purpose in living. Despite the shotgun at my head. And that's the work in my life right now. That's what I do. I've asked myself whether I needed that particular shotgun to make it happen. What if I hadn't got AIDS, but I just kept right on drinking? I would have drunk myself into a hospital, for sure. So my answer is, maybe not this shotgun. But, ah . . . Who cares how you come to health, as long as you come to it?

It's funny. Since I've been sick, and come to live here, my mother has become more motherly. She would like to keep me at home, and keep me safe, so that nothing will happen to me. I've tried to protect her from things that go wrong with me. I've tried to hold information back. Because I didn't want to have her hurt anymore than she's hurt in this situation anyway. I do not know what it is for a parent to bury a child. But I am told that it is extremely unpleasant. So I've been trying to protect her. And although intellectually I know the process and recognize it when I'm doing it, I still have not been able to change how I feel about protecting Mom. And she doesn't want any protection. She's complained to family members. Christ, she's complained to my therapist that I do this, and she doesn't want it done. She just wants to be told. There has been more opening up, more communication. This is an ongoing process. There's so much pain in this situation already. So much pain. And my relationship to my mother in that sense has changed, probably for the better. I trust her very much. I sort of have to.

I need to call a meeting of my family members, where everybody comes. I want everybody to come: my therapist, the doctors, and the nurse. Because I've become very very concerned that if I become ill, I might not die quickly. I might die very slowly. And in that case, I'm going to need a lot of help. The hospices can only provide certain services. So questions like where I'm going to be taken care of, and who will be taking care of me, have become very important for me now. My doctor was saying to me, "If you don't work this out soon, then you know what will happen. I'm going to be outside your hospital room, walking back and forth in the

corridor with your family, while we try to figure something out in this emergency, instead of having some plans already in place." So this meeting will take place, soon.

I've done all the legal things. Power of attorney. Patient advocate. Will. Not that I really need a will. I don't have that much. I have a little money left, but that's about it.

It's funny, with all the problems I've got, one thing goes through my mind. When I die, I will leave behind absolutely nothing. A little bit of money, and I mean a little bit. A few pieces of furniture. Enough clothing to start your own Morgan Memorial. I have a one-thousand-dollar insurance policy that was taken out on my life in 1957. Yes, 1957, believe it or not. My parents made the payments all these years. And that's it. At age thirty-seven right now, I have never bought a home. I don't have a car. That bothers me. In many ways I've had a good life, a very lucky one. But I don't have anything to leave behind.

A photograph lasts a long time after you're gone. So do your thoughts and words, if you write them down, or someone else does. Part of the fear, and one of the consequences, of having a life-threatening, fatal disease banging on the destiny of your life, is just being gone. There's a part of me that's afraid that people will forget me. They'll forget I ever lived. It's an irrational fear, but it's there. I thought it might be good to be in this project, where part of me might possibly still be here when I'm not here. So partly, I not only did this for the adventure of doing it, I guess there was a little selfishness in there, too. It's sort of greedy, in a way. It's tied up with a wish for immortality. I guess it's why some people have children. You just make something to leave behind when you're gone. A little bit of you goes on living. But maybe wanting to have something last after me is not necessarily a selfish thing.

Tom's condition became more critical just before Christmas 1987. At the family meeting, it had all been decided that when Tom was too sick to remain home, he should have hospice care, if it was available, or, as a last resort, a bed in a good hospital. Shortly after New Year's, a bed became available on the AIDS floor at Shattuck Hospi-

tal. Tom had mixed feelings about the Shattuck. It is a public hospital, and there was some shame for him in that. Then, too, his own father had died in that hospital, eight years earlier. Most difficult of all for him and for his mother was the perception that AIDS patients who went there never came home again. But Tom was very ill; it was difficult for his mother to care for him at home, even with help. Tom reluctantly agreed to go.

The doctors at Shattuck treated as many of his minor infections as they could, but with only small success. Finally Tom asked them to stop. He was tired, and he wanted them to leave his body in peace. One afternoon in early February, Nick was visiting. For two days Tom had been bleeding internally, and his doctors were trying to find out why. He was very weak, in some pain, and terribly tired.

TOM: You know, sometimes when a guy is down in a hole, and he knows he's there, sometimes the best thing is just to let him stay there. Don't interfere, don't try to cure him. He doesn't want it. It's hard to face the truth, but there it is. That time is here for me.

I think I'm ready to let go now. I'd like to stop all this, the IV and treatments, the medicine, the drugs. I'd like to stop all this, and just say good-bye.

Nick, I'd like you to help me. I haven't had anything to eat or drink all day. They haven't let me have anything all day. They're trying to find out where this blood is coming from. But I'm tired of this, and I'm thirsty. Give me a glass of water, will you?

NICK: But it might hurt you. I don't know what to do.

TOM: But it's my life. Please, don't you do it, too. Don't try to protect me.

NICK: But you're asking me to help you die, in a way. You're my friend. It's hard to help you die.

TOM: But it's what I want.

NICK: Yes, I know. Here's the water.

TOM: I knew I could count on you. Thank you. Nothing ever tasted so good.

Two days later, on February 8, 1988, Tom Moran died.

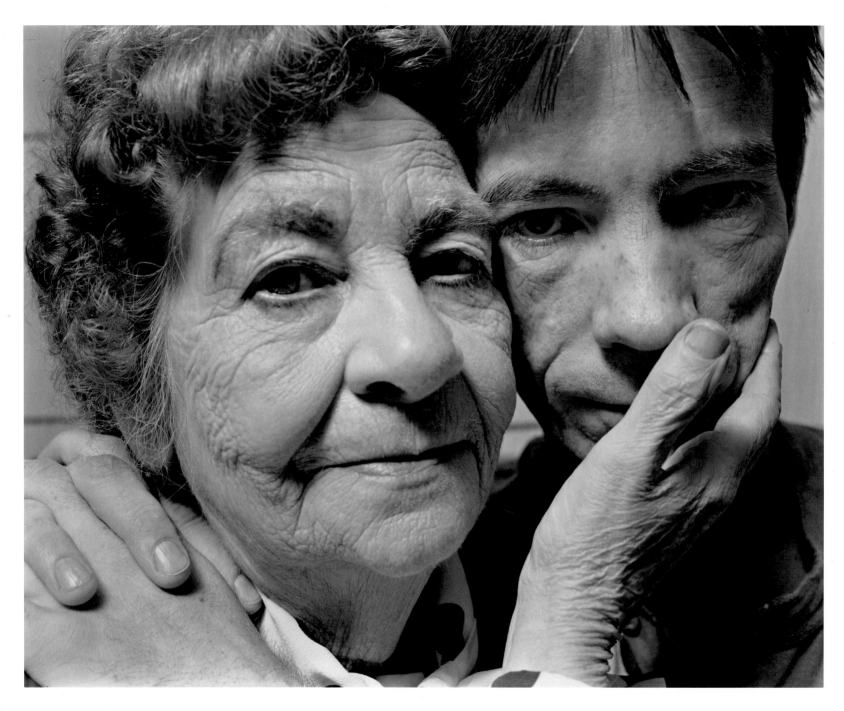

Catherine and Tom Moran, East Braintree, Massachusetts, August 1987

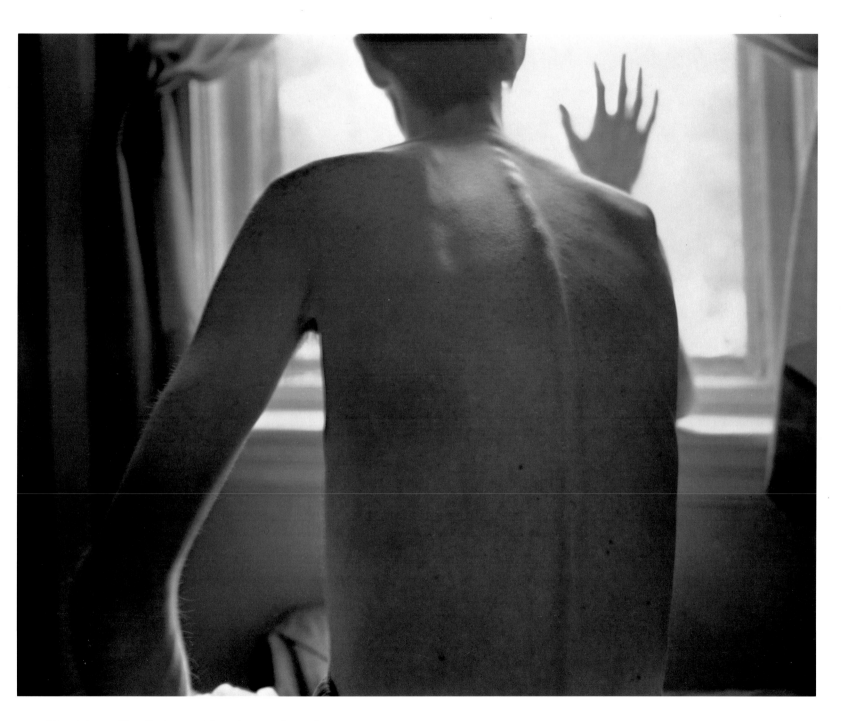

Tom Moran, East Braintree, Massachusetts, September 1987

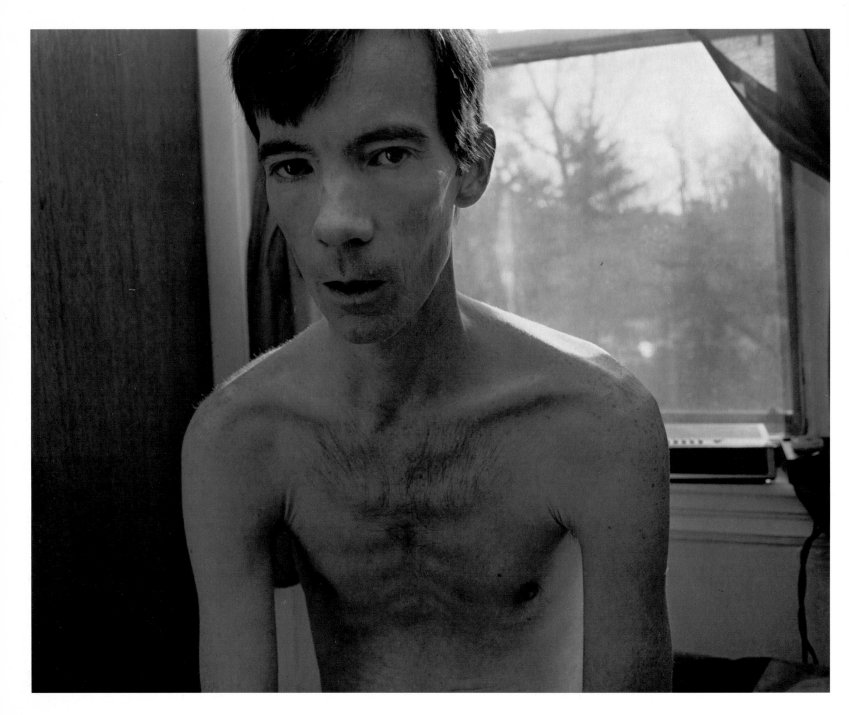

Tom Moran, East Braintree, Massachusetts, November 1987

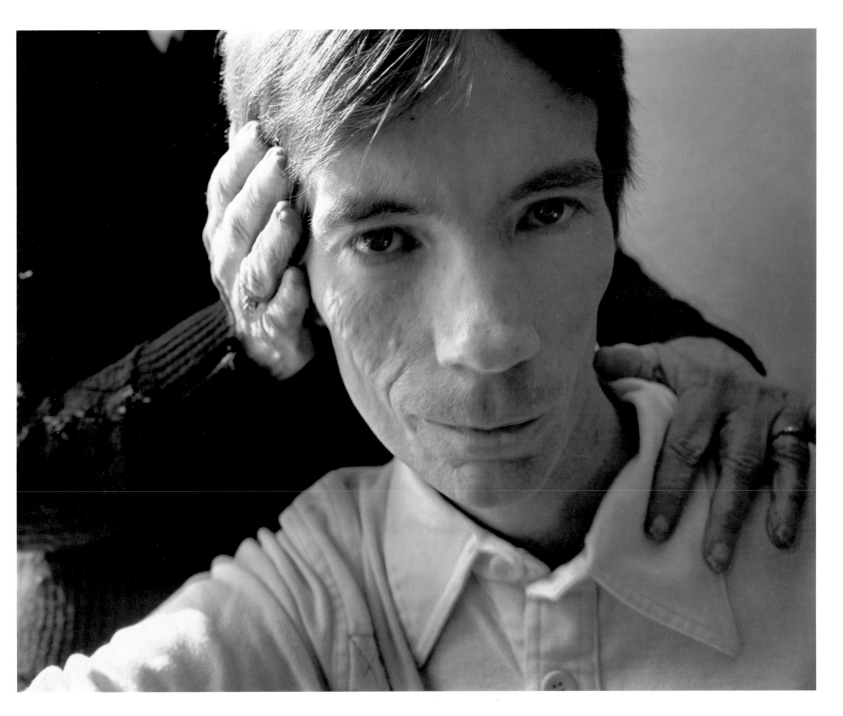

Tom Moran, East Braintree, Massachusetts, November 1987

15

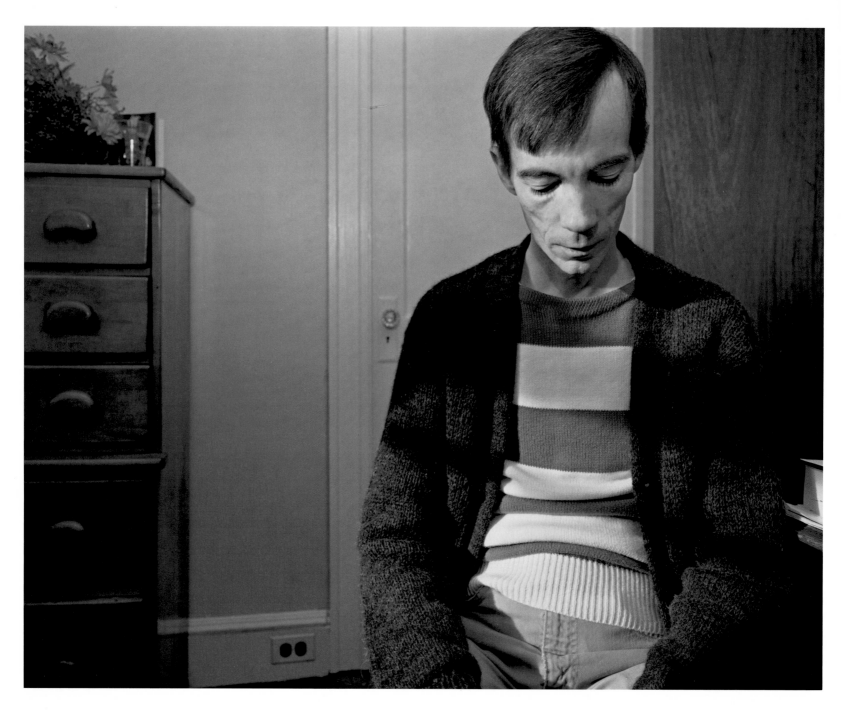

Tom Moran, East Braintree, Massachusetts, December 1987

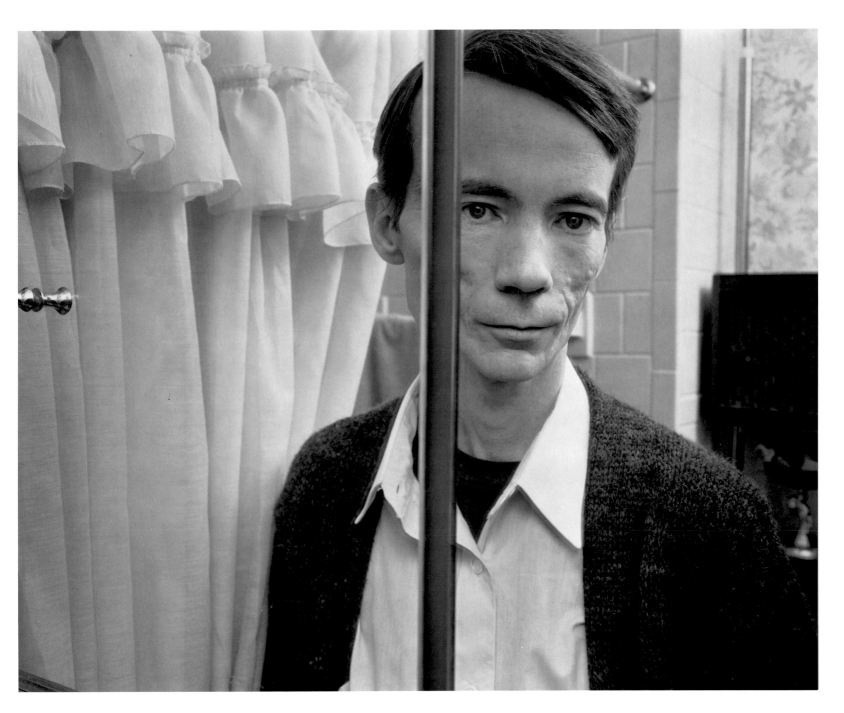

Tom Moran, East Braintree, Massachusetts, December 1987

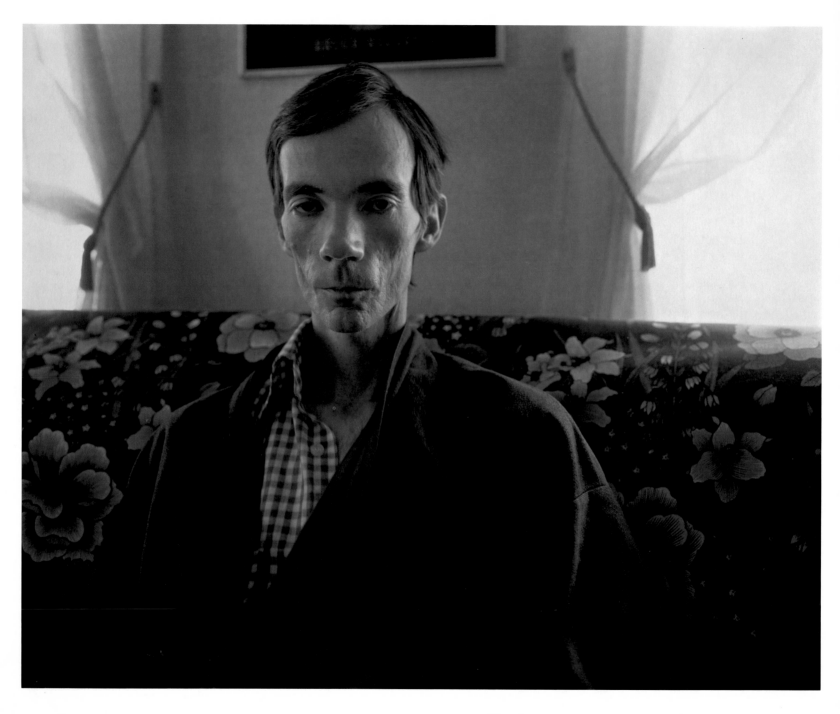

Tom Moran, East Braintree, Massachusetts, January 1988

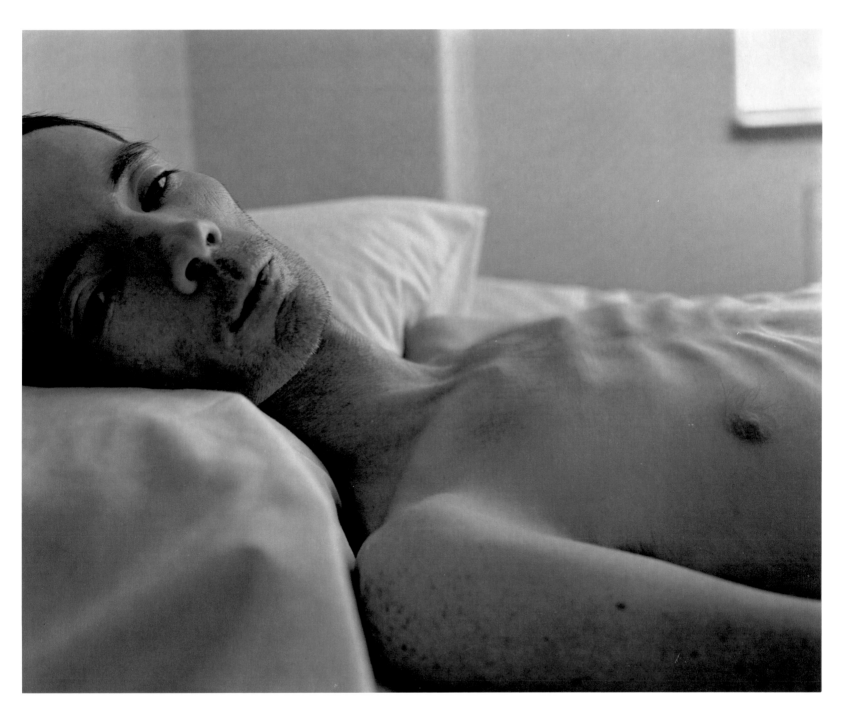

Tom Moran, Boston, January 1988

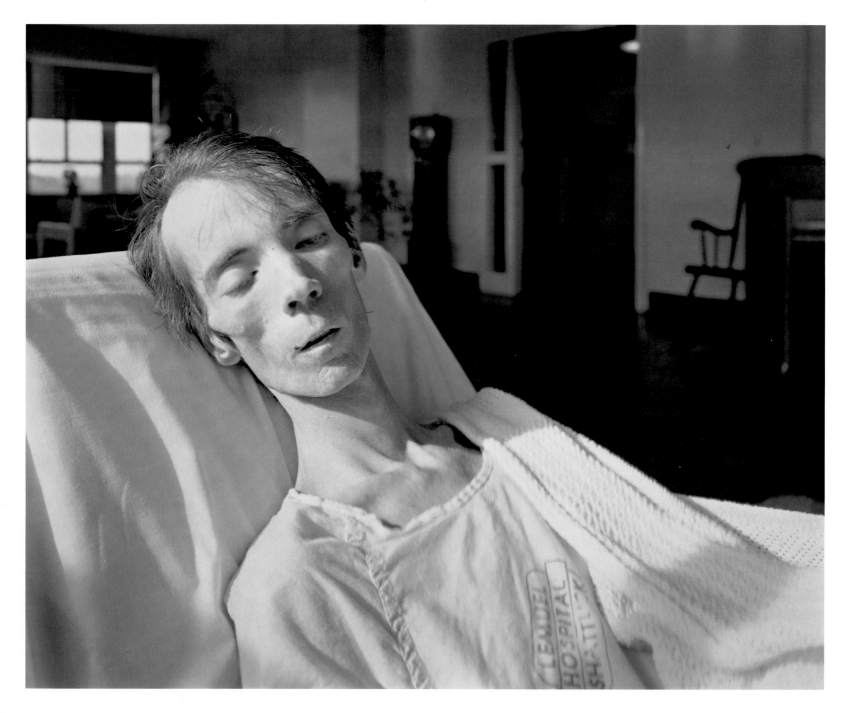

Tom Moran, Boston, January 1988

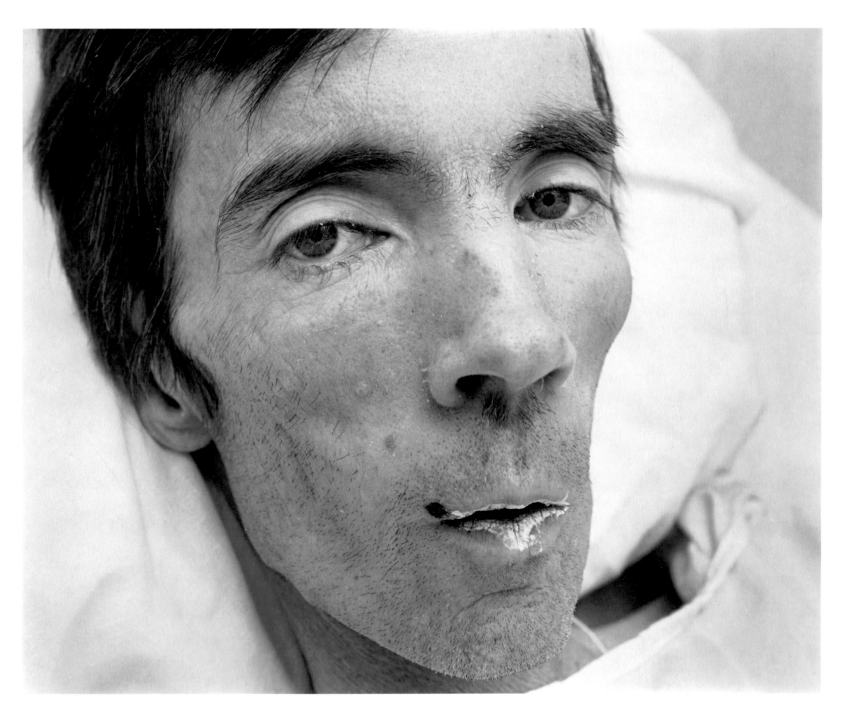

Tom Moran, Boston, February 1988

Joey Brandon

Joey Cloyd grew up in a close-knit family in Muncie, Indiana. There was one school for third grade all the way through high school. During his years there, Joey knew of no Jews, no Catholics, and only one black person. By the time he was sixteen, he knew that he was gay, that he wanted to be in the theater for the rest of his life, and that he needed to leave Indiana. In 1979, when he was nineteen, he moved to Boston to attend Emerson College, and changed his name to Joey Brandon.

For half a dozen years, he immersed himself in the excitement and the disappointments of Boston, the fringes of theater life, the competitiveness of other struggling actors, the city's huge subculture of students, of casual and serious drug users. He fashioned a life for himself as a gay man that fit his idea of who he wanted to be. He made many friends, and had a promising future in the theater. Still, he maintained strong ties with his family, and returned home every summer and every Christmas.

SEPTEMBER 1987

My parents and I have always been very close. My father is a big, gentle man, and my mother is also very strong emotionally. They both have stood by me. It's amazing, I can be really, really sick and the minute they get here I feel better. If something hurts, my father puts his hand on it and says, "Just be still." And the pain goes away. When he turned fifty was when it all really started to change with him. Because there was no factory production going on in my hometown, he stopped having to be this constant factory worker. He turned to painting. And now he'll open the back screen door and

hold out his finger and birds will light. And he builds houses for wildcats and raccoons. He has gone one step backward and yet fifty steps forward.

I think I'm of that generation that had the last real American childhood. We were so close. We did everything together. My parents and my older brother and I, we'd go to the county fair, picnics, family vacations, we were as nuclear a family as you could get. Plus, my aunt and uncle who lived next door and their two children; it became like a family of eight. We were always together. But by the time I was sixteen, I had started having sex. I was just counting the hours until school was out. And then, through very odd circumstances, I came here to visit, loved Boston, decided I was going to come back and go to school. And I made my life here . . . made some money, and got completely involved in theater, which is what I always loved.

In the summer of '85, I started feeling strange. My body just wasn't the way it had always been. At first I thought I was just getting older, that this is what getting older feels like. But I'm only twenty-seven. And I couldn't breathe. In January of '86, I went to St. Croix and I kept saying, "There's something wrong with the way I'm breathing. There's something wrong. I just know it." And it being 1986, I was naturally concerned about AIDS, and I kept going to my clinic and the doctor was having me eat yogurt and things like that. I said no, it's something more serious. Finally, in July, I had an X-ray by a specialist at the Deaconess [Hospital] and she said she was very concerned and that I should have another test that would be conclusive, and I got the diagnosis. If you're a

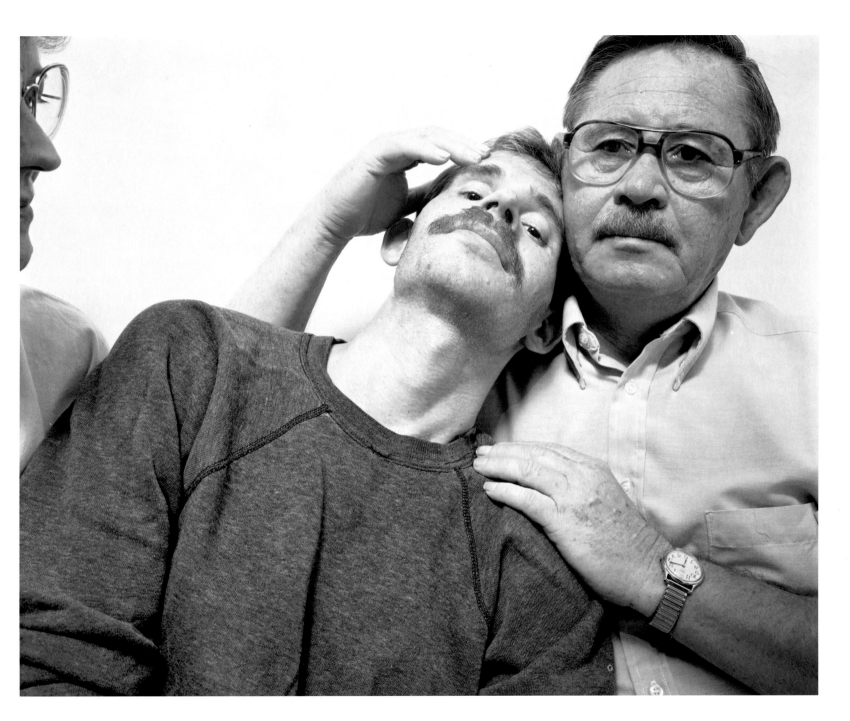

Joey Brandon with his parents, Zana and Everett Cloyd, Boston, October 1987 23

gay man, it isn't really a surprise, not if you're honest with yourself. But it is a shock. A terrible shock.

After the shock wore off, I had the time of my life. Really, the best. August, September, October were three incredible months of healing, learning metaphysical concepts, delving into the politics of AIDS. When I first got out of the hospital my own philosophy was, well, if you don't have a lot of time left, you'd better do what you've always wanted to do. And the thing that I always wanted to do, besides ultimately what every actor wants to do, which is Broadway or the movies, was direct.

I wanted to do a show, myself. I felt energized and liberated by my diagnosis, and I wanted to raise money through benefit performances for AIDS research. So a friend and I formed a little production company, and we got theater groups we knew around the city to donate and donate, money and time and everything. We got Mel Brooks to waive his royalty fee, and we put on the play *Archy and Mehitabel*. It's about a cockroach who has the soul of a poet, who is in love with an alley cat who has absolutely no morals. He tries to change her and she tries to change him, and both of them end up changing one another to the point that they realize it doesn't work unless you're yourself. Interesting music, very complex, very fifties-before-rock-'n'-roll. I was pretty sick, but we pulled it off. I had an oxygen tank backstage, and I would finish numbers and go back and use it. It lasted through the holidays. And then it was over.

Since then, it's been about a year. I've had minor bouts of different opportunistic infections. I've had pneumonia five times. I was cast in a new production of *The Normal Heart*, and tried to work, but I just couldn't. My health has gone steadily downhill to the point that now I can only work on me. I can't work on anything else.

NOVEMBER 1987

It has been important to me to keep my parents as part of my life. Even before I was sick, I'd visit a couple of times a year. They knew who I was and accepted it. But even if you, as an adult, have a very close connection to your parents, to spend a week in their home again can be very hard. I have had that feeling, during other vacations; I'd go visit, and I'd feel like I had to act like a child, or at best, be eighteen years old again. But, since I've been sick, when I go home now, we're well beyond that stage. My parents know that there's not a lot of time.

If AIDS hadn't happened to me, I would've continued running the rat race until I was ravaged in my fifties or so, and then something would have made me stop. If it hadn't been this it would have been something, because I was living eighteen-hour days and each of those days had to have a cocktail and a joint in it and you know, I was just going full tilt and I was thinking, oh yeah I'll smell the roses when I'm, well, older. I'm realizing now that you never do, that it takes something this jarring to awaken your spirit again, and that's been worth everything.

I've been ready to move on, to pack it in and say good-bye to this world. The hardest part is finding supporters for that, people who realize that I'm losing this physical body but I'll go on. I have come to believe that. Rather than live with this uncooperative body, I'd rather move on.

I've thought about whether I would ever do anything to make it happen more quickly. Just being so meticulous, I have to have every question answered. But when you start asking how many milligrams of Seconal it takes to kill a hundred-and-twenty-pound person, people say, "Oh, no, you don't want to do this, you wanna fight." And they may perk me up for the moment. But the fight is still mine.

Until I know exactly what to do, I've decided to make a concerted effort to keep going. But when I was suffering with fevers that were almost more than I could endure, I was thinking, "What pills do I have? Should I take them with alcohol? Will I be able to keep them down? How long would I have to get into it before someone would find me and try and stop it?" I did put together a Living Will which, although not legal in Massachusetts, does help with some decisions. I'm pretty comfortable and at peace with it.

The people that matter the most to me now are in support of me in this. I don't know anyone who isn't. If they're not supporting me, they're not close to me. It sort of works out that way.

My biggest regret is that I can't do anything to help my parents. Yes, I'm the one who's ill and I'm the one who's suffering. But part of my suffering comes from watching my parents, and my friends, in pain. My suffering will be over soon. Theirs will go on and on.

Throughout his many battles with pneumocystis pneumonia, a loyal network of his friends helped Joey manage the difficult process of living with AIDS. His lovers, Mark and Barry, virtually gave their lives over to caring for him. Joey's parents came to Boston from Indiana every other weekend during the fall and winter, to nurse Joey when he was ill, to talk and laugh and savor a little time together when he was well enough to enjoy it. His father, Everett, quit his job to take care of his son. Joey's mother, Zana, an elementary school teacher, arranged for substitutes to take her classes every other Monday, so she could stay in Boston for three days at a time.

In late November of 1987, Joey's doctor discovered that the virus had invaded his bone marrow. There was nothing further she could do for him, no further treatment available. Joey understood only too well that his immune system was so completely compromised that he was now vulnerable to every infection.

Long before he became so ill he had decided that, when the time came, he wanted to die at home, in his Boston apartment. His lovers, his friends, and his parents promised that they would honor his wish. And they did. As Joey grew weaker, they worked out a schedule so that someone was always with him at home. When he could no longer move from the bed to a chair alone, they added shifts of home health workers and aides, who could give them a brief respite from the grueling job of caring for a dying man. By March 1988 Joey rarely talked anymore, and had to be fed and cleaned like a baby. He was bedridden, wasted, and nearly blind. Finally, his parents came to remain with him until the end.

MARCH 1988
ZANA CLOYD, JOEY'S MOTHER

We've been told many, many times that we were exemplary parents, in the way we've taken care of Joe since he got sick. But my whole thought is always, "How could it be any other way?" I don't understand how it *could* be any other way. I don't know about exemplary parents, but we've been what we've always been: loving parents.

It has been hard. The kind of stress I've had this winter, and the going back and forth, and the getting here on a Saturday, and going through the emotional thing we go through every time we see him, because each time he looks so different. And then leaving on Monday, and saying, okay, this may be the last time, and going through that, going back, getting home at eleven o'clock at night, and getting back in the classroom at eight o'clock on Tuesday morning. We know there's no such thing as coming to terms. How can there be? Until you have to. I have friends that ask me how I stand it. You have no choice. You just do.

These past two years that we've had with Joe have been a hellish nightmare. But we had many times that we would not have otherwise had in an adult child's life. We've always been in contact with him a lot by telephone, and seen him twice a year, but this way, we've been with him a lot. And we wouldn't have had that. He wouldn't have wanted it, normally. We've had the worst days of our lives, and some of the best days of our lives.

There are nurses at home with Joe on Wednesday, Thursday, and Friday nights, and all day during the days. At times, it's just extremely hard to be with Joe for forty-eight hours, because it drains you so, just the emotion, and the work. It confronts you all the time. It's a nightmare. You get just distraught. Two nights ago, we'd been with him and he had this severe diarrhea, and we were so panicked. You just think, "I've got to stop this, some way." We had not slept a full night for four days. Your emotions are just stripped bare.

I read somewhere that the death of a parent is the death of the past. And the death of a child is the death of the future.

And believe me, that's harder. That's exactly what you feel. And, as far as with Joey . . . ahhh, such a future. And such a joy in our lives. Maybe in the future, I'll think back on things, but for now, I've been able to shove that aside and not think about what might have been. The fact that I work, and I work with a job that demands a lot of concentration, helps me to not think. It's when we're here with him, and I have time on my hands, that it rushes in.

From our background, you don't really deal with the sexuality of your children. We've been forced to with Joe because of this. But what we have seen, what we are constantly amazed at, is the love that Joe receives from Mark and from Barry. If that has to do with gayness, then so be it. It's true. What they do for him is love in its purest sense. Because it surely isn't going to be returned in an active way by him. In *any* way. We can go home to Indiana knowing that here are two people who are absolutely looking out for his welfare as well as we would. And in many ways better able to manage.

After Christmas this year, Joe went through a period of real depression. In many ways, that was the hardest thing to take. Now, even though he's so completely helpless, at least he isn't miserable. Something has happened in his mind. Whatever it is, it's as though he knows no yesterday, or no tomorrow. It's just now. It's easier.

I was reared in the church, in a fundamentalist group. I rejected that in my twenties. Before this happened, I would say, you die, there is nothing left. Joe's illness has not made me believe any more or less than I did, about spirituality. Yet, there's part of me that will not say that Joe is going to be gone forever, and there's nothing but this. But maybe I feel that because I need to feel that. Whatever. Maybe there's just a part there that's just what man's search for religion has always been. Just a feeling that this can't be all there is. It's surely made me think a lot more. I have to think, "Is there something else here?"

When he told us what he had, it was July twenty-sixth, nineteen eighty-six, at six o'clock. He told me on the phone, "Daddy, I don't regret what I've done. I chose to live my life the way I wanted to, and I don't have any regrets. But I am so sorry I am doing this to you. You know, I heard this somewhere, somebody said, 'I sowed the wind.' But oh, Daddy, I reaped the whirlwind."

I think the government and the pharmaceutical houses that work on this have really been slow with it. And I think that came about because most people thought, "Who the hell cares? The queers have all got it, so let 'em die." But it's more than that kind of a problem now. It's our century's bubonic plague. I just feel sorry for the people that suffer this.

I of course love my son. And it didn't make any difference, when I found out he was gay or homosexual or whatever term they use. But I have come to understand something that I didn't know before. I was born in Kentucky, and I live in Indiana and the Midwest, and some like to call us redneck types. What this has gotten me is a son who is going to die soon. But I've met some of the most fantastic people that I have ever seen. I've met a doctor who is not only an excellent physician, but is a kind and gentle human being, and has been of immeasurable help. You just can't estimate her help. She's just a kind and gentle woman. She gave my son respect. And she gave him excellent medical help. Barry and Mark are Joey's lovers. I joke with them about this all the time. I don't know whether to call them my daughters-in-law, or my sons-in-law, or whatever. If it's daughters-in-law, then Barry is the former wife, and Mark is the present wife. But anyway . . . These two men, he asked them if they would help him die at home, and they said yes. I could sit here for the next two hours and tell you what they have done, and what they've gone through. And they intend to see it to the end.

There is a songwriter, here in Boston. There is a doctor at Massachusetts General Hospital. They've been his friends through the years, and they were there two weeks ago to visit. Joey had diarrhea and we were cleaning him up, and I

kept hearing the dishes rattle, and I looked in the kitchen, and here's a doctor washing dishes and a songwriter drying dishes. Nobody asked them. The doctor is coming back one day next week to stay all night, so that Mark can have a little vacation. Those kinds of people I didn't know existed anymore.

There's a man named Chuck, who knocks on the door every Tuesday, takes a grocery list and a handful of money, goes to the grocery store, comes back, brings a bagful of groceries and a bouquet of tulips, says, "Have a nice day, Joey," and he leaves.

These four nurses, who do this kind of work, they do it out of choice. A lot of nurses won't touch an AIDS patient, which is understandable. But these four nurses are not pretentious. They want to do this. Now they obviously get paid. They have to make a living. But they want to do this. Yesterday, when Ellie, the older lady, went home, she bent over him and she said, "Joey, it's time for me to leave. Now, I won't be here tomorrow, because I have to go pester somebody else." Joey has knickknacks and little stuffed animals everywhere. And when she leaves, she hands him a stuffed animal, and he hugs it. She could just get up and walk out and say, "Bye." But she doesn't. So they are remarkable people.

And I've learned some things about AIDS. About as much as there is to know for a layman like me. I know that I am not fearful of touching my son or hugging him. But I also don't take any chances, with bodily fluids. We wear the examination gloves, we make no pretense . . . And at one point, in a hospital, his nose was dry, and he blew his nose, and it was slightly bloody, and he dabbed it, and I walked toward him, and he shouted, "Don't touch that! It has blood on it!" He told us early on, that we were never to touch any of his body fluids without protection. And so, these things I've come to learn.

Joey will have been diagnosed with it two years this coming July the twenty-sixth, and on the day that he told us this, I knew he would die. I knew it wouldn't be the next day, but I knew he would die. And I've had an awful time coming to grips with it. I was twenty-eight years old when

my first son was born, I was thirty years old when my second son was born, and I always believed that they would have to suffer my death, and I never would have to suffer their deaths, in the natural order of things. And so now, I will. I am watching him die. If you look at him from the neck up, he looks much like he always did, with his eyes shut. But, when he opens his eyes, the right eye is destroyed. If you take the covers down, he weighs about seventy pounds. And so it never leaves us. I accept that he will die. But I sure as hell don't have to like it. We have loved him. And he knows that. There was never any doubt in his mind that we loved him. There was never any doubt in his mind we were proud of him. And I've done everything I could for him, and so, that's all there is to it. He will leave me soon. And I can't stop it.

He told us about Nick. On two different occasions, when he had his right mind, he told his mother and I, asked us, that no matter what he ever said, Nick was to take the pictures. He believed, and I believe, in what you two are doing. Somebody needs to look at the ugliness of this, that these are people, that they're loved by somebody, that somebody cares.

Beginning early last November, he had a terrible bout of diarrhea. And we took him to the hospital. He stayed ten days. At the end of that ten days, we got ready to bring him home, we had a meeting around a long table, with all of the support team as they like to call it, and the social workers, and Dr. Pinkston [Joey's physician]. And everything was laid out. "Joey is going home to die. Do you all understand this?" We all understood this. Each person had the chance to say anything they had to say. And it was understood that Dr. Pinkston, as the head of the medical team, would do the prescribing, and we were to follow her orders. And she had talked to Joey's mother and myself and we had agreed along with Joey, that he would be allowed to die without any artificial anything. And so we wait.

In the hospital, he began to speak strangely. And we thought it was the medication, because he would not be real plain. For instance, we walked into his room one morning

and said, "How are you?" He said "I'm fine. Larry Neal was just in to see me." Well, Larry Neal was a little boy Joey knew when he was seven years old. And we said, "Oh, that's nice. Was it a nice visit?" He said, 'Yes it was. Then Cheryl was in to see me. And I hadn't seen her for a long time." And it *had* been a long time. About fifteen years ago, back in Indiana. So we began to talk to the doctor and asked, "Does this medication do this?" And she said, "Well, it has sometimes been known to," but she very gently began to tell us, "It's the disease. Heavily sedated, he might not be coherent. But you have to understand, it's the disease." So we began to understand. From there, it really went down.

I came and got him, and took him home to Indiana for Thanksgiving last year. He was horribly depressed, because he was aware of what was going on. So then he came back to Boston, and stayed a few weeks after Thanksgiving, but he insisted on coming home at Christmas. By this time, he was so weak. I tried to talk him out of it, but he just insisted. And so Mark and Dane flew with him and brought him home. Dane is Joey's roommate. They were boys together, went to the same school and everything. And they share the apartment. As it turned out it probably was not the thing to do, because he looked at the Christmas tree for the last time, he looked at his room for the last time, he looked at where he lived, and he looked at his kinfolk for the last time. And he was terribly depressed. But he was himself. He was lucid, most of the time.

After Christmas, he was back here ten days, when another terrible bout of diarrhea hit him, and Zana and I flew up to help the boys. The boys had been doing seven nights a week. So we came up, and it was a terrible shock. Because he would say things that made sentence sense, but they made no sense. For instance, I said "Good morning, Joey, the sun is beautiful today." He said, "Good morning. Yes, it is. It's really bright. But it always is when the janitors all line up."

And so, he went from that period, steadily down in weight, and he's gone steadily down in talking, in that he almost doesn't talk at all now. In February, we stayed a twelve-day period with him when he only said two words to us. Now, he is blind in the right eye, his vision is limited in the left eye, and if we get down and we talk to him gently, he will answer, once in a while. But what he will do is, he will smile, and he will take our hand and he will squeeze it. And so he knows who we are. The times that I have been there, when Nick comes, he has always responded to Nick. The last time I saw Nick, he said, "Hi Joey, how are you this morning? Is it okay if I take a few pictures?" And Joey said, "Sure." And began to straighten his shirt up, the little ham. But he doesn't know whether it's yesterday or tomorrow, he's just in his own world when he's awake now. So we keep him warm and dry and comfortable, and pain free, and we will not be sorry when he's dead.

There's nothing easy about it. There wouldn't be for anybody. And it doesn't make any difference how much you get yourself prepared, every time when I walk into that room and he's there, I want to touch him, and I don't want him to die. So it's hard on an old man that thinks he had nature and the world figured, that my children would watch me die, that they would sit there and watch me die and say, "Papa was a nice fella." At least, I hope they'd say Papa was a nice fella. But it isn't going to be that way. And so I work at it. I try to take care of myself. I have another son who needs me. And I intend to do what little I can to help somebody else when the time comes, like they've helped Joey.

At home, I've had the same doctor for twenty years. We talk often about AIDS now, every time of my regular visit. He told me that in the city I live in of eighty thousand people, we have one hospital, and it is partially closed down because they don't need all of the rooms now. He said that there is no facility in that place to treat an AIDS patient. They would take it to Indianapolis. And so he quizzes me a lot about what I know, and how they do things, like that. But there's nothing where I live. Even in Indianapolis, which is a large city, they have very few patients, and they simply take them and pretty much let them die. Now, there isn't much you *can* do. You can't stop them from dying, and there's nothing to cure them. Each time I see Joey he is thinner, his limbs are now beginning to be fairly rigid. I talked to Dr. Pinkston this morning,

and I mentioned this to her, and she said, "Well, unfortunately that's another step." So, it's just horrible.

This July we will have suffered with this two years. And it is all to no avail. No matter how heartbroken we are over it, and no matter how much we love him, we can't save him. And it's a hell of a thing to sit and watch your son die, for two years. He'll be twenty-eight years old, the thirteenth of September this year. But he won't make it to his twenty-eighth birthday. But I love him, I've been proud of him, he's made me proud to have him as my son. Nobody could ask for more. He's a kind and gentle-hearted loving son, and I'll miss him.

He even had all these arrangements made for his death. He dictated his will to his brother. He provided in his will who he was to give his things to. He made his dying as easy as he could. But he was always that way. In his will he asked to be cremated. And he asked that I would place his ashes where he told me to. Now, I like the outside. And one of the places he told me was, I was to go in my backyard, and I was to scatter some of his ashes in the wind, so that every time the wind blows, he would be in the wind for me.

I see Joey, and I think, "Why are you hanging on so long?" I know he wouldn't want to be this way. He would despise this. When we have to clean him up, he tries to cover himself. Now, he's stopped doing that with his mother and I. But I notice even now with the nurses he'll try to cover himself. And Monday night into Tuesday, he was having such severe diarrhea, and Zana and I were there with him, we didn't sleep any during the night, and we were cleaning him, and he kept trying to move. And I said, "Joey, what's the matter, honey? Are we hurting you?" He said, "No, I don't want to get my sheets messed up." So I whispered in his ear, "You let Daddy worry about the sheets, you just relax. I'll tell you what you do." We always put his shirt on him backwards, now, because it gets wrinkled under his back, and he's so thin, it just makes welts. So I said, "You hold your shirt for Dad, and you let Dad and Mom worry about the sheets. I'm the best laundry man in the world." And he smiled, and nodded his head. And

every time we go to clean him now, he takes his shirt and holds it on his chest with his hands. Such indignities he suffers. Even though he's touched with great love and care, he would not want to be this way.

But I look at him and I think, "How can you hold on?" I don't know, but I've got a suspicion. I said to my doctor one time, "I don't know how he lives like this." He said, "Well, I don't know, either, but I've seen some strange things in medicine. Sometimes, when people are not in great pain, even if they're desperately ill, if they're touched with love and kindness, they don't give up the ghost. This is a very unprofessional thing for a medical man to say, but I think the mind can just turn the body off, when it needs to. And when a person is not in a great deal of pain, and isn't suffering, they just hold on, because they're not afraid. They just hold on to the love. And when it's time for them to go, they let go."

And I think that's what Joey is doing. Holding on to the love. But Joey, the way he is now, he doesn't know if it's today or tomorrow or yesterday, and he's happy. All he hears are words of love. So he hangs on. He's not unhappy. He's not in pain. We see that he's clean and warm and has enough to eat. And he just lies there.

What's hardest for me is not being able to help Zana. She just sits and cries and holds his hand. And I know there's nothing I can do. I know. Because when I sit and stare, or get angry because the hurt is so bad, and my heart feels like it's broken, she tries to help me. But nothing she says or does can help. No words, nothing. It just hurts and hurts. So I think, just let her cry. I used to say, "Come on out of there, let's go in the kitchen and have a Coke." But now I think, it's good for her. Maybe it helps her to cry. But it hurts me to watch her. I cry in the middle of the night, when she's asleep. So she won't see me and worry about it too much.

She knew about this gay thing a long time before I did. I feel bad that she didn't think she could tell me. See, I'm not a very social person. I've never gotten close to anyone, except my family. I'm the kind who resents being invited to a party. I don't like having people at my house. I'd resent it if someone would just drop in on me. I'd be civil and polite, you

know, but I didn't like it. But I love animals. It hurts me even to set a trap to kill a mouse. When one of our cats died, I buried her in this little graveyard in our yard. It's hidden from the road, so nobody thinks there's some weirdo living there. But I have little tiny crosses with the animals' names on, and their dates . . . I'm really a very gentle man. But I think she thought I couldn't take it, knowing about Joey's being homosexual, or gay, or whatever you call it. I think she thought I'd be angry, or I'd hurt someone. Because, like I say, I can't stand to see an animal hurt. But if someone tried to hurt my family, I'd kill 'em in a minute and sleep real well that night. I really would. I think she was afraid of what I'd do. And I feel real bad about that. Real bad.

I'm not a religious man. I've always thought that you come into this world knowing nothing, and after you leave you know nothing, and that's it. Now, that doesn't mean I think everyone ought to think that way. I'm happy that other people believe in a soul or an afterlife or whatever. But if you ask me to believe it, it's like asking me to sit down and read a newspaper in Chinese. I just can't do it. It doesn't make any sense to me. Now maybe after all this is over I'll feel different. I just don't know. But I do know that as long as I'm alive, Joey will still be here. He won't be gone. He'll be in here with me, and I'll never let him go. It will be like he's in Boston, and I just can't see him or talk to him. That's all. I have so much stuff I've saved over the years. Things he and his brother don't even know about. Some baby clothes.

Hundreds, no thousands, of pictures and movie films. All of their report cards, and achievement awards. Stuff they made all through school. I've got reams and boxes of things that were theirs. I don't know why I kept it, I just had to. It's the memories, that's what they are.

But oh, how I hate to think of what might have been. What might have been . . .

I could talk for two days and all you'd hear would be words. Just words and words, and they wouldn't make any difference. None of them do any good. They won't help my boy. They won't keep him from dying. And they won't keep me from having to help him die, having to watch it and be so helpless. I thought I had it all figured out. I never thought I'd have to watch one of my children die before me. I thought I'd be gone. But I was wrong.

Joey Brandon died at home on April 18, 1988. He was twenty-seven years old.

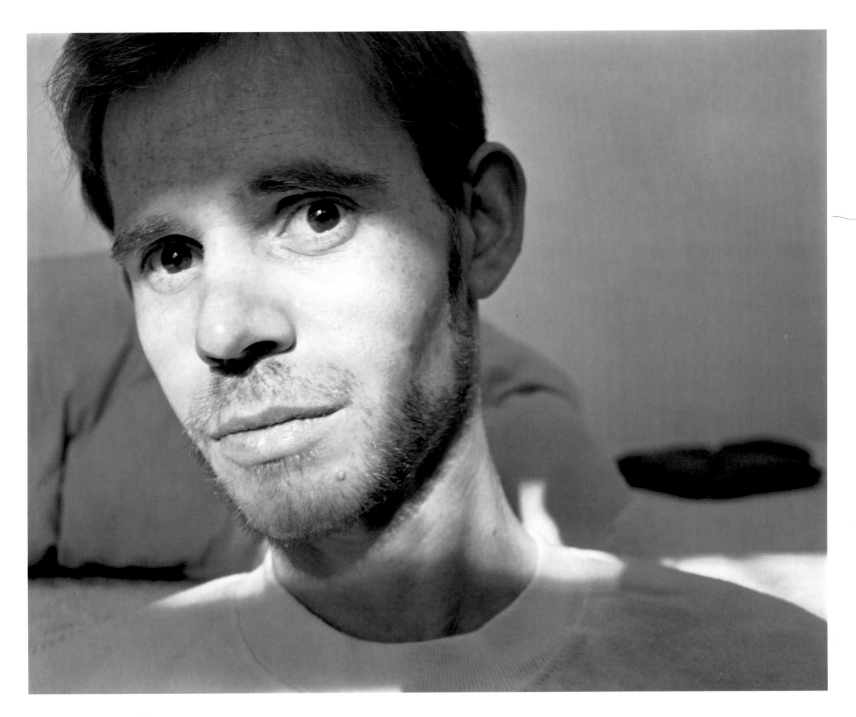

Joey Brandon, Boston, December 1987

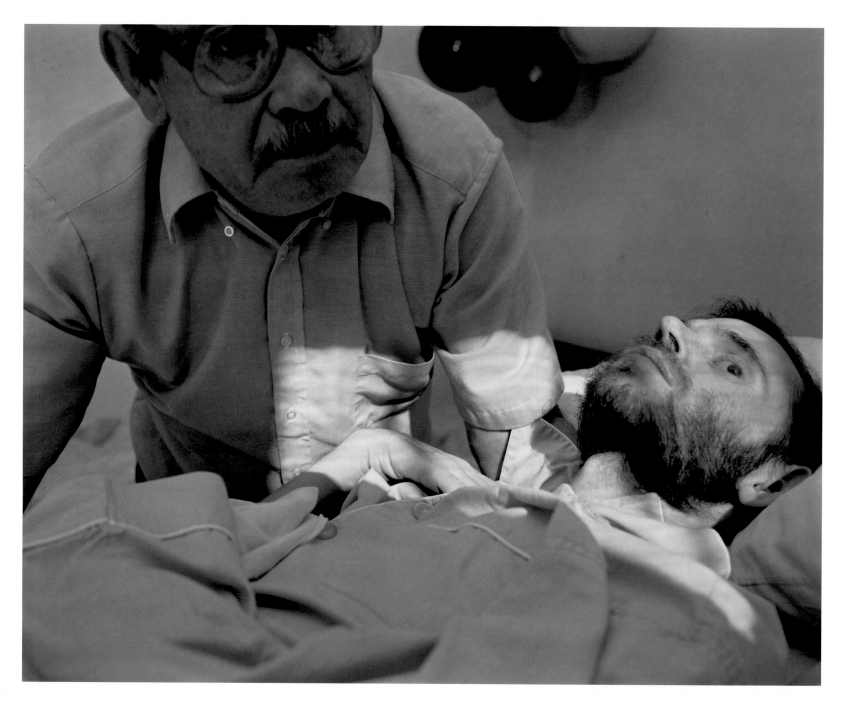

Everett Cloyd and Joey Brandon, Boston, March 1988

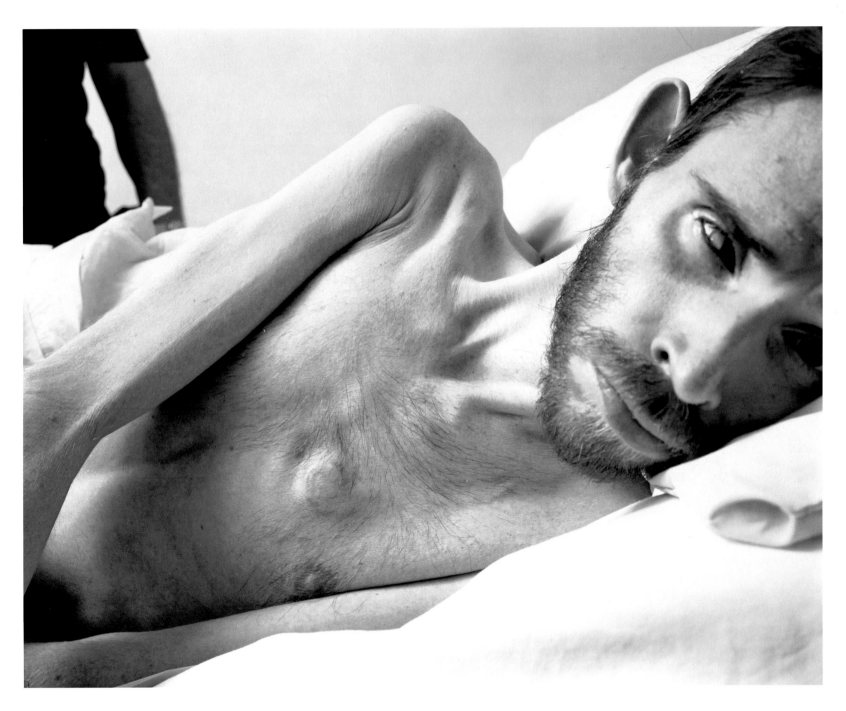

Joey Brandon, Boston, April 1988

Linda Black

Linda was a shy, graceful woman, who worked as a traveling department-store photographer. In the early 1980s, she lived in Florida with a man she was deeply fond of, but who, she became convinced, didn't love her enough. When the affair went wrong, shortly after her father's death, she moved back to Rhode Island where she'd grown up, to be near her family. There, she had trouble settling down. She changed jobs every few months, and kept restlessly searching for a good man.

In early 1986 Linda began to feel run-down; she had had a sore throat for three weeks. Her dentist saw blisters in her mouth and told her she had thrush, as well. By summer she began to have fevers and chills, and was in and out of the hospital for two months, with no confirmed diagnosis. She came down with pneumocystis pneumonia in September. A blood test confirmed that she had AIDS.

She had always been tiny, but during her hospitalization she became almost skeletal. She lost all her hair because of the medication.

FALL 1987

I really didn't think I was going to come out of it. You don't think you're ever going to get well even though you're getting well. I didn't think so anyway, until I went on AZT and the AZT made such a difference. The first three or four days it was rough, because your body's getting used to that real toxic poison that they're putting in it, 'cause it is real toxic. After three or four days it gives you back your appetite, which is the main thing that you've lost. In three months I went from 106 pounds down to 75, real fast, because I couldn't eat any-

thing; not that I couldn't keep it down, just no appetite. The AZT, that's one of the first things it gives you. So I put on my weight real fast and once that happens, it's like a new lease on life. I really thought I was raring to go after that. It's been almost a year, now.

My first doctors were not experienced with AIDS or AIDS patients, and they really didn't know how to deal with me. They were afraid, I think. I wasn't sure they really wanted to help me. They were very young doctors, careless of my feelings and my pride. They just didn't know how to handle themselves with AIDS. I was embarrassed for them. Thank God, they understood that they weren't the best doctors to treat me. It kind of scared me to do it, but I went and found Dr. Fisher instead. They were relieved. So was I. I completely trust Dr. Fisher. He's been taking care of me right along now. But I still call those other two guys, from time to time, just to let them know how I'm doing. Besides, I don't want to hurt their feelings.

When I was diagnosed, I didn't feel any panic. It was just, "What do I do first?" It turns out you don't do anything first, you just continue with your life, really. 'Cause unless you're rich, life has to just go on.

I learned real early in life that you have to have family, you have to have something to claim as yours, to be a whole person. My family has always been close. There's so many of us, eight children and now fourteen nieces and nephews and we all live in Rhode Island, so we're very close. And my mom's still alive.

We've had so many serious problems through the years

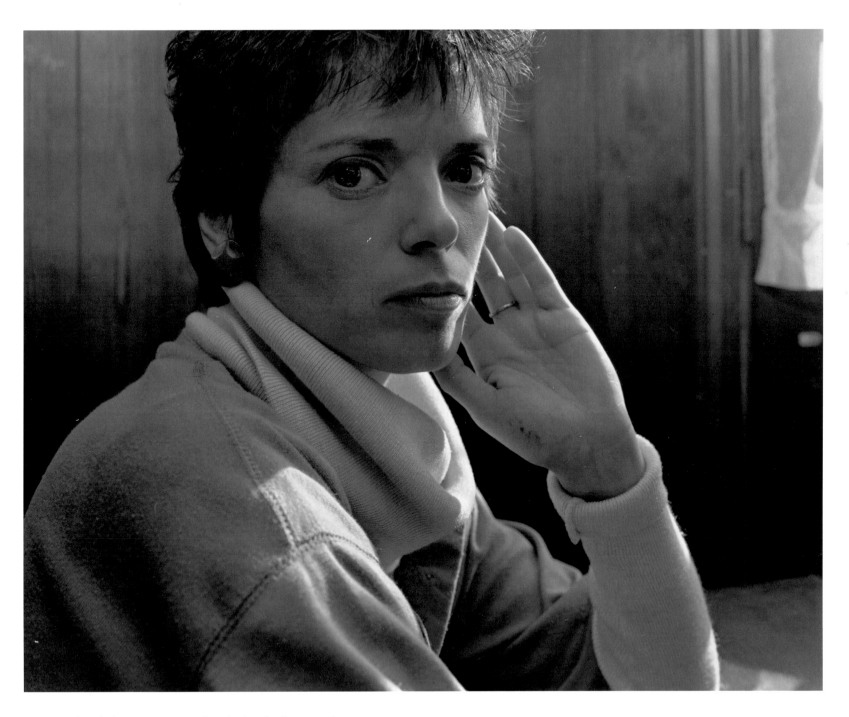

Linda Black, East Greenwich, Rhode Island, September 1987

that we've stuck through. Growing up, my youngest brother died; he got hit by a car on his bicycle. It was really pretty bad, and we had to go through that. And my father's dying. My father was the Rock of Gibraltar of the family, but he was very sick. He had emphysema for twenty-something years. It kind of brought us together. Because my father was ill all those years, dealing with sickness at home was almost normal. That's why, when they found out about me, even though none of the family really knew what it was, and I had to explain to them and educate them, they were fine. They know there's a possibility I could die—I could, possibly, a little sooner than I think.

SPRING 1988

Back in 1980, 1981, I was really confused and going through a bad period. One night, I was out with my sister. We were at a local pub having a couple beers and playing pool. It was a nice place that women could go into and everything, it wasn't a sleazy dive or anything like that. We were sitting there having a beer and these guys came and we met them, and next thing you know they're doing drugs.

I got involved with one of them. And I got started doing drugs too. Not that night; it was like a week later or so. At first I just snorted it, 'cause I'm definitely afraid of needles, I really am. But that's where I got AIDS. After I left him, I found out that the guy I was with used to go to New York, and he probably shared a lot of needles in New York. My doctor seems to think that it probably was from having sex with him more so than the IV. 'Cause I had only done it maybe a dozen times. I didn't want to do it for the needle part of it, I just wanted to get the escape of the drug, and even then I didn't do that much of it because I was always afraid of OD'ing or something like that. Deep down inside, I felt I was doing something sneaky. I stayed in my apartment, I didn't let anybody know. I couldn't even go to the store or anything or visit my family when I was on it. Not that they would know, but I knew.

After two or three months I felt so dirty, and I stopped

seeing this guy. I finally got away from him and lived with another gentleman, sharing an apartment not sexually or anything, and it was well away from my family, and everybody, 'cause I had to get back my self-esteem and get back my self-worth, and I couldn't do that unless I got back on my feet.

I got my apartment and started working. But then I met this other guy and had a bad relationship with him, because he battered me. He'd drink and then he would just haul off and whack me because I said something that he didn't like. It's hard for me to talk about him, because I didn't do anything wrong. It's hard for me to think about this, because when I remember, I remember the real bad stuff.

There was one time he thought I'd lied to him. That was the worst. He actually tortured me with a knife and burning cigarettes. Beat me for several hours, I'd say five or six hours. He hit me so hard I actually went across the room and then he continued hitting me and punching me and kicking me and stepping on me and taking my head and banging it up against the wall. I was black and blue all over, I had a collapsed lung, I had four broken ribs, I had a sprained ankle. And after he beat me for hours, just punching me and hitting me and punching me and hitting me, he tied me up in a chair and took a cigarette to my head, took a knife to my throat— a butcher knife, a real big butcher knife—and threatened to kill me. We had a huge plastic bag that a mattress had come in that he was going to put me in and throw me in the lake, 'cause we lived on the lake, way out there, and it was very quiet. I just prayed and prayed and prayed. Finally morning came and he untied me and I tried to get up and I couldn't. I could barely, barely walk. And I said, "I have to go to the hospital, I have to go." And he just said, "Go." I drove myself, barely, 'cause I couldn't even see over the steering wheel, but I made it to the hospital. When I got there I was so afraid that he was going to kill me that I told them I was mugged. And they believed me. They believed me.

I was in the hospital for a week, and of course he insisted on seeing me. I went back home with him, and I lived with that fear for a long time. I couldn't go into the room where it happened. I stayed out in the living room and I just existed

for a while. And then one day I just took off to California. My sister was out there and I stayed with her. I didn't let anybody know that I was going, except for one brother in case anything happened to my mother or anything like that. But I didn't want anybody to know where I was 'cause I didn't want him to come after me.

But he came after me. He found me. He tried to sweep me off my feet, he did all kinds of crazy things. He came to the house dressed as a clown with tears in his eyes, and balloons in his hands and chocolates and cards, and begged forgiveness. I guess I really did care for the guy, unfortunately. Because I gave in. My sister and her friends all thought what he was doing showed how sorry he was. They thought, "Oh, look at that. How can she not forgive him?" It hurts me that nobody wanted to see my side. Nobody wanted to protect *me*. They betrayed me, really.

So, I went with him, up and down the coast of California and he showed me all the sights and spent lots of money. We went down to Mexico and went shopping and we got married down there, in Tijuana. We stayed in Southern California for a few weeks 'cause he had friends there. Then we drove home and halfway home, he hit me again, and when he did that, I said to myself, "You're dead, Linda. This is the end, you're doomed." That's how I felt. I felt he was my penance for whatever I'd done wrong.

I convinced myself that I deserved it. I had to. Why would God do this otherwise? And I couldn't seem to get out of it, I just couldn't seem to get out of that frame of mind. I just couldn't get rid of him. Because I was afraid to tell him, "Just get lost."

Every couple months he would smack me just to remind me of what he did. He never beat me again, he never really hurt me after that. He would just smack me in the face, enough to maybe cut my lip or maybe just enough to make me cry, just to let me know that he was still the boss. You know, things'd be going fine and for no reason at all he would do that.

I finally moved out, found a little place on my own, just one and a half rooms. He ended up still hanging around. But

he couldn't stay at my house and I was finally free and alone and by myself and in control of my own life for the first time in I don't know how long. And that's when I came down with AIDS.

He stuck around a little while when I was sick and I told him, "If you're going to stick around we're going to have some type of relationship and you're going to have to take care of me. You better make up your mind right now 'cause I want to know today." And he said, "Well I'll think about it." And then I never heard from him again. So, I felt lucky actually, that I got the disease so I could get rid of him. Honestly, that's how I felt. I was so trapped. And from that moment on, I was free. Isn't that weird?

Of course, he might get it too. When I was diagnosed he refused to believe it. Even though the guy that I was with in 1980 those two or three months died in '83, I still didn't think of it. It was too remote . . . I thought, "It'll skip me." The guy who beat me up could be sick somewhere now. But I was glad to get rid of him. The relationship almost killed me. Actually, the guy almost killed me. And I just couldn't do anything about it, I was so confused. Dealing with AIDS is pretty easy compared to the past.

After almost a year on AZT, the drug started depressing Linda's blood counts to dangerously low levels, and she had to go off it. She developed another bad case of pneumocystis, and was hospitalized a second, a third, a fourth time. With the loss of the AZT, Linda pursued nontraditional cures. She became a disciple of Louise Hay and Bernie Siegel, and gradually gave up taking all her medications. She felt it freed her, and gave her a measure of control that she'd never had.

Just a few hours before she died, Linda was baptized as a member of the Episcopal church. In the end she felt that she herself was blameless, and forgiven by God.

Linda Black died alone at Rhode Island Hospital on May 12, 1988. She was thirty-five years old.

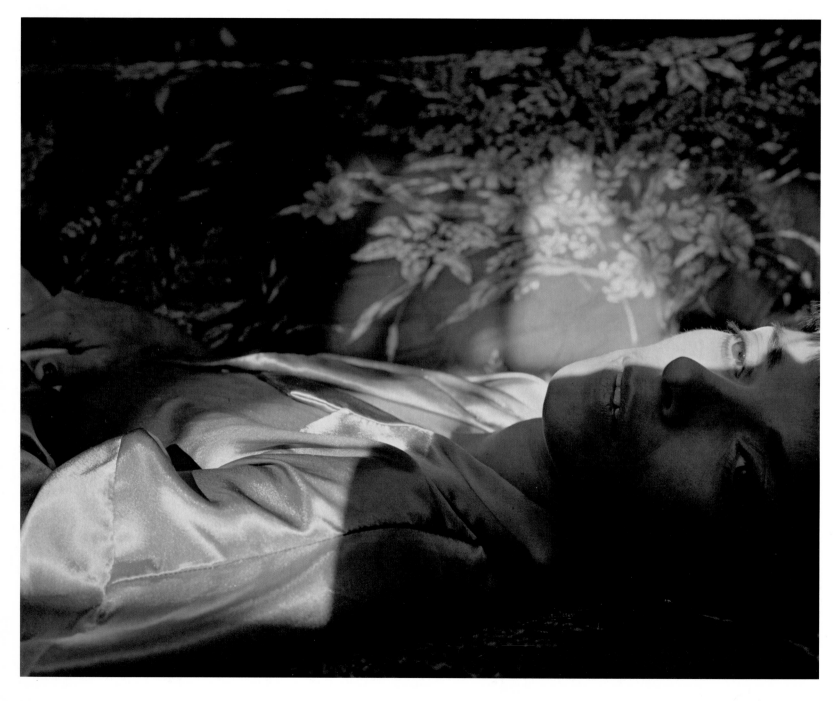

Linda Black, East Greenwich, Rhode Island, December 1987

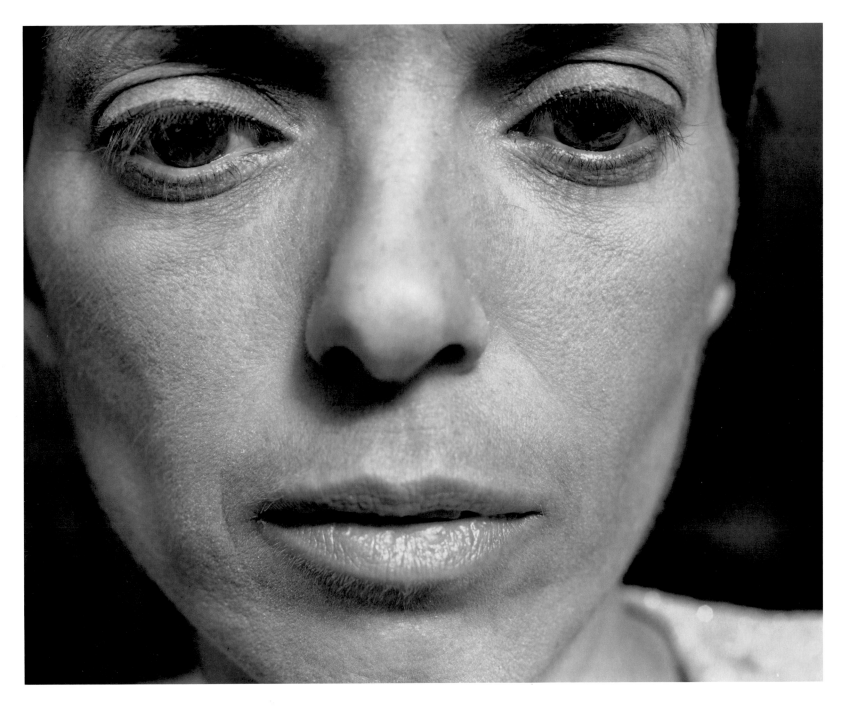

Linda Black, East Greenwich, Rhode Island, January 1988

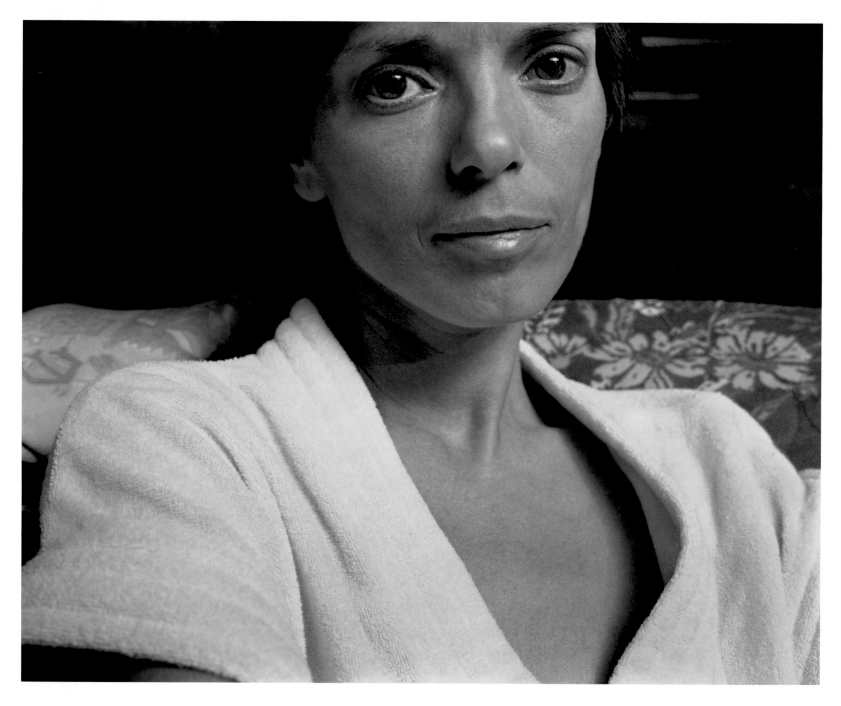

40 *Linda Black, East Greenwich, Rhode Island, March 1988*

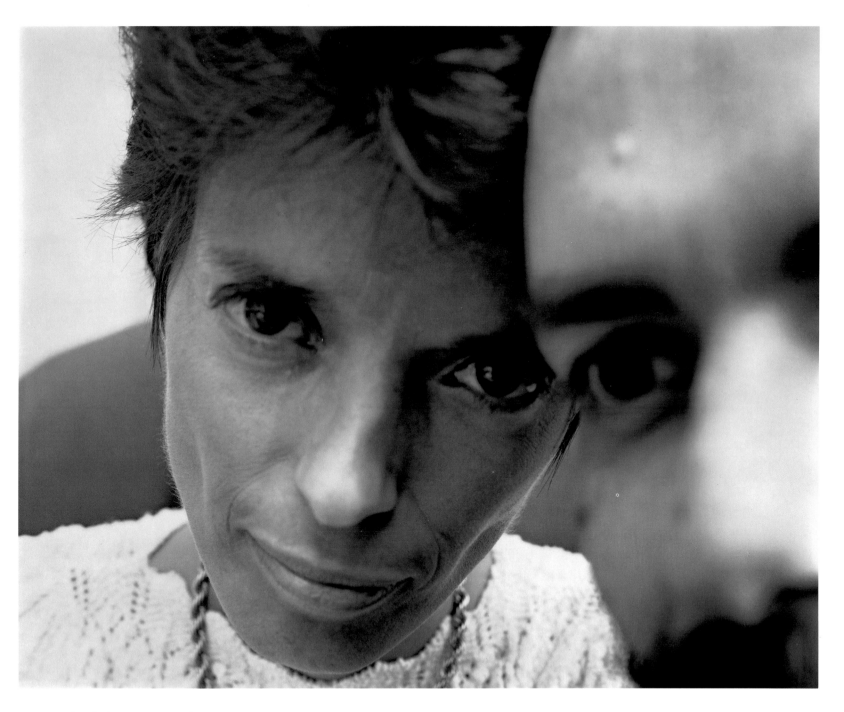

Linda Black, Boston, April 1988

Tony Mastrorilli

Tony had been a successful actor in New York for several years when, in the early spring of 1987, he discovered a small lesion. He thought he might have AIDS, but wasn't certain. Though he felt well, he left New York and moved home to his parents' house in Mansfield, Massachusetts. For a month, he lived at home, telling his family only that he was seriously ill, possibly with cancer. He traveled almost daily to Boston's Massachusetts General Hospital for tests. When the results were conclusive, he decided to tell them what he had suspected all along.

During that summer he went public with his illness, and began speaking at AIDS Action Committee events. He went out into the community to talk about AIDS education, prevention, and awareness at high schools, church groups, and clubs. He was featured in newspaper and magazine articles that talked about "bravery" and "living with the disease, not dying of it." He became interested in the PEOPLE WITH AIDS project, as another way to contribute, to make some use of his disease, to teach others about it.

Nick began photographing him, but the pictures were awkward and stiff. Tony had expected some kind of PR photography, not a hard look at Tony Mastrorilli. He had thought that Nick would somehow just follow him around, like an invisible presence, recording and celebrating the surfaces of his life. He was uncomfortable with the intensity of Nick's involvement, uneasy about what the camera was asking of him, and what it was revealing.

He became increasingly uncooperative during picture sessions. A couple of times he failed to show up for appointments. Eventually, in September, Nick asked him to withdraw from the project. He felt that neither of them was happy with what was happening. He sent Tony several batches of photographs, wished him well, and asked him to call if he ever wanted to rejoin the project.

Just after Christmas of 1987, Nick received a telephone call from Tony. He said, "Nick, I'm ready."

He had been very ill, he said. He'd lost the use of his legs, because the disease had attacked his muscles. He now spent most of his time in bed, or on a couch in his parents' living room. When he finally became too ill to get upstairs, they moved a hospital bed into the living room. Tony's sister, Theresa, who also lived at home and was a critical-care nurse, helped them look after him.

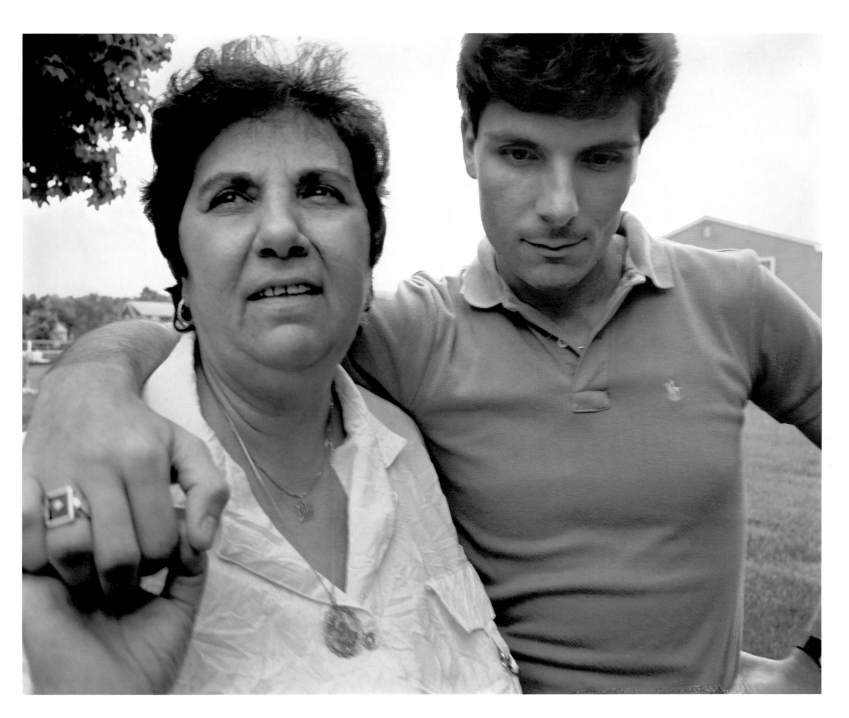

Anna and Tony Mastrorilli, Mansfield, Massachusetts, June 1987

I was in New York, working, and I knew something was definitely wrong. This was fall of '86, winter maybe. I knew. It was hard to bring myself to go to the doctor, because I knew.

We were having a seventy-fifth birthday party for my grandmother. My sister was getting everything ready, I paid for everything. And I came home, knowing I was sick, very sick. Knowing I was going to tell my family at this party that I was sick. But I hadn't decided how much to tell them. Not yet. And I wanted my grandmother to leave, before I told the rest of the family.

We had a bunch of people invited here for Thanksgiving and I was so scared. But I did tell every relative.

They were really uncomfortable at first. You know what it's like, when you don't know what to say to someone who's just told you something horrible. I would be the same way. You think, "Am I going to stare at the lesions?" You just don't know what to say. I understand that. I really do.

My parents didn't know I was bisexual, either. They never suspected any of it. So it was doubly hard to tell them. Because I'm their only son. I explained it to them. They were devastated of course. I told them I'd not be getting better.

When I came home, I left the theater in New York. More than that, I really left my whole life. My friends, my dreams. My future. I just wanted to be home, with my parents. I wanted, no I *needed*, them to take care of me. I'm not married, so my family is most important to me. And I was scared.

If I had it to do again, though, I'd do it differently. You see, I thought I'd be dead in six months. I've lasted a lot longer than that. I've done some good things with the time since I came home. But it's been as if I had to start a different life. In some ways, it wasn't the best thing for me to do. If I had it to do again, I'd stay in New York and continue working as long as I could. When I started to feel that I couldn't be dependable, then I would stop.

When I got over being angry, upset, and frightened, all those things that people feel when they learn they have a terrible disease, I thought, "Okay, this is a chance for me to change something about my life, to be somebody different. I want to fix some things that aren't quite right." The first number I called, when they gave me a list of doctors and services in Boston, was the AIDS Action Committee. I knew I wanted to educate people.

I have changed over the course of this illness. I think I'm more open to things now, more open to change. I'm very meticulous. I like everything in its place. And when I got so sick this last time, I realized I needed to put my spiritual house in order. I looked in the mirror, and I saw I looked different. Older. Thinner. There is something much more accepting too. It's something from within. That's why I called Nick.

Nick's photography is so different from show business photography, which is what I'm used to. That's all air-brushing, and he's the opposite, completely natural. But it's interesting that one medium could do all those things. It's a tool. It's a very interesting tool, depending on whose hands it's in. It turns out different things. It's like acting. It's just all human imagination and creativity. It's as flexible as you can imagine it to be.

I've always been very religious. I almost became a priest. And since I became sick, I don't think my relationship to God has changed. What is different is that now I'm open to all religions. I've been learning about very new religions, visualization and all that stuff. I didn't know anything about it before, and I didn't think very much of it, either. But now I see that it's good to try whatever there is.

I have never been angry with God. Never. Never. Never. I'm not angry at anything or anyone. I had sex and I have AIDS. I had sex with someone who was infected and they infected me. I'm responsible for my own actions.

I do worry about my parents. Their friends and some people in the family are helping them out. But there's so much pain. When you lose your only son, I can't even imag-

ine it. It's hard to put into words. They say until you experience it yourself, you can't understand any of it.

Sometimes, I try to think about what is going to happen to me. Not when I'm dead, but when I'm dying. I'm scared. I get lonely at night. I want my mother to be here or I want my father to be here with me because I feel so vulnerable. I get panicky when I stop breathing. It's so claustrophobic, if you stop breathing. There's no more treatment for me. If I walk in with pneumonia, they're not going to treat it. When I die, I'll die within a week. At this point, I'm so far along that I might wake up some morning with only two more days to live. I do want to be made comfortable. I want as much medicine as I need, to keep the pain away. I've given them permission to put me on the respirator as long as there's a chance I may recover. But if it's just keeping me alive like a vegetable, I said pull the plug.

I don't want to die at home, I don't think. I'd rather die in the hospital so that my parents don't have to deal with it. When you die, you lose all your bodily fluids and everything. It's messy. I figure that's the least I can do, after all they're doing for me. It's also very hard for me to imagine them having me here, dead. Finding me dead, or having to watch me die. So, I'd rather be in a hospital. Partly that's for them. But it's for me, too. I sleep a little easier when I think about it.

Tony Mastrorilli died at home in his sleep, on June 28, 1988. He was thirty years old.

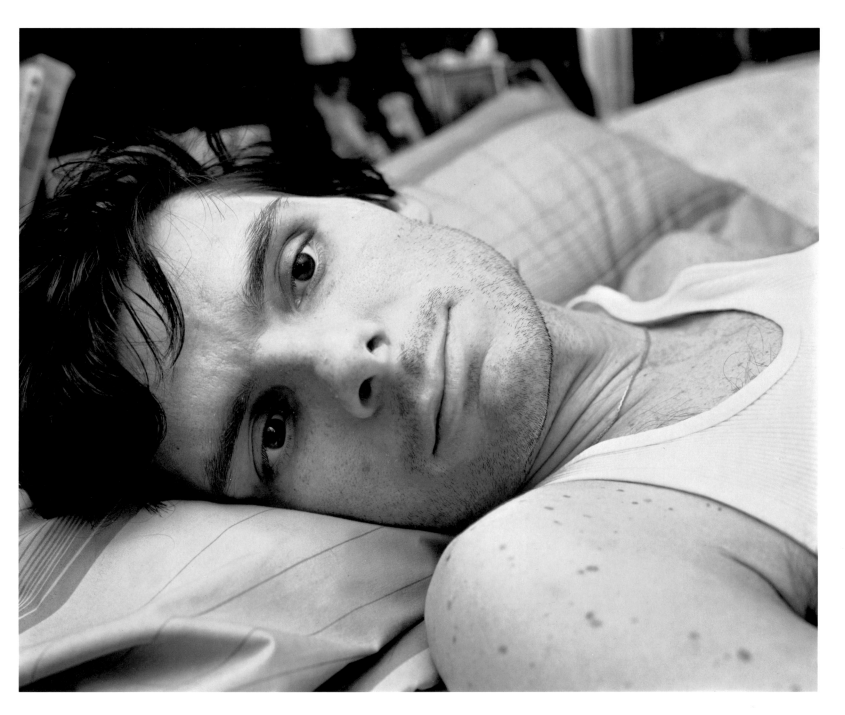

Tony Mastrorilli, Mansfield, Massachusetts, October 1987

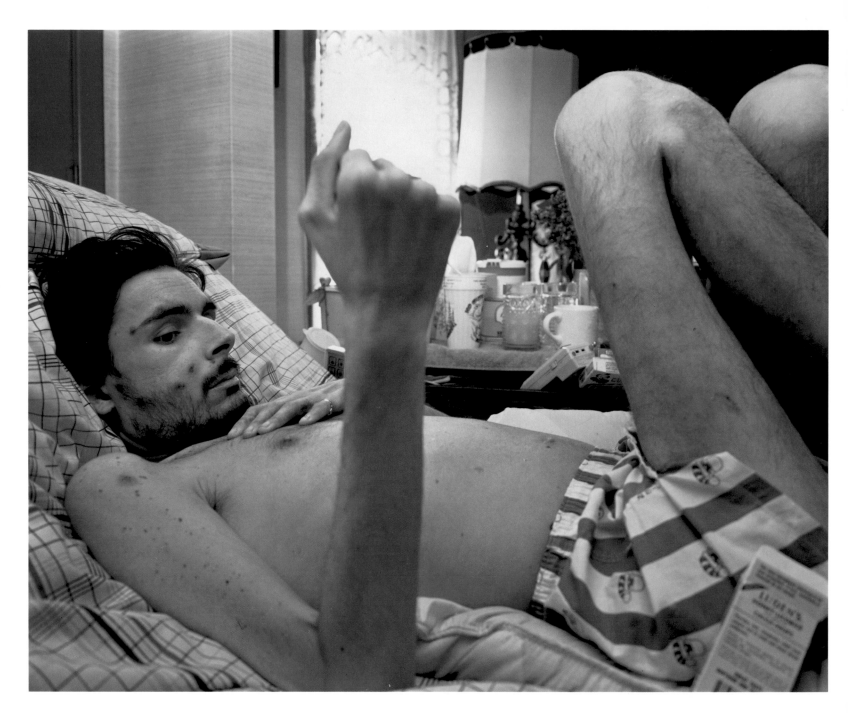

48

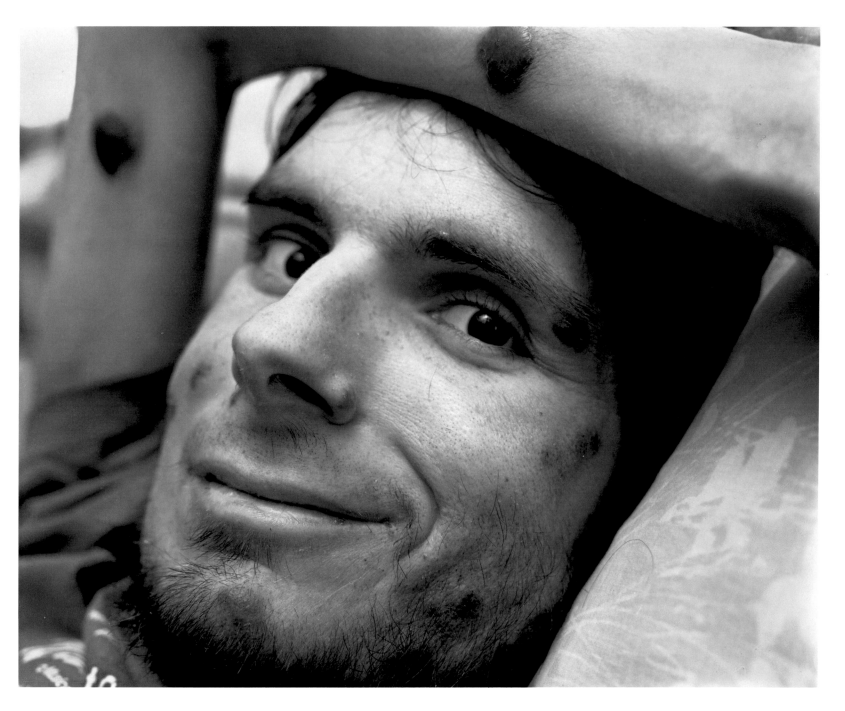

Tony Mastrorilli, Mansfield, Massachusetts, April 1988

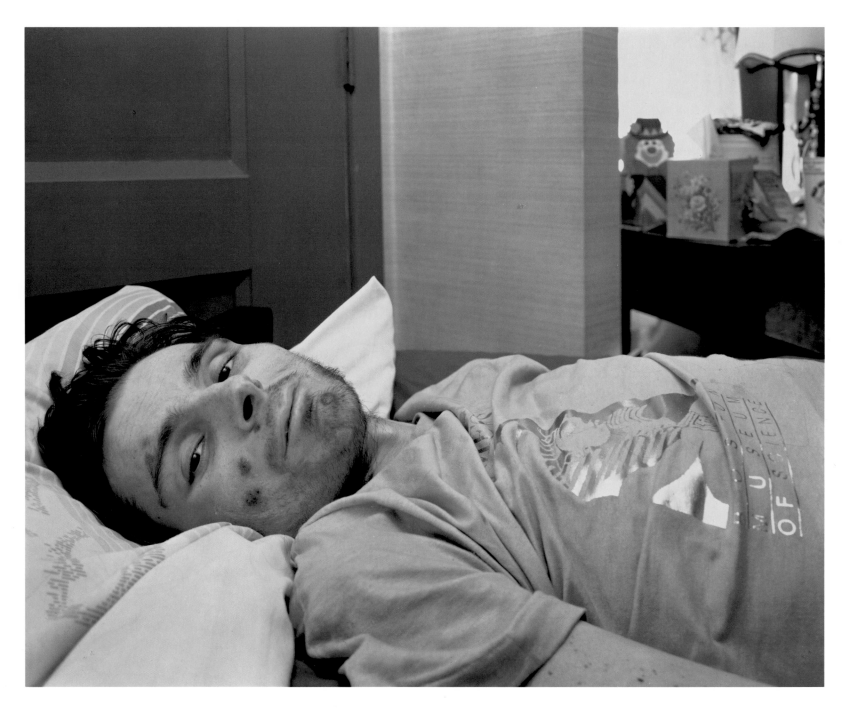

Tony Mastrorilli, Mansfield, Massachusetts, May 1988

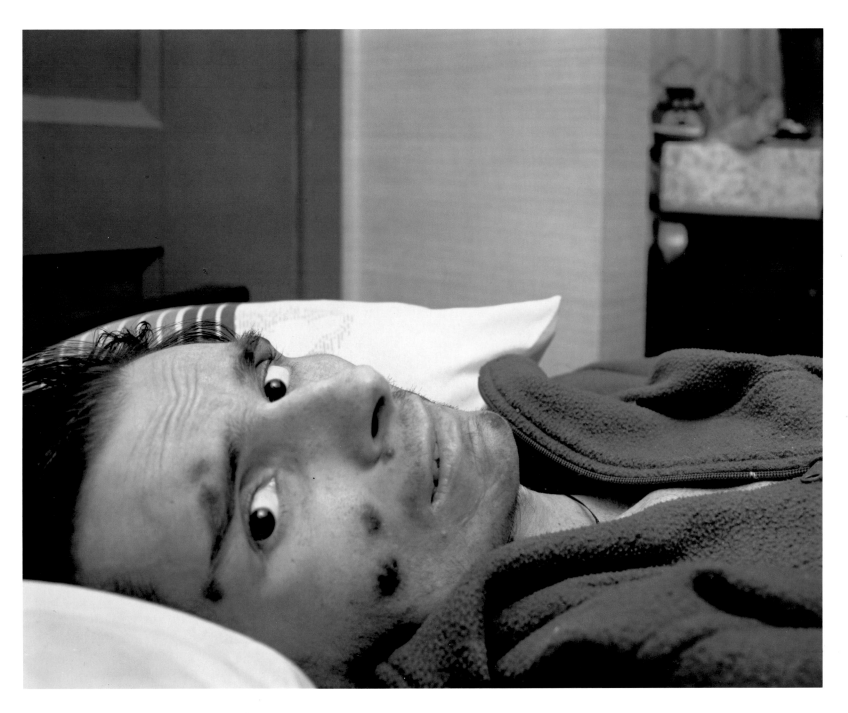

Tony Mastrorilli, Mansfield, Massachusetts, June 1988

Keith McMahan

Keith was a baseball lover, a fiercely loyal St. Louis Cardinals fan. He had been an oil rigger and had lived all over the world. Following the oil crash in 1983, he returned to the United States. He went to nursing school in New York, but couldn't finish; then he tried working for a mortgage company in Boston for about a year. He went to his mother's in Memphis during the summer of 1986, and came down with pneumocystis carinii pneumonia, or PCP. She mocked him for having "the gay plague," then she asked him to leave. Threw him out, in fact, he said. Keith spent three weeks in a Memphis hospital, recovered, broke off relations with his mother, and drove to San Diego, where his car was stolen. He made his way back to Boston, and lived at the YMCA, trying to reassess his life. He became infected again with PCP, and nearly died at Boston's Beth Israel Hospital. He became dependent on codeine, and had to go into a drug treatment program.

When he was released from the hospital, Keith had few friends, no job, almost no money, and no place to live. Eventually, space opened up in a group house in Boston run by the AIDS Action Committee. It was far from homey. Keith was one of five or six residents, who all had AIDS, and who shared the difficult and painful circumstance of having no one to take care of them, and nowhere else to go.

FALL 1987

I worked on the oil rigs. I made so much money. And I blew it all. But I did everything I wanted. I used to live in Singapore and Bangkok and Thailand. I went to Syria for about six months. Went to a place called Palmyra. I moved to a place called Barbak. Lived in Fiji, lived in Athens, and on the Gulf Coast of the United States. I wish I could do those things again. But I know I never will. So I'm glad I did 'em then.

My whole thing right now is learning how to deal with the possibility that I'm going to live for a while, like several years. Because it worries me that I'm sick right now. But I've been very sick before, and I've recovered.

It worries me that I'm not taking advantage of enough opportunities. But at least I'm in a comfortable situation. I don't have to work. I'm getting money from the government. I have a good doctor. I hope that my health stabilizes. I'm afraid that I'm not doing everything that I could to prepare myself for a life ten years from now. I don't know how to really go about approaching people for advice or assistance. All these people who tell me I have AIDS, they probably haven't even thought about the fact that I might be living for a while, like several years. I guess that's why your project is so great for me. You don't treat me like I'm gone already, dead already, useless already. This project is going to last a couple of years, and you expect me to live through it.

I haven't seen any of my family for almost a year and a half. I think they're afraid to be around AIDS. I have a friend here in Boston, I used to go over all the time. Since I've been sick, he hasn't invited me over to his house once. And I ask him, "Are you afraid to have me in your apartment?" "No, no, no," he says. "It's just that our lives are so different now." They used to invite me over all the time and they haven't asked me over once. I just get the feeling that they're really afraid to have me in the apartment. When things like

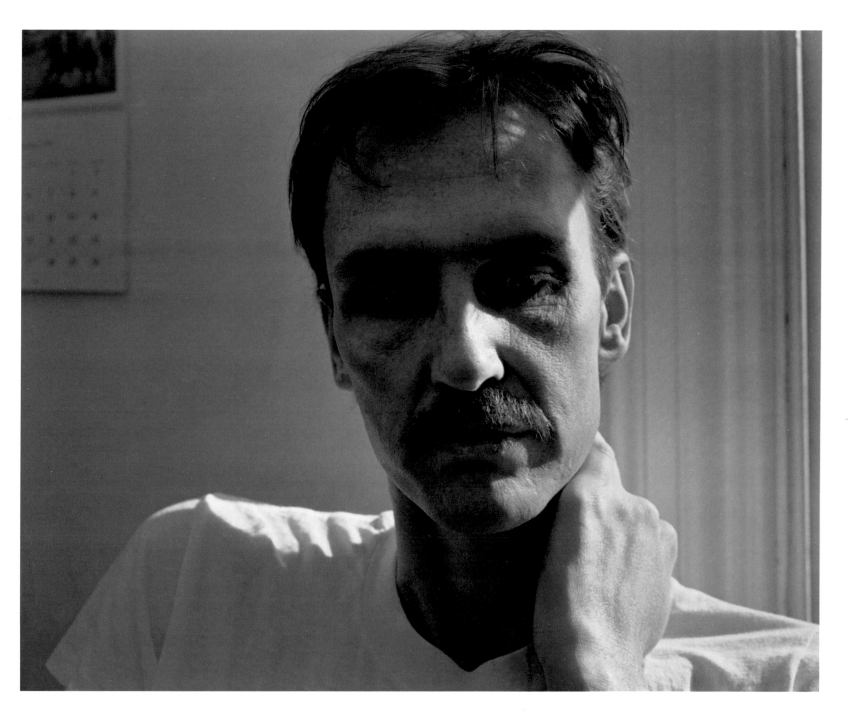

Keith McMahan, Boston, October 1987

this happen, time after time, you kind of change your outlook on things.

Right now AIDS gets a lot of attention. But what's going to happen to us when this trendiness wears off? Are we going to be on our own? I'm frightened.

SPRING 1988

Recently I got diagnosed with KS [Kaposi's sarcoma] and that kind of upset me. It's a whole new aspect of the disease; it's something entirely different to worry about than pneumonia. Because these lesions can crop up in your lungs and start bleeding. So I'm worried. Because there's not much they can do to slow them down, once they start.

I know it's hard to run a place like this AAC housing. But after a while you get tired of the silliness. On a couple of occasions they tried to treat us like we're just a bunch of little boys, sitting around with the AIDS virus chewing on our brain all day long. I know we can be difficult in a situation like this. The house managers and everybody, they're dealing with adult people who are used to living their own lives, who don't even know each other, don't necessarily even like each other, and are all sick. Here they are, living among a group of unrelated strangers. But the way they choose to deal with us is like the lowest common denominator, the least complicated, least sophisticated, least respectful way.

I don't trust these people. I've gotten paranoid. I don't trust my buddy. I feel like they report on me and they talk with each other about me. On several occasions, my buddy has known things about me that I haven't told him. I've gotten to the point where I don't really know who to trust. I don't even trust my advocate anymore. You see, it's become a business to them. It's never more than a business.

People die. They live and they die. I worked on oil rigs for five years. I've seen people get their arms chopped off. I just don't know how to accept all this sort of peaceful compassion, the orchids and the lilies. I really don't. I just don't.

When you're sick, you get presented with a different way of looking at things. Like God. I always accepted God and a lot of the values that various religious groups put out. I accepted them, and the value, the truth of what they say, like the Koran and the Bible, but I never could accept the Virgin Birth and all this stuff. And I never thought it had very much to do with me. But now, now I'm looking for God, not for a religion. I'm looking for the God who takes care of people like me, who accepts what I believe in. He doesn't necessarily have a representative here. And I'm not sure He's ever been around here before.

Keith's lesions eventually spread to his lungs. During his final illness, Keith's brother came from New York to look after him in the hospital. His mother telephoned from Memphis three days before his death, and spoke not to Keith, but to the nurse. She wanted to know if he was dead yet, and told her where to ship the body.

Keith McMahan died on July 16, 1988, at Beth Israel Hospital. He was thirty-five years old.

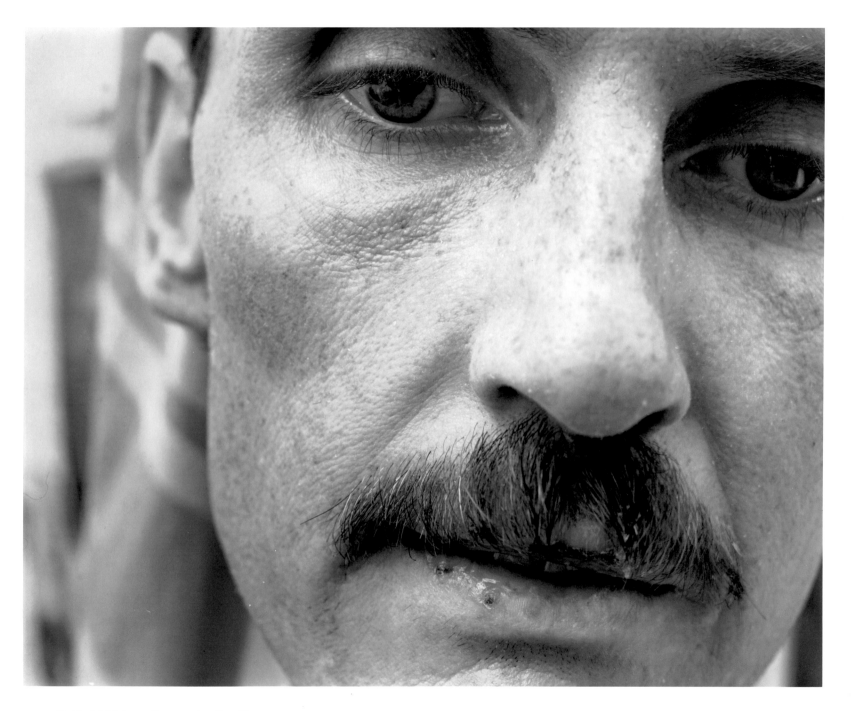

Keith McMahan, Boston, April 1988

Dean Madere

Dean lived in Providence, Rhode Island, with his lover, B.C.

WINTER 1987

My mother called me a bastard. That's what kids in her town called me, too. My parents never married, were never together. I was raised by my grandmother in Virginia. She was a loving sweet woman, who taught me patience and gentleness, and forgiveness.

My mother was very disapproving, very condemning of me and my being gay. There was a lot of nastiness. My father was never around at all. He lived up in Maine, and he was very bitter toward me. I went into the service when I was nineteen. I needed to get out, get away. I stayed in Germany four years. When I came back, though, I got into real trouble. I went to Boston, tried to make a life there. It wasn't easy, and I was messed up. I was lonely, and confused, and I got heavily into drugs and alcohol, gay bars, what have you. It was such a waste.

After four or five years of that, I pulled myself out of it. I got clean, and straight, and I got myself on the right track. I went to nursing school at the Shattuck Hospital in Boston. I was almost through — this was 1986 — when I met B.C. It was love at first sight. We saw a lot of each other, even though he lived in Providence and I was in Boston. As soon as I finished my nursing degree, I moved down to Providence to live with him.

Then I found the lesions on my leg. I knew what they were, but I didn't want to know. It took me eight weeks of living with them, and getting steadily sicker, before I could face it. By that time, I was really sick with pneumonia, too. I was diagnosed August 28, 1987. Two weeks after my thirtieth birthday.

On March 15, 1988, six-and-a-half months after his diagnosis, Dean Madere died at the VA Hospital in Providence.

WINTER 1989
B.C., DEAN'S LOVER

Dean was such a good man. He was handsome and nice, and a real homebody too. But he had this secret side, and I think he worried about many things he never talked about, not even to me. He loved his little sister, and he was angry at his mother for keeping her away when he was so sick. The mother never told the sister what was wrong with Dean. Even though she was just sixteen at the time, she loved her brother, and she had a right to at least come to see him before he died. The mother was supposedly very religious. But she sure didn't show much Christian feeling toward her own son. She wouldn't even send money to help him out when he was in the hospital. When he was dying, I called her and begged her to come. It would have meant a lot to him. But she wouldn't.

Dean was very scared, very brave, very denying. He was going to be the one who made it. He was so proud of how he'd changed his life, so proud of his accomplishments. And

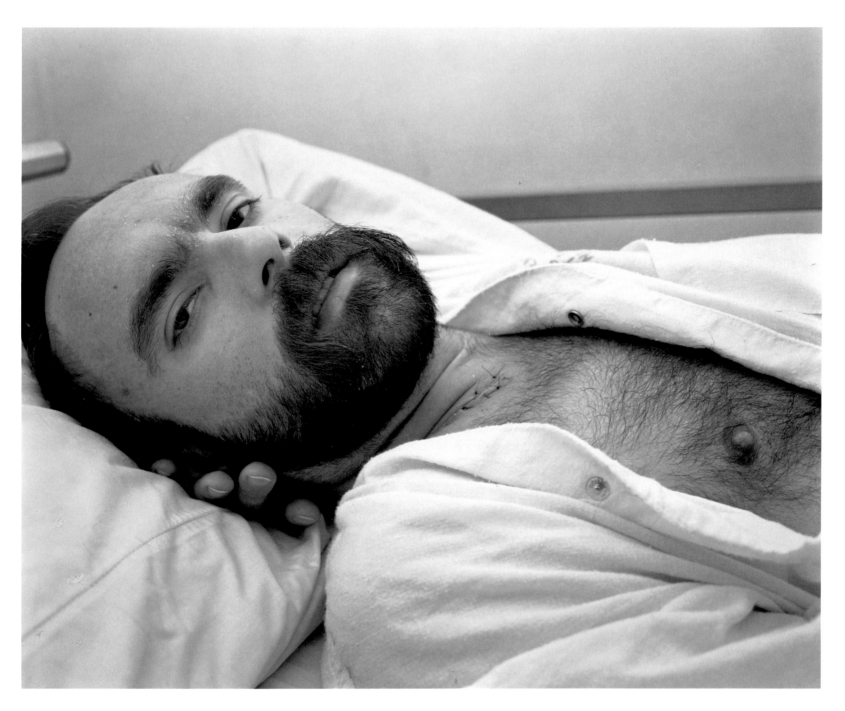

Dean Madere, Providence, Rhode Island, February 1988 57

then this. He couldn't work, and I had to support him. That almost killed him right there. He didn't want to lose his independence.

He was gone in seven months. He had one infection after another, and was in and out of the hospital constantly. The nurses on his floor at the VA Hospital were real attached to him, real fond of him. The last time he went in, for some reason he was placed on the fourth floor, not the fifth, where he always had been. The fifth floor nurses went down and got him, and brought him up to his old room. They were his nurses, and they wanted to take care of him until he died. They changed him and watched him, and stayed with him until the very end. He needed constant care the last two weeks, but he was very conscious and aware, although he was so terribly weak. He knew he needed help, and he accepted it.

His room at the hospital was always full of people. He loved having people around him. He always said his friends were his family. He was real surprised and shocked one day about three days before he died, his father came to see him. I don't think they'd spoken in years. His dad said he was sorry. I think it made a big difference to Dean, but I think he was still angry and bitter at what he'd gone through because of his parents.

He never complained about the sickness, though. He was one of the bravest people I knew. But then again, Dean really thought he would make it. He was scared, and he could not accept his own death. He only made out his will on March eleventh. He died March fifteenth.

The night before he died, I stroked his hair, and we didn't talk. Just our eyes spoke. He knew he would die. I had seen his pain through his eyes all throughout his sickness, and he'd never spoken about it. His eyes told me so much. He slipped into a coma, and was gone the next day.

I hated God for a long time after Dean died. I wouldn't even pray. And I was angry at Dean, for all the pain he'd caused me. I was mad at him for dying and leaving me all alone. I've made my peace now. I say my prayers every night, and every night, Dean is in my prayers. He was a good man. He was Somebody on this earth. I was lucky to have known him. And I will miss him for as long as I live.

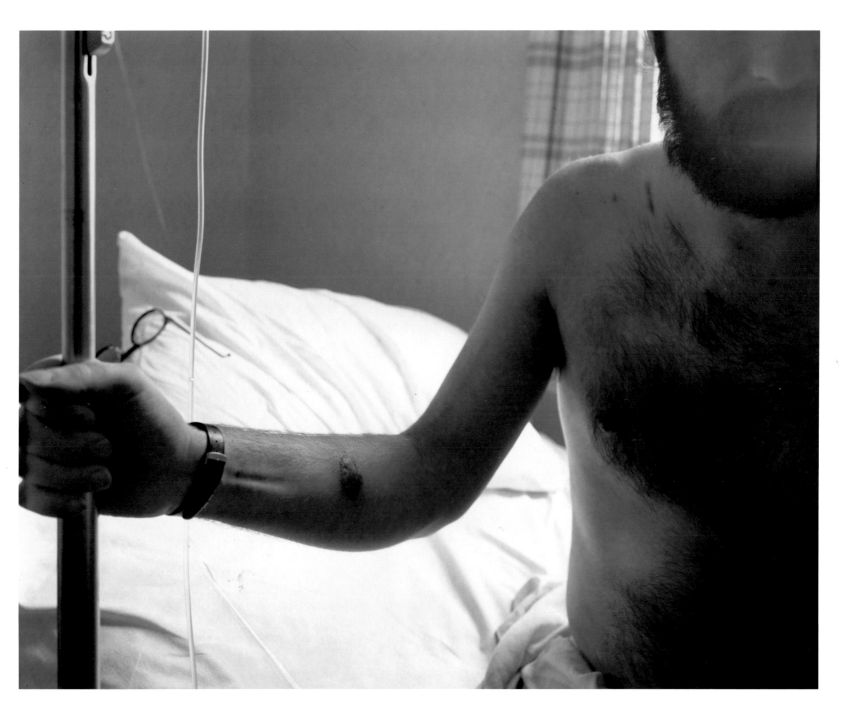

Dean Madere, Providence, Rhode Island, March 1988

Donald Perham

Donald was a hemophiliac who contracted AIDS *from a blood transfusion in 1980 or 1981. He was diagnosed in 1984. He lived with his son, Nathaniel, his second wife, Jane, and Jane's daughter from her first marriage, in the small town of Milford, New Hampshire. When the* PEOPLE WITH AIDS *project began, he had already been ill for four-and-a-half years, but was in remarkably good health. He was enrolled in several experimental drug protocols at Boston's Beth Israel Hospital. He was their longest-surviving patient.*

MARCH 1988

I don't know any other people with AIDS. It's not deliberate, it just happened that way. In all of New Hampshire, there are about twenty or so people with AIDS, and there's a long distance between them. It's not like you're in the neighborhood.

At first, when I got AIDS, I wanted to shoot them all. The gays. But I've become more compassionate the past couple of years. The disease is horrible whether you're straight or gay, so, I changed. That's the answer. I do think that the gays' lifestyle helped spread the disease. The gay community responded responsibly, once they knew it, though. The number of cases of gays having AIDS now has been reduced. But IV drug cases have doubled. That's another question of lifestyle. Making it easy for the disease, this disease, to get passed along. And it's very hard to reach that population, the drug users. They don't want to be reached. All they care about is being high anyway. I feel, unless you cure the drug problem, you can't cure the AIDS problem. It's got to be in that order.

I think the clean needle give away is a good idea. If they'll use them. If they'll change them.

I was a pretty successful banker. And was just beginning to start to make a good salary. We had just begun to enjoy ourselves a little, and this hit us in the face. I don't know what's going to happen to me. I don't know if I'm going to live, I don't know if I'm going to be sick tomorrow. And the uncertainty is difficult to live with. It's always there. A lot of my friends, and a lot of things I do, are all related to AIDS. So I just get full of AIDS after a while. I read all the stuff that comes out. It's become a hobby, almost.

As a hemophiliac, I was already in a different world. I already needed people's acceptance of an exceptional situation. It wasn't hard to reach out a little more. I've had bad reactions from a couple of medical people. But other than that, no problems. Once, I was bleeding in my kidneys, and I went into the emergency room, and I told them I had AIDS, and they wouldn't treat me. I had a dentist that did a lot of work on my teeth, and after AIDS, he wouldn't help me, either. The people in the community are nice. I was concerned about my kids in school, when I became public about AIDS. I figured some panicky mother would come in and say, "I don't want this child here." But that didn't happen, so I was lucky. Those things happen out of ignorance. And I waited a couple of years before I became public about it. And there's a lot more information out there about AIDS now than there was a couple of years ago. I haven't talked with my kids about it much. They know. But they're thinking about other things. My son's thinking about race cars, and all that stuff.

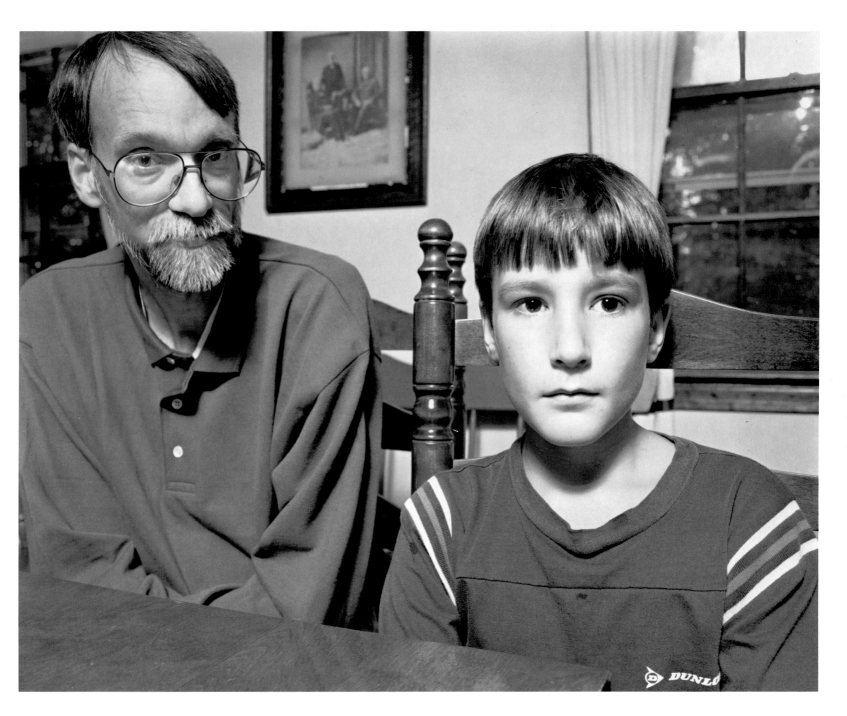

Donald and Nathaniel Perham, Milford, New Hampshire, July 1987 61

The biggest change in my daily life is that I'm usually bored. I don't have enough to do. I miss my job. There's only so much you can read, only so many TV shows you can watch. I try to get out, but the limits on my physical stamina just make it impossible to do much.

I'd love to be able to work part-time. But because of the disability payments the bank gives me, I can't work. They won't let me. If I earn ten dollars, they'll take half my subsidy away. I've even thought of working for free. What I've also thought of, which I think is a good idea, is that I'd go work for some company, and they wouldn't pay me. But when I die, they'd pay my widow. I would think you could do that. Sort of like an IRA. It seems unusual . . . But if an insurance company caught you, they'd get after you.

It's a shame, having something to contribute, and wanting to, but not being able to because of the bureaucracy.

Part of the psychology of all this is that all my life I've been resourceful and productive, and somehow, to go from that to this . . . I told one person, "I used to be able to remember a thousand things. Now, I can't remember ten things." He said, "Well, that's because your mind is not active enough." I know how old people feel now. I just have complete short-outs. Slowdowns. I think that kills a lot of old people. They just get bored to death. Almost literally. That's one thing about this project. It's real. It's something to do. Things like that are important when everything else in your life is falling away from you.

JUNE 1988

I helped start the New Hampshire AIDS group. We support AIDS people, providing advice, a buddy program. You'd be surprised at the number of people that respond to that. In rural New Hampshire I wouldn't think we'd get many. But there were twenty-five people in our last class. And we're working on another one. So you can see how the education has been improved. Just that there are that many people who think they ought to do something. There's straight and gay, and there's women. All generally about the same age, forty,

forty-five. I'm the only person with AIDS in the group. One fellow, he runs a gay bar, and he's had six or seven of his friends die of AIDS in the last year. It's kind of tragic. I got into this because I figured, if I'm around a few more years, I should do something to help somebody else. We have weekly meetings, for the past year-and-a-half, we've done this. We have twenty-two clients, and we're supporting two of them 100 percent on AZT, which is about eight hundred dollars a month for each person. And we've set up social services and assistance, and a lot of things. We ran a walkathon and made ten thousand dollars. And we've only been in business a year, so we've done a lot. We have no funding behind us. It's all private. Somehow, people with AIDS seem to find us.

I get frustrated with the experimental drugs they're toying with for AIDS. Because it takes them so damn long to come to any kind of conclusion, all the clients are dead. And the drug companies and the hospitals and the doctors, they always have what sound like perfectly reasonable arguments, in *their* language and on *their* terms. But in basic human terms, it is not reasonable. I don't think there's anything morally wrong about giving all kinds of drugs to somebody who's dying. It might give them a chance. But the drug companies and the FDA don't want to do anything to hurt anybody. They're just afraid they'll get sued. It's a product liability question. It just comes down to money. There's something a little obscene about it. I get quite incensed about this. And I think there are some real questions about the ethics of the way the clinical trials are run once they finally do get started. When you're working with something that's as volatile as AIDS, to not throw everything you've got at it is criminal.

I have the greatest respect for my doctors and their team at Beth Israel. They were concerned about putting me on this experimental drug, and the manufacturer was concerned, because I was a hemophiliac. And in the animal trials it caused bleeding in some of the animals. They were concerned. So I represented the opportunity to be a real different guinea pig. So I joined up. And it hasn't affected me in any way. I was lucky there. Some of the people on AZT get seriously ill, and

have to go off it. I've been on it for eighteen months, and I haven't noticed any bad effects.

Nathaniel is my son. I think my death to him will be tragic. We are reasonably close. We've gotten closer because of this. I worry that I won't be able to participate in his future, and guide him, and all that.

My wife works, she has a good job, and we've dreamed about the future. Get the kids through college, then she and I could have our life to ourselves, travel, and do all those things. And now she won't have any of that. She'll be kind of lost, I think. For a while. I try to encourage her to get married again, and she says, "Oh no!"

This isn't my fault. I'm not responsible for AIDS. But because of me, and things that are happening to me, people I love are being hurt. And will continue to be hurt. I don't feel guilty about it, but it's because of me.

I don't know what will happen to me personally. I'd hope I could go on quite a bit longer, at least two years. And be healthy. I can't really judge beyond that. I'm only saying two years, because the last two years have been so good. And I'd like to match it with at least two more years. I made some mistakes. I quit my job too early, and I slowed down too much. I could have accomplished more things. I'd be happier if I were busy. But, the doctors told me when I quit work that I had twelve to eighteen months to live. Somehow I felt, I'll take the summer off, play with my son and all that. The time you spend with your kids, you just can't put a dollar sign to that.

I have a lot more stamina than people think I do. Some mornings I get up at seven, and go to bed at eleven-thirty, and have a real active day. I'm an outdoor person. I can hardly wait until the weather gets warmer. I have a garden, and I have flower beds, and I'm always puttering around, and I enjoy that. I think I'm going to go to the beach a lot this year. Last year and the year before, somehow we never got there. There's a state park up about fifteen miles from our house, with a nice small lake, a nice sandy beach. I never get that much to the ocean, though I like it. New Hampshire only has seventeen miles of coast, you know. It always disturbed me, why they would put a nuclear plant on a coastline that is so limited and so beautiful.

I don't think religion does that much for this generation. People are more interested in ceremony than they are in helping people. My minister doesn't get out in the community. He doesn't go see people in nursing homes. As long as the church runs all right, donations keep up, he doesn't really care.

But I've thought differently about spiritual things since I got sick. I started going to church, and started reading the Bible. That was some comfort for me. And you worry a little about what is after. After death. Where do you fit in? What should you believe or not believe?

It's hard to say what I think about the "future." After death. I kind of waver back and forth. My wife is more of a disbeliever than I am, about the spiritual afterlife. She really thinks this is it. Sometimes I like to believe there is a spiritual being afterwards. But looking at things realistically, I can't swallow that. There used to be this old guy that told me, "When you're dead, you're dead for a long time."

Donald Perham died on September 4, 1988 of complications from AIDS. He was forty-one years old.

During his illness, and throughout his participation in this project, Jane had firmly avoided the public eye. Eight months after his death, she talked about his illness.

Some years ago, in the very, very early eighties, Don and I went to a meeting of the Hemophilia Association down in Massachusetts. It was our first introduction to AIDS. The doctors were talking to people with hemophilia, saying, "There is this new disease. We don't think it's really going to bother you. We think it's going to only affect maybe one percent of the people with hemophilia." Something in my mind said, "I know Don is going to get this disease." It was just some instinct in there that told me, "I think Don is going to get this disease." A premonition. Of course at the time I never realized how ugly it would all get. Not only the disease itself but also the politics of it, all of the hysteria that's been around. The other strange part about that premonition was that, "Yes, Don will get it. No, I won't." And in fact I test negative. There's no logic.

As a hemophiliac, Don was already dealing with a lifelong chronic illness. Because he was a hemophiliac, he might have been more accepting of life's disappointments, and the possibility of not living as full a life as other people live. But he'd figured out how to live, and live well, with that. Hemophilia certainly wasn't going to kill him. And it didn't prevent him from doing a lot of things. He was a very stalwart and self-contained person; even if something were going to slow him down, you wouldn't necessarily know about it. In living with hemophilia all his life, he was never really free of pain. He was never really free of discomfort, at least. So, in that way, illness was familiar to him. He seemed to be very accepting of the fact that he was going to die before he was really ready to die, before his life was really finished. He seemed, in a way, sweet about that, not angry but calm.

But he got tired. In the end, the last couple of months, he was just tired of it all. He didn't specifically talk about taking his own life but I had some concern. He had some depression there for a while and I had some concern. He never actually said he wanted to die. I never heard him say that. He was just tired of it. I could see that in him. He used to lay there in his bed and he was tired of it all. Tired of hurting and tired of fighting it. And we all felt the same way. We were all tired of it.

One of the things clearly that kept me sane over the years that he was ill, is that I have a job and it's very busy, very demanding. I work at a bank where I'm in charge of the mortgage loan department. Don also worked at a bank. Not at the same bank. He had a career that was certainly growing, and as he stopped working I found that my career grew in the direction that his would have. I'm sure it was hard for him. So we had problems not only associated with his being ill but we also had the classic career struggle, which only complicated things.

He had had a very high-powered job as a commercial loan officer, dealing with customers who were looking for million-dollar loans. It was devastating to him to have to leave his work. When he did leave, he told only a few people that he had AIDS — the president of the bank and his immediate boss — and asked them to keep it quiet, and they did. They were excellent. After Don died, I wrote a letter to the president of the bank thanking him for what he did.

When Don first decided to go public about AIDS, we discovered the story was going to hit the newspapers over the weekend. I told the president of my bank, and my boss, and they were immediately supportive. I didn't know if I was going to walk out of the bank and find TV cameras on me or what. I really had no idea and I was scared to death. As it turned out, people were incredibly supportive. But I'd never do it again.

The support network that Don started, the New Hampshire AIDS Foundation, has continued to grow as an organization. They do an annual AIDS Walkathon in the fall. They're finally getting respectable corporate sponsors. Don was very modest about it but it was really a pretty good thing for him to be doing. It wasn't till after he died that the whole impact

of everything he did occurred to me. I had a lot of problems, when he first started talking to reporters. I kept saying to him, "They're using you, Don. Don't talk to them." I wanted to hide. It took me a while to understand that he knew exactly what was going on, but it was his way of using them also, to get his story out. But I felt that he was putting our private life out on public display, for people to see it, and I struggled with that issue a lot.

I think he told Nathaniel right in the beginning. But I think Nathaniel was too young to really understand the magnitude of it. He was only seven or eight at the time. I don't think even my daughter, who was a teenager then, really fully understood the magnitude of it. She was so busy in her own life, the way that teenagers are, that it never really occurred to her, the seriousness of what was happening. Five years ago, people still didn't really understand the enormity of it all.

Since Don's death, I have remained close to Nathaniel. In fact, if anything, we're closer now than we were when Don was alive. He lives with his mother, but she's right here in town. He'll be here with me this weekend. I just took him to a Red Sox game last week. He and my daughter and I went on a nice vacation last March. So we've stayed close. Nathaniel's very quiet and reserved. But the odd thing about him, after his father died he became a chatterbox. It was kind of fun to watch him open up and start talking.

Donald talked a lot about how tragic he thought his death would be for Nathaniel. He meant that for himself as well. That was something that really hurt him, that he was not going to be able to see his son grow up and share those things with him. His son was clearly the most important thing in his life. And I recognized that. Even being married to him I knew his son was the most important thing in his life. And it was crushing for Don to realize that he would not get to see his son grow up.

Don should have been a farmer, not a banker. He was a banker because it was a good job, and that's how he could make money and earn a living. But he truly was a farmer. He grew up on a farm and he raised birds all of his life. Different fancy chickens and geese and pigeons, everything under the sun. He had always kept his birds out in the yard. Toward the end of his life, he knew he was dying and he wanted his birds with him. It's so magical, having birds inside and having them with you when you're ill, it seems like such a wonderful way to bring living creatures to you. The only negative aspect of it is that birds carry a lot of diseases, and Don was susceptible to disease. I told him that and he said, "Too bad. I want my birds with me anyway." It wouldn't affect somebody like you or I. But for somebody with AIDS it's critical. The nurses who came to take care of Don quietly said to me, "You know Jane, birds carry a lot of disease." And I said, "Yes I know that and so does Don." You make choices.

A few times Nathaniel and I would go out and bring in one or two chickens and set up newspapers all over Don's bed so the chickens could walk around and he could still see his chickens once in a while. And he had bought a lot of birds and kept them in cages inside, when it became too difficult for him to get outside to take care of the others. In his room he had little parakeets and all sorts of other different kinds of birds. Finches, lovebirds. Nathaniel has a lot of them now.

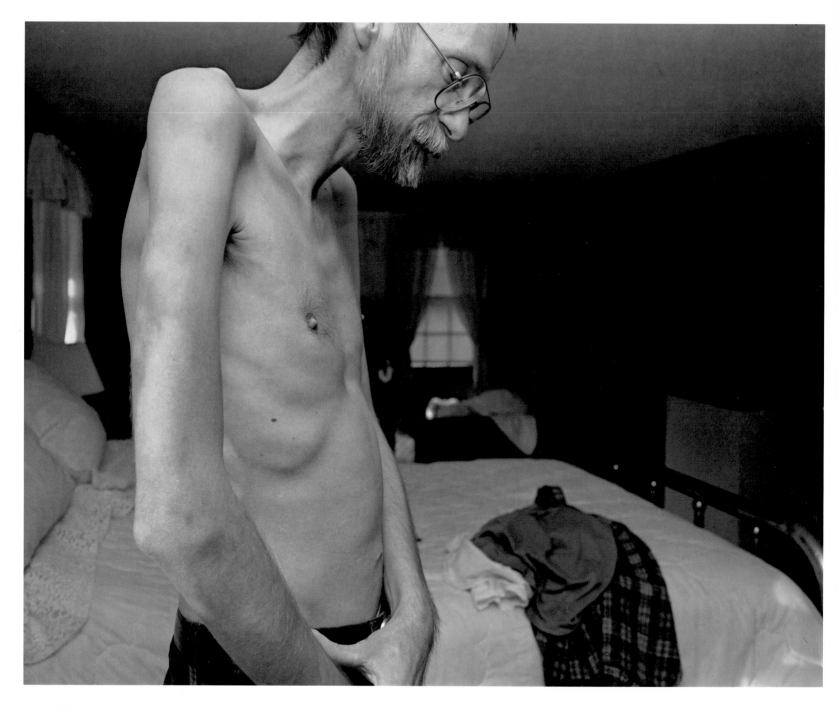

Donald Perham, Milford, New Hampshire, November 1987

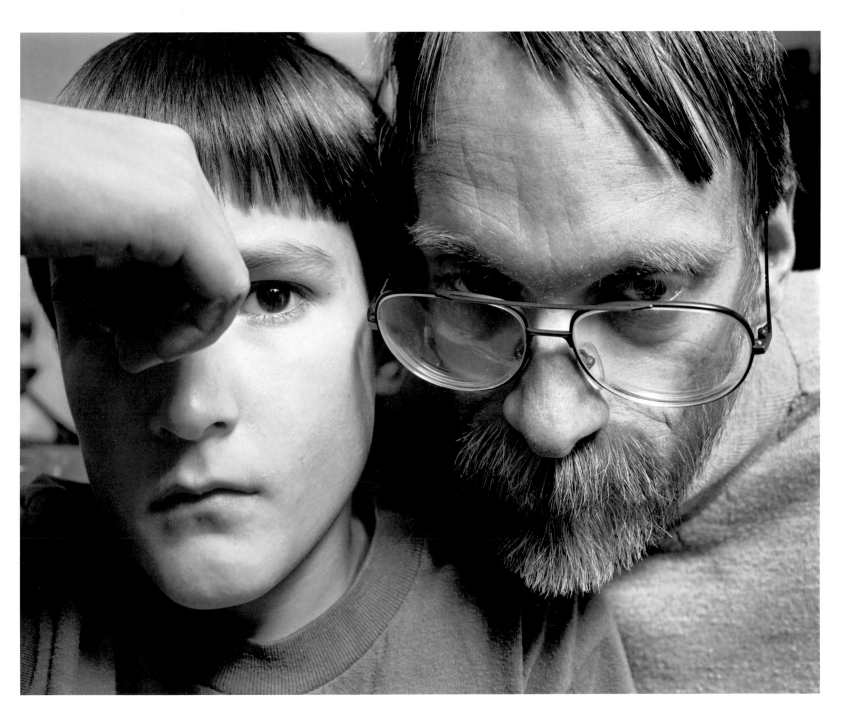

Nathaniel and Donald Perham, Milford, New Hampshire, January 1988

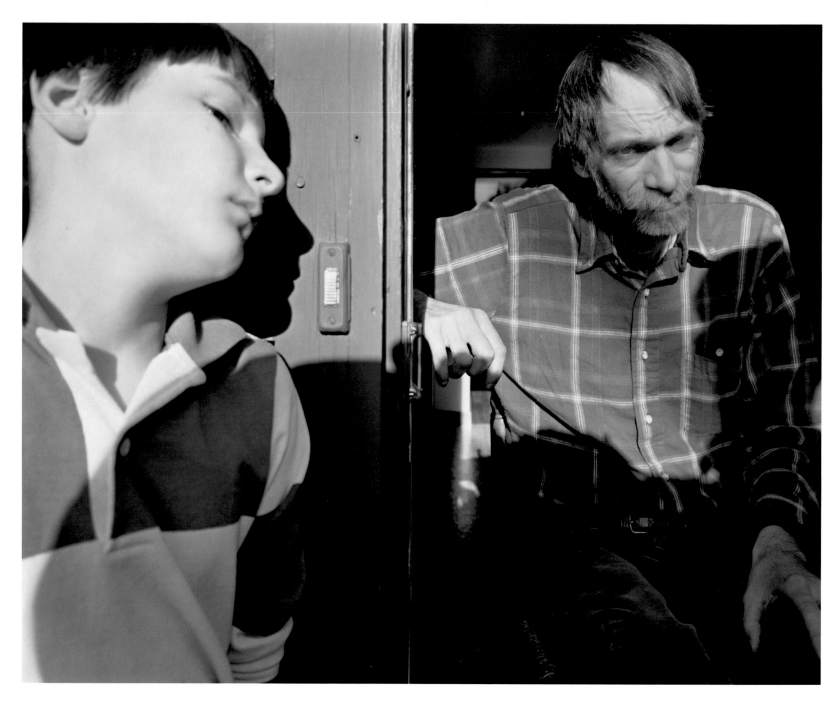

Nathaniel and Donald Perham, Milford, New Hampshire, March 1988

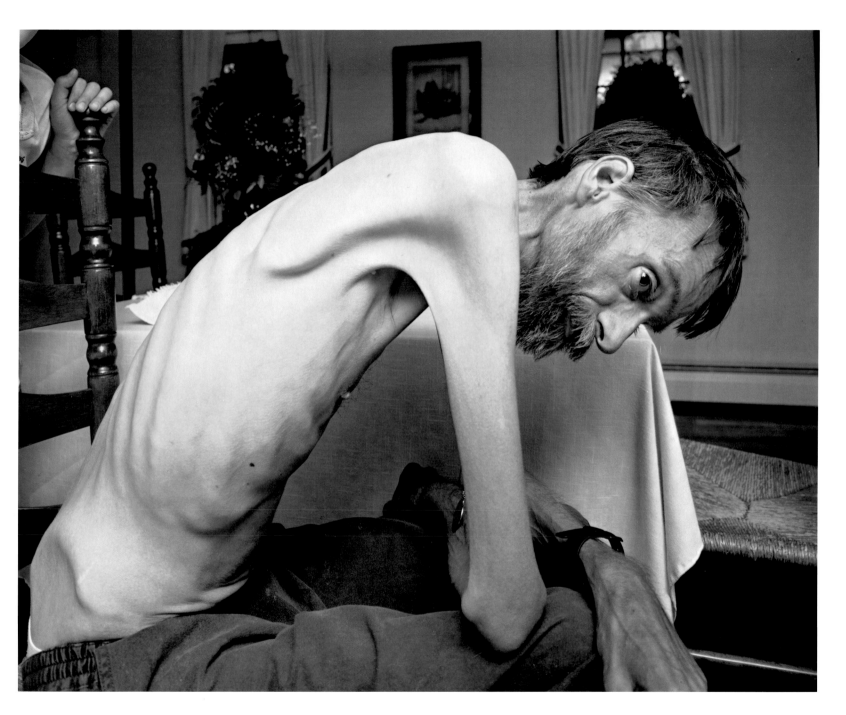

Donald Perham, Milford, New Hampshire, May 1988

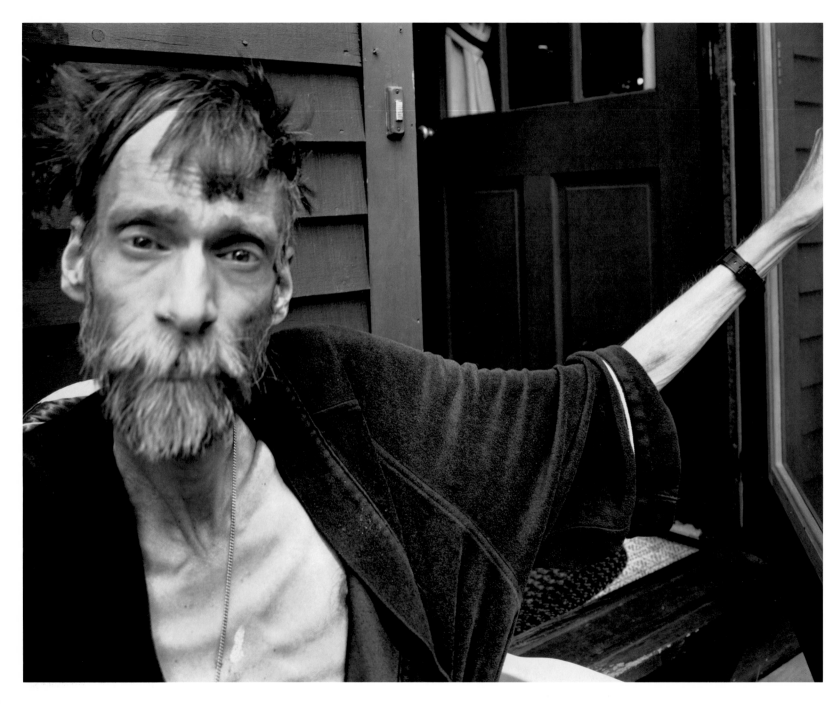

Donald Perham, Milford, New Hampshire, June 1988

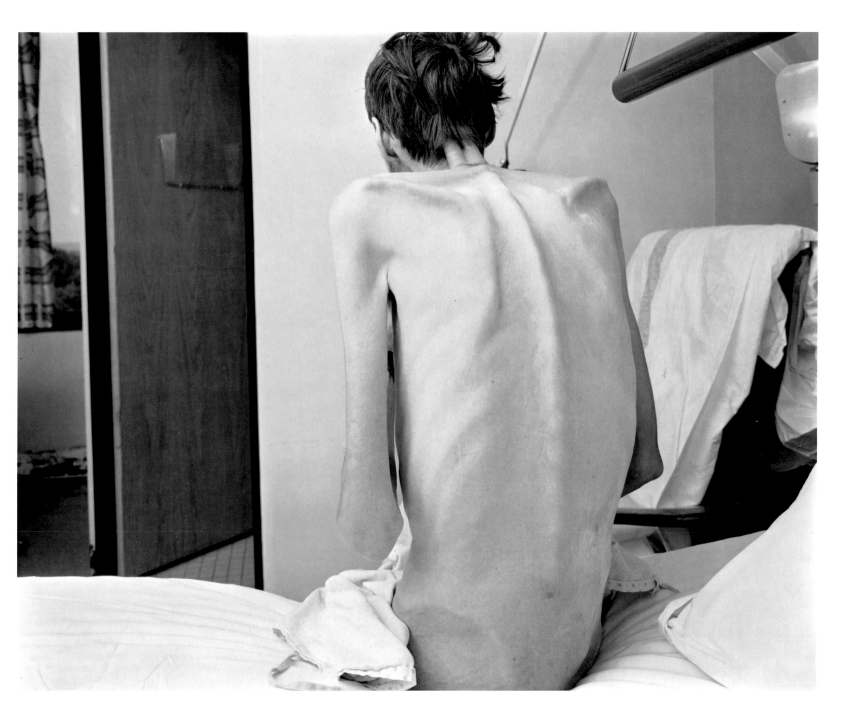

Donald Perham, Worcester, Massachusetts, July 1988

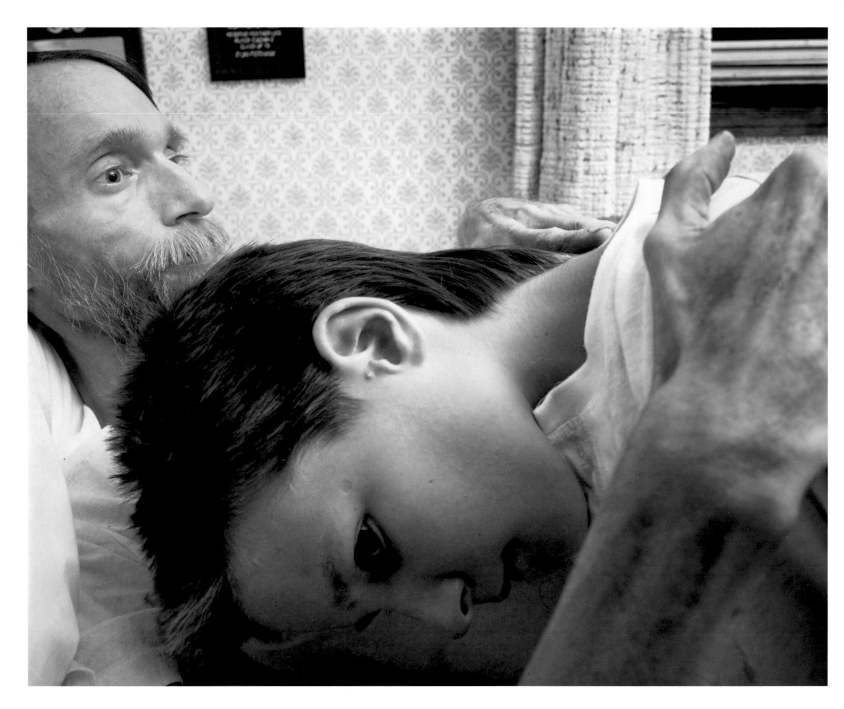

Donald and Nathaniel Perham, Milford, New Hampshire, August 1988

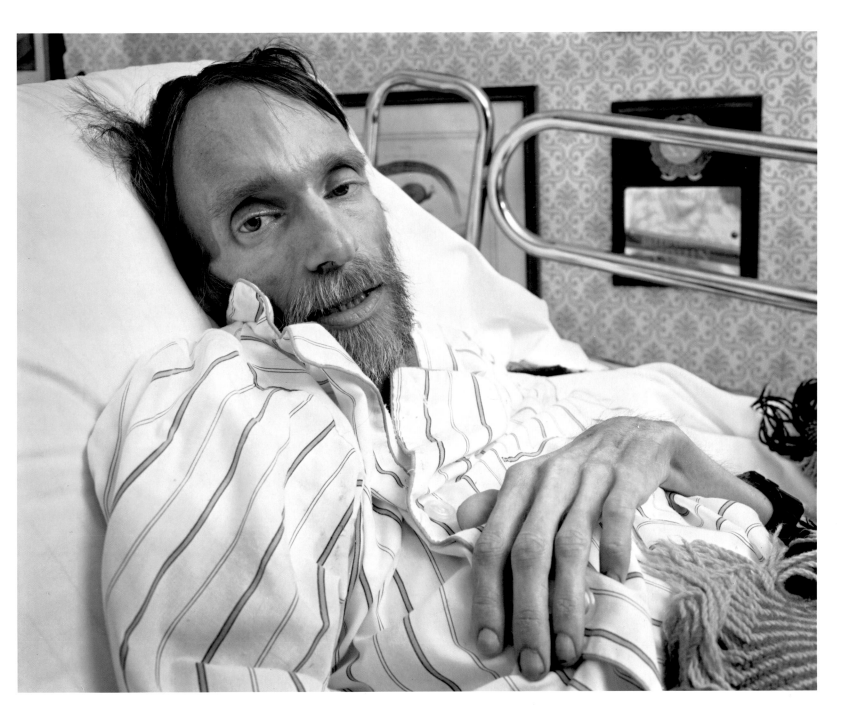

Donald Perham, Milford, New Hampshire, September 1988

Bob Sappenfield

Bob was, as a friend once described him, "very tall, very thin, very smart, and not hesitant to let you know it. His head always seemed to be tilted to one side, and his forehead crinkled a little, as if he were solving some complex equation in his head or contemplating a philosophical dilemma."

Bob and his brother and sister grew up in Jefferson Parish, a quiet, suburban New Orleans neighborhood. Ginny, their mother, is a nurse, their father, Robert, a doctor. Bob was unusually brainy, and his intelligence and eloquence, coupled with his compassion for others, and interest in serving the common good, eventually brought him to Boston, to Harvard's Kennedy School of Government. In 1986, while he was still a doctoral candidate, he was appointed to the Presidential Commission on Executive Exchange, advising senior administrators on how better to train public policymakers. In January 1987, while preparing for the final exams for his Ph.D. in public policy, Bob was diagnosed with AIDS. He resigned from his academic and political posts, and decided to dedicate the rest of his life to educating others about the illness that he called "the great thief."

SPRING 1988

I haven't been able to continue working. Between the end of January last year and the end of the calendar year, I spent fifteen weeks in the hospital. I spent two days of every week that I wasn't in the hospital in some sort of doctor's appointment. There was no way that I could make and fill an honorable commitment to an employer. And take care of myself. And spend time with the people I cared about. And get the kind of sleep and rest I needed. So for the first several months I was really ill enough that I was a full-time PWA, person with AIDS, taking care of myself.

I've been much healthier since the summer. But I'm still a full-time PWA. I spend about half my time taking care of myself, and about half my time speaking and doing volunteer work with the AIDS Action Committee. Virtually everything I do is influenced by the fact that I have AIDS. I try to be a living argument for a proper approach to AIDS treatment, to AIDS policy, and so forth. No one meets me or spends any time with me, that doesn't know fairly soon that I do have AIDS. And how I feel about it.

Keeping and maintaining a sense of humor has always been very important to me. So far, I've managed to keep it. It helps. It makes me feel powerful. It makes me feel like I've got it in control. I don't. But it makes me feel like it hasn't overwhelmed me, if I can laugh about it. It's a very empowering coping mechanism. Because, damn it, if AIDS is gonna kill me, I don't have to let it ruin my life.

AIDS is a true tragedy. I don't normally cry. I've never

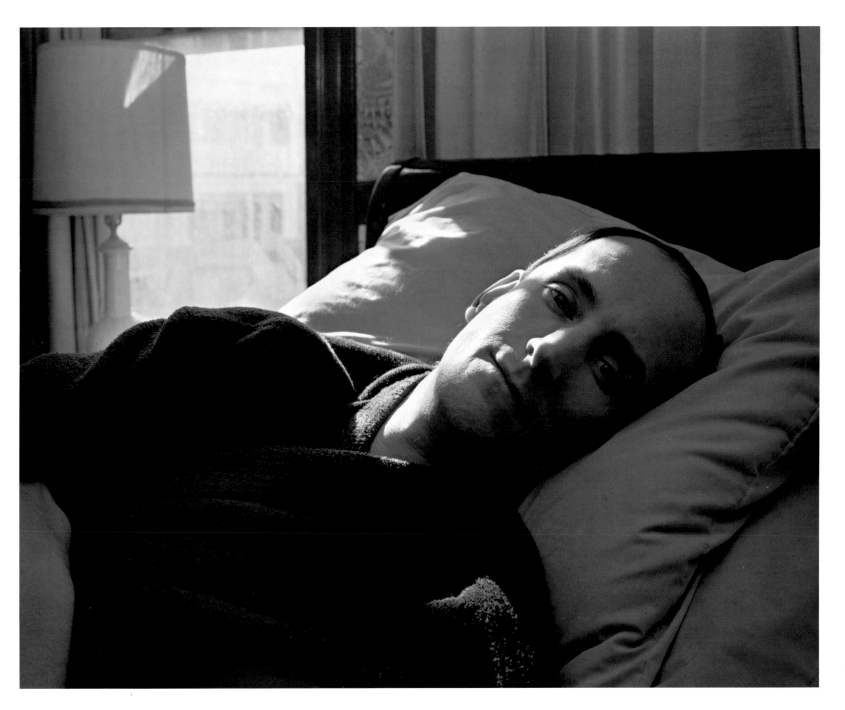

Bob Sappenfield, Dorchester, Massachusetts, January 1988

been the kind of person who expressed my emotions that way. But the other night I saw a story on television that made me cry. There was a young man in Manhattan, a musician. He had been traveling around the country. Supposedly, he contracted AIDS from a woman he'd been dating, so he was "an innocent victim." Aren't we all?

His only family in the world was his brother, who was an advertising artist in Manhattan. So when the man became ill, he went to his brother, and with his brother's help they filled out all the appropriate forms, for Social Security, Medicaid, Disability, food stamps. And he qualified for all of them. He made the appropriate checks with people, and he was "in the mill."

But in the meantime, he received nothing. No income supplement, no food assistance, no pain medication. No medication. No medical care. Emergency rooms wouldn't even take him because he was never in a suitably "emergent" condition to qualify. And they were already overwhelmed with AIDS cases anyway.

His brother eventually had to stop going to work, because he had to stay home and take care of him. Eight months went by with no financial aid, and no medical care whatsoever. He sat there and watched his brother die. They believed in the system, they kept checking with the appropriate people, but for eight months, nothing.

After eight months, he was down to close to eighty pounds. And then everything came in a flood. Backdated checks, food stamps, nurses at the door, medical help, and four days later, he died.

He did nothing wrong. He believed in the system. The system was working. Just not quickly enough.

I went four months without being approved for Medicaid. If I hadn't come to Beth Israel, which is an endowed hospital, and is committed to offering care, I'd have driven off with a couple of days of care, at most, and died. One of the best things about becoming ill was finding out about that hospital. The care there is extraordinary. The facilities, the doctors, the nurses, the support staff. They've saved my life any number of times.

But I didn't receive any disability payments for nine months. I borrowed from friends and family to live, to pay my bills. When I had to move from my apartment, I called the Public Welfare Office to let them know I would be moving, and where they could reach me, and to inquire about my benefits' termination. I wasn't complaining. But the lady got rather ugly. She said, "What are you living on now?" The implication being that if I had lived for eight months without their help, why did I need it at all? Well, what was my choice? Just to stop living?

For about two months, essentially I was on the street. I was going from friend's apartment to friend's apartment, because I had nowhere to live. This was a major change for a person who, no more than twelve months earlier, had been doing management consulting in the White House.

Now I live in AAC housing, in a three-unit apartment in Dorchester. My roommate, Jerry, also has AIDS. I'm still fairly mobile. The subway stop is about five or six blocks away. I still have independence of movement. It's lonely. It's far from where I'm used to being. But there's nowhere else for me to go. I'm there because I have to be. It's the only place in town I can afford to live, and stay in the Boston area. Leaving Boston I think would be a very, very big mistake for me. Medically, socially, supportwise.

I have a good relationship with my family. And I love being able to go to New Orleans, to see my friends and family, people I care about. I spent six weeks there last spring. A week there this summer. Six weeks between Thanksgiving and Christmas, about a month in February. But medically, care isn't quite as advanced there. AIDS care is strictly part of the charity hospital care system. Medicaid is woefully inadequate. It doesn't cover AZT. The AIDS wards are multi-bed wards, there are no nurses' call buttons. Because it's a charity hospital, a teaching hospital-type situation, PWAs are not assigned a personal physician, and your doctor changes on a monthly basis. So there's no continuity of care. Support services are not there. If nothing else, disability payments aren't as large. And, needless to say, that area of the country is not even as tolerant of "otherness" as the New England area is.

That's one reason why I came to Boston in the first place.

If I moved home, to a wonderful home, in a great American suburb, I would be effectively isolated. Or, I would become so dependent that I would isolate myself. "Mom, can we go to the store? Dad, would you take me to the library? Mom, I have a doctor's appointment. Dad, I'd like to go see Ken." I'd become a child again. I'd become a burden. No, no no no no no no. I'd be living in an environment where at best I'd feel like a burden, even when I'm feeling good. At that, I'd feel like even more of a burden when I'm feeling good than when I'm feeling bad. At least when I'm feeling bad I have a reason for being a burden.

I'm more afraid of surviving with AIDS than I am of dying of it. What will I do with my life if I don't die of this disease? If I don't find an adequate maintenance program? I'd never really be sick again, but I'd never really be healthy again. Am I really employable? Would I ever be insurable again? Would it make any sense for me to ever buy a car, or buy a home, if I'm not insurable? Because every time I became ill, or needed hospitalization, I would have to liquidate everything I owned, and beggar myself to pay my bills, and then eventually qualify for Medicaid, and then if and when I recover, start all over again.

Any imaginable maintenance would be much less than enough for a reasonable quality of life. It would have to be tied, virtually immediately, to a publicly announced and publicly supported policy of some sort of insurance, health insurance, for PWAs. So that I could indeed go back to having a somewhat normal professional life. Otherwise, I would be one of the few competent, educated, motivated, Harvard-educated members of the welfare class. I would never be able to associate, or work with, people I have taught all my life, taken care of all my life. Simply because I wouldn't be insurable. And that would make my employability a matter of question.

I talk to many people like this. And I like to think I'm not always preaching to the choir, or preaching to the converted. This is my work. And it is precious to me. I feel productive when I talk to people. It's so fundamental to our human condition, so very, very hard to ignore, that we are all dying, all of us, not just the ones with AIDS. I believe I can make a difference.

By summertime, Bob began to experience short-term memory loss. He learned that his illness had found its way to his brain; there were tumors on the brain itself. His powers of concentration and articulation sometimes left him. Gradually, the brain lesions began to affect his speech and motor abilities. His right side became partially paralyzed, and he needed help to stand, eat, walk, and dress himself. He was in almost constant pain. He became frustrated, demanding, angry. He contemplated suicide, and pleaded with friends and family members to help him die quickly, soon, now. He had once said he was proud of having survived seven of the eight major opportunistic infections that go along with having AIDS. But in July he entered the hospital again. It was clear to Bob's doctors that he almost certainly would not bounce back from this round of infection as he had from so many others.

Bob's parents came from New Orleans to stay in Boston as long as they were needed. Together the family implemented the plan that they had made many months before: as soon as he was able to leave the hospital, Bob would continue to live at home in Dorchester for as long as it was physically and emotionally possible. Bob's parents would be his principal care givers, assisted by trained hospice workers, who at first came for eight hours a day, then for sixteen, and finally for twenty-four hours a day.

By late September Bob was still living at home, but with more and more difficulty. His parents, who by then had been there a month, were exhausted. They slept at the apartment of a friend of Bob's, several miles away, and returned to Bob's Dorchester apartment every morning.

I've gotten very tired being up here. We really aren't here at the apartment that much, but I really am tired. Yes. I was just as tired when I was home, but . . . It was worse in many ways, because I was so anxious, and rolling my hands, and wondering and sitting and stewing. At least I'm here and I'm tired and I know why. And I can sleep so I can come back the next day. It's so much easier than it was being home.

We met a friend of Bob's who is a doctor, and he has AIDS. His mother and father have moved into his condominium and are taking care of him, doing it all themselves. The father is very, very angry about the whole disease. He's read all about it. "This is no virus, no such thing. It is a mutation of syphilis, and the doctors are doing this. And they're putting all this stuff into these boys, and killing them." He's very angry. It was embarrassing watching this man let his father take care of him, and talk this way. He brought his parents here hoping they would learn. But it has been very degrading for him.

Physically there's no way for Bob and I to do all the work that needs to be done, taking care of Bobby. And to Bobby it would be very demeaning for us to have to bathe him, and clean up after him, and do all that a nurse or an aide does. It would almost destroy the last of his dignity. He even hates to eat, because as soon as he eats, he has to poop, just like a baby does. It's very hard, keeping your personal pride. He did real well going out to eat last night, with Brian, the hospice worker, being there. Brian took him to the men's room, when he had to go. And we had taken a bag, because we had learned this from the parents of Bobby's doctor friend. Wherever they go they bring a change of clothes, towels, Tucks, and Wet Ones for their son. This is what you have to prepare for.

Bobby's never really . . . I don't think very many young people have ever had to face this kind of death. And this is very, very hard for them. When I was twenty-one years old, I was on duty in Indiana one night, working the eleven-to-

seven shift, on the fifth floor of a hospital with not a breeze in the world. And I had nine patients die on me that night. I learned what death was. And it's . . . easy. But I think when you've never been around it, it's very hard. It's a very interesting process. I hate to say everyone should see somebody die, just because they themselves will someday die, but this dying . . . it's part of living. Bobby asked me recently, "Do you know that when you die, that you urinate all over yourself, and you defecate all over yourself?" And I said, "Yes, son, I know. But why would we have told you? What day do you bring in a young person and tell him these things? You don't." So, he's had a lot to learn up and grow.

The second day we were here, we went and made all the arrangements about the burial and so forth. A family friend was here that next day, to talk to us, and he said, "That must have been hard on you." But really, it wasn't. In New Orleans, they have what they call an Irish wake. I'd like to have something like that, a big party afterwards. A celebration. A release. His spirit's free. I will I'm quite sure cry during the funeral. And I really will be sad to lose him, but I won't. We've had him such a short time. If he's thirty-six years old, I've had him for not quite half my life. And glad I did.

While caring for his son that fall, Dr. Sappenfield wrote the following letter to be read at Bob's memorial service:

Dear God,

Please bring comfort and peace to my son Bob, who is in the terminal stages of AIDS.

My son has been very lucky in his lifetime. He has attended and worked at some of this country's leading universities, including Harvard. He has surrounded himself with a multitude of interesting and caring friends, who admire and respect him.

Bob was born with a cleft palate, and learned early, in spite of our best efforts, that he was somehow different from other children. He adapted to this challenge by basing his self-

respect and security on his natural talents: high intelligence, deep empathy for others, and productivity as measured in the eyes of those around him. This of course made him very vulnerable.

In spite of this vulnerability, he had the courage as a young adult to discuss with us, his parents, his discovery that he was gay. He faced this challenge by being open and honest, not by making pronouncements or denials, but by acknowledging it to his loved ones and friends, at times that considered their needs and feelings. He encouraged us to do the same.

As a physician, I am aware of how little we know of the causes of the variation of sexual preference. We know that genetic and/or environmental factors very early in life seem to determine our sexual behavior. The only matter of personal choice seems to be that of celibacy versus sexual activity. Since I know of few of us heterosexuals who would deny themselves the love and intimacy of sexual relations with their loved ones, and since there are many of us who are sexually promiscuous even though it threatens our families, our self-respect, and even our lives, I cannot denounce those different than I, but must try to gain understanding of the forces that drive us, and that drive various behaviors. Each person's judgment must be reserved for you, oh Lord.

When Bob discovered he had AIDS, he handled the challenge in his usual fashion. He spent his limited time and energies in a mission to educate people in general, other AIDS patients and their families, AIDS support groups, workers, and even young fraternity members, about AIDS from a personal, as well as an academic point of view. His goal was to get those who could to change their behavior that was putting them at risk for AIDS, and to get the rest of us to understand those already infected, to treat them with the respect and empathy they deserved. He hoped we would become a kinder, more caring society, as a result of the AIDS experience.

He is now losing those natural abilities that helped him overcome his original challenge. His intelligence now increases his ability to recognize the fears and loss of identity that are so inherent in the late stages of AIDS. His courage, strength, and spirit are being tested again.

His last wishes are that all the suffering and loss to society that has come from AIDS will not be in vain, and that the price being paid will be made worthwhile by the new knowledge gained, the recognition of equal rights of every individual, and the resurgence of the basic human characteristics of mercy, caring, and trust.

Please, God, help his final mission to end in success.

P.S. Please, Lord, help the leaders of this world to gain greater understanding of the problems related to AIDS, and of Bob's mission. And also, Lord, help them provide the leadership for our society, to reach the goals set by a son of whom I am very proud.

Yours respectfully,
Robert A. Sappenfield, M.D.

Bob himself wrote a letter, in mid-October. In part, it said:

. . . There's nothing special about AIDS. It's another form of dying. It's particularly horrible because the mind lives on aware while the body rots around it. I can hear street noises from my bed, and it's vaguely reassuring to know that life will go on without me.

AIDS is not a sin. It's a tragedy, especially because it could cost us our humanity, cause us to be less than we really are or could be. AIDS is causing me incredible pain, emotionally and physically. I want to die, though I'm not sure I want to die. I know I want to stop hurting, and to stop hurting those around me. But going ahead to die would cause them the ultimate pain. I've decided once already to stop taking all my medicines and hasten the end. I'm not sure this is the answer. I had to ask my parents to help me kill myself. Things have gotten that bad that I've had to make that request of every close friend I've got. This is the desperation I feel, the impotence, the inability to escape, but certainty about *wanting* to escape. I still love the people who love me, and want to be there for them. They might see my suicide as some form of betrayal.

I'm not sure we can afford to give up on people like me.

I've lost friends to AIDS, all of them younger, talented, resourceful men. I shudder to think about the lost generations, the whole generations of creative minds being lost forever, irretrievably.

I guess one of the worst things about having AIDS is feeling trapped, emotionally, physically, medically. Only about 50 percent of problems AIDS patients have are medical in nature. The emotional and psychological pain is the worst part.

My fear is that in my dying process, I'll not be the person I hoped I'd be, that I'll lack sufficient courage or strength to die the way I want to. I'm sure everyone who's dying goes through this litany of questions and concerns, whether they are dying of AIDS or other causes, especially if they know they are dying. There's an exquisite pain caused by that realization. Death isn't what I'm afraid of, but dying and what I'll learn about myself in the process.

The process of my urination takes twenty minutes, and two other people to help me successfully accomplish it. Me, who walked the West Wing of the White House, who was asked to advise senior administrators on better training of public policy makers. I've come to this, worrying that I'll urinate or defecate on myself, have to lie in my own excrement. This is the ultimate humiliation, and lack of control, the powerlessness you feel as a result of this disease.

Loss of control is something I fear. Fear is what I feel most of the time. They shut off the gas in my apartment the other day as the result of a billing error, and it took them six hours to turn it on again. This is how tenuous my life has become, that I am so dependent on the world continuing to function as it always has, afraid that it will not do so. Powerlessness about medical care and financial matters is intense. It's difficult not to be afraid all the time. Fear is what has driven me to the decision about ending everything, when I'm not sure that's what I want to do. I still enjoy good things about life — eating, being able to go to the bathroom, to share and express myself to friends that visit. I'm not sure I want to give all that up, but I'm afraid my fear may drive me to do so.

Bob Sappenfield went into a coma and died on October 14, 1988, at Beth Israel Hospital. He was thirty-six years old.

Several months after Bob's death, Ginny Sappenfield wrote:

Dear Bebe and Nick, dear friends,

. . . I received the pictures that you sent. I like the one best that had the crooked smile on his face. That's my man! It is finally sinking in on me that he's gone.

We had over the years spent so much time with him away from us that the exhaustion and things just had us in shock. But now I think that I'm just going through the final stages of realizing he won't come home again. We'd been so lucky in seeing him at least a part of every month in the last year. We could bring him here or we'd meet him somewhere so he'd have something to look forward to. Now I realize that we'd had something to look forward to, too.

The pictures reassure me that I don't want him back as he was. I enjoy them and look at them so often and miss him. They reassure me in so many ways. And we must get on with our lives.

We want to thank you one more time for being there with us and giving us the gift that you did.

Love,
Ginny

Bob Sappenfield, Cambridge, Massachusetts, March 1988

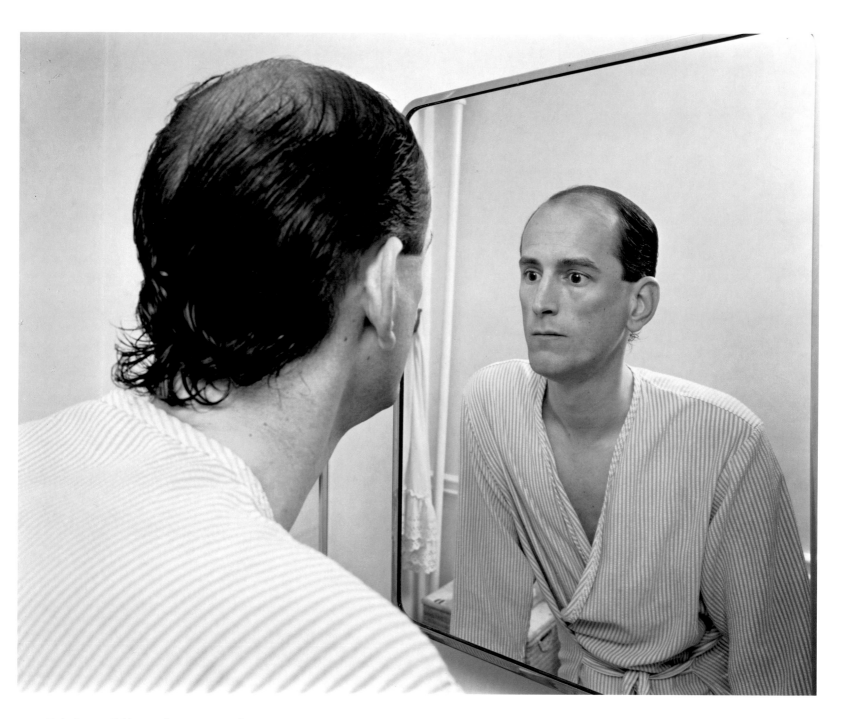

Bob Sappenfield, Dorchester, Massachusetts, May 1988

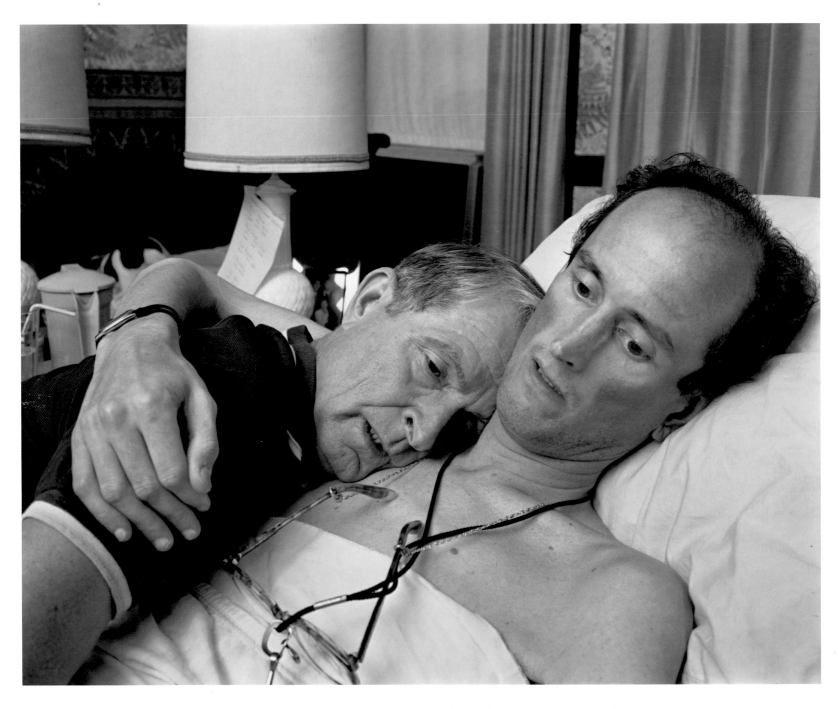

Robert and Bob Sappenfield, Dorchester, Massachusetts, August 1988

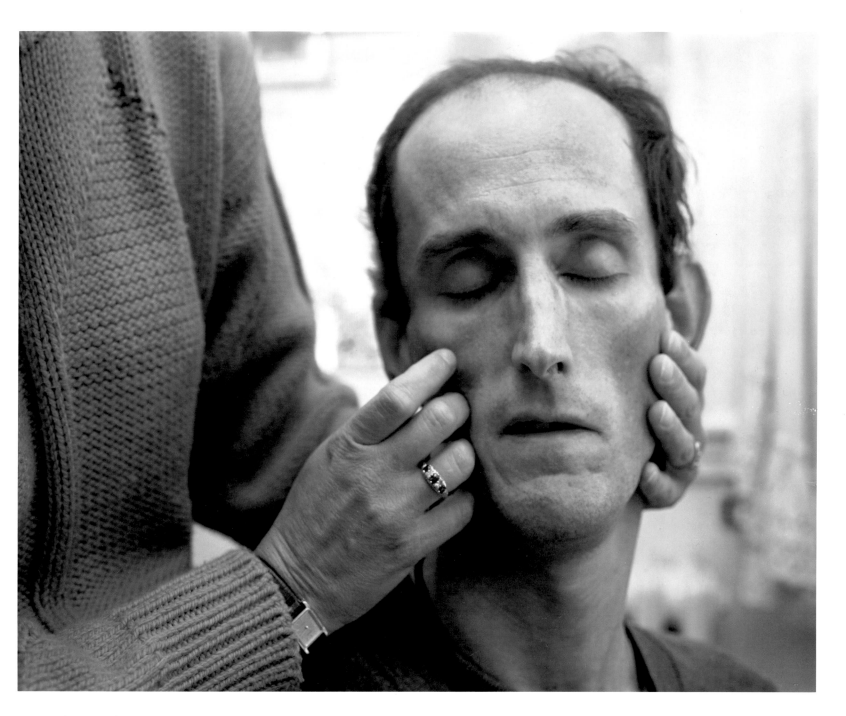

Bob Sappenfield, Dorchester, Massachusetts, August 1988 85

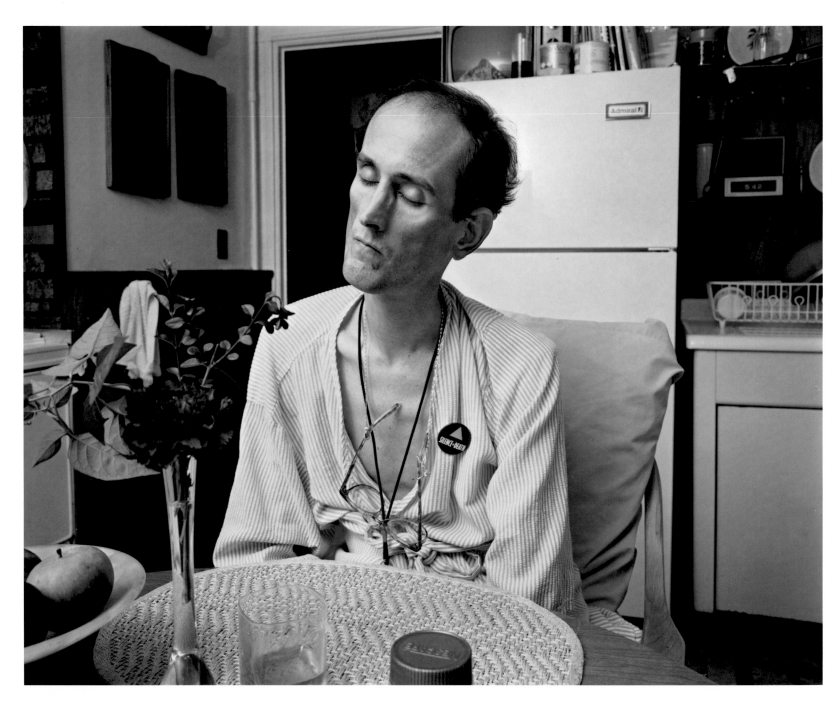

Bob Sappenfield, Dorchester, Massachusetts, September 1988

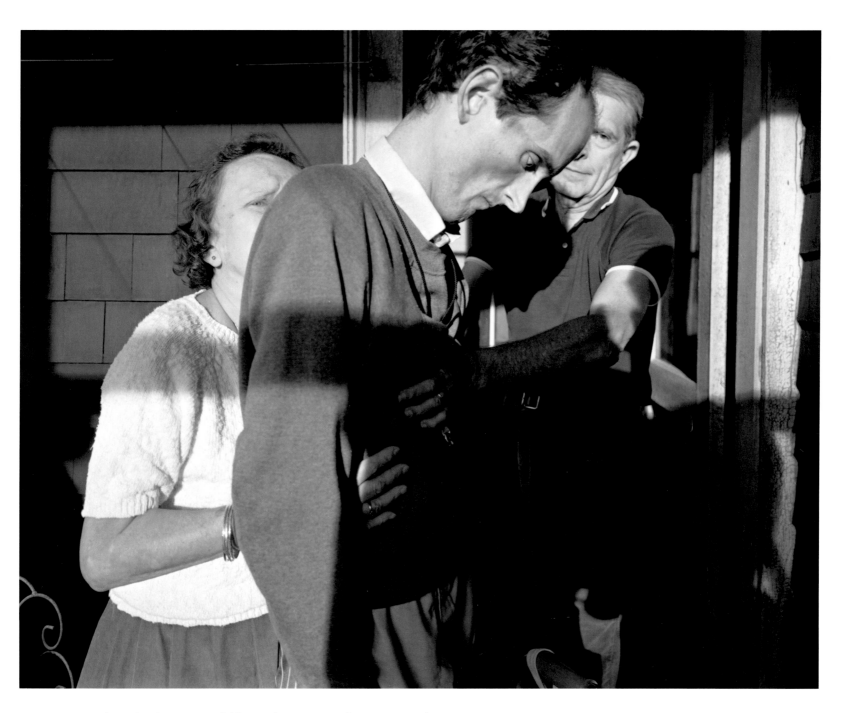

Ginny, Bob, and Robert Sappenfield, Dorchester, Massachusetts, September 1988

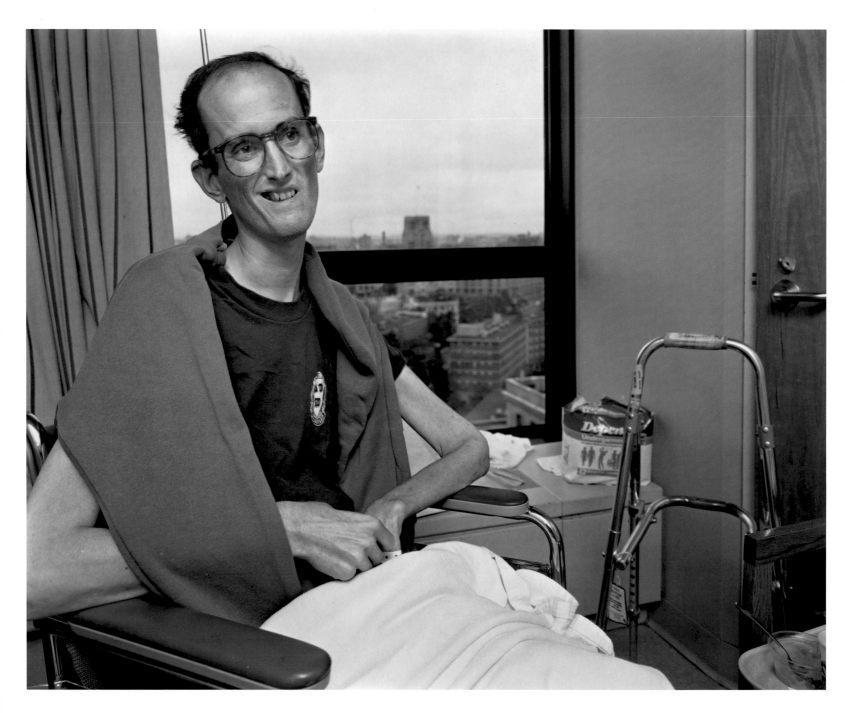

Bob Sappenfield, Boston, October 1988

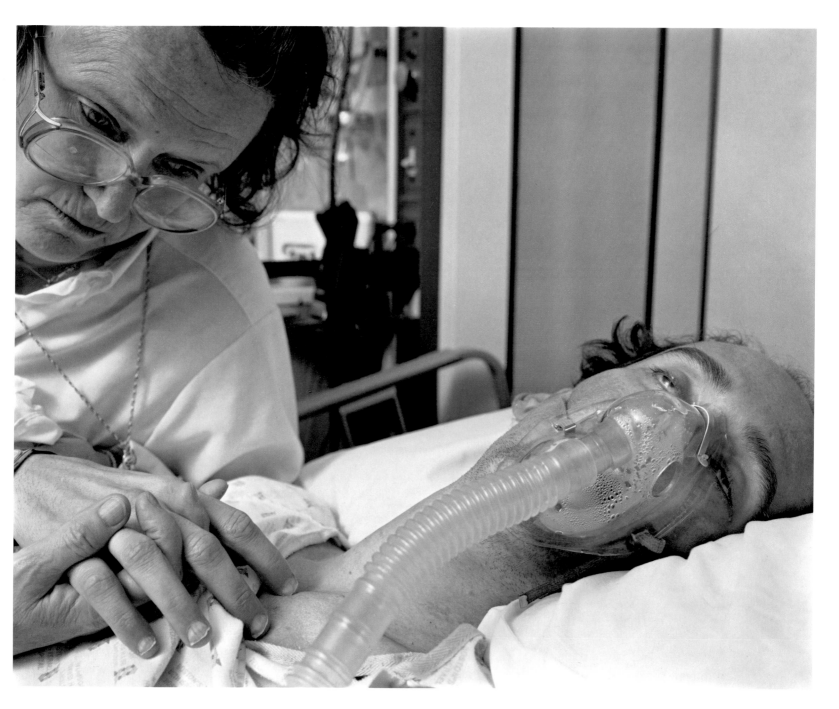

Ginny and Bob Sappenfield, Boston, October 1988

Elizabeth Ramos

Elizabeth was the mother of two hyperactive young sons, Christo-
pher and Matthew. After her husband left her, she raised them alone
while working full-time at the John Hancock Insurance Company.
In April 1985 she started to have trouble breathing. Her doctor
treated her for bronchitis, but she didn't get better. The doctor didn't
test or treat her for anything else. Oddly, in May, she received noti-
fication from the Red Cross that blood she had routinely donated in
February had tested positive for HIV infection. She didn't even know
what that meant. When she asked the doctor if it could have any-
thing to do with what was wrong with her, he said no. As her
illness worsened, the doctor treated her again for bronchitis, then for
stress, and finally, for hysteria.

In late September she developed pneumonia; frantic, she went
on her own to the emergency room at Boston City Hospital. There,
on October 1, she was diagnosed with PCP, the signature pneumonia
of AIDS. She was in intensive care for nearly five weeks, being kept
alive on a respirator. Her lungs were severely damaged.

When she got out of the hospital, she did two uncharacteristic
and drastic things. First, she went public with her illness. She
decided to devote all her time to speaking out against AIDS igno-
rance, to reaching the Hispanic community, especially teenagers, to
making them know what AIDS was and how to avoid it. Second,
she and two lawyers drew up a malpractice suit against the doctor
who had so badly misdiagnosed and mistreated her illness. She
wanted people to know what had happened to her, to highlight the
price she had paid, and, if she won, to provide money for her sons
after she was gone.

Because of my condition, I can't have many goals in life. I
could go to school again, but I never could use it in any
professional way. Talking about AIDS, reaching out to people
in the community, this is my joy right now. I have to use all
my time to spread my message. I believe there's a mission for
me to accomplish. If people see me and hear me, and even
touch me, they'll know this is for real. It can happen to
women, it can happen to men. Then maybe they'll start doing
something about it.

I got AIDS from my boyfriend, José. I never used drugs.
I wasn't promiscuous. But he had the virus, and I got it from
him. He was an IV drug user. For the longest time, he denied
that I got it from him. He said some bad things about me,
about how *he* thought I got it. Then he got sick. He said it
was this, he said it was that, he said it was skin cancer. Finally
I asked him straight out, "Do you think I got it from you?"
And he said yes. And yes, he had been sharing needles with
different people around here, around the apartment complex.
Clean needles are very hard to find here; once somebody has
one, everybody uses it. I asked him, "I wonder if their wives
know?" I talked to them. They don't know anything. And
they don't believe me when I tell them what's happening, and
what happened to me. The neighborhood is so congested, so
close, everyone ends up living with everyone else. And I'm
worried that if these men are infected, they will infect these
women, and the women will infect other men, and they will
infect their unborn babies. I want to do something to stop it.

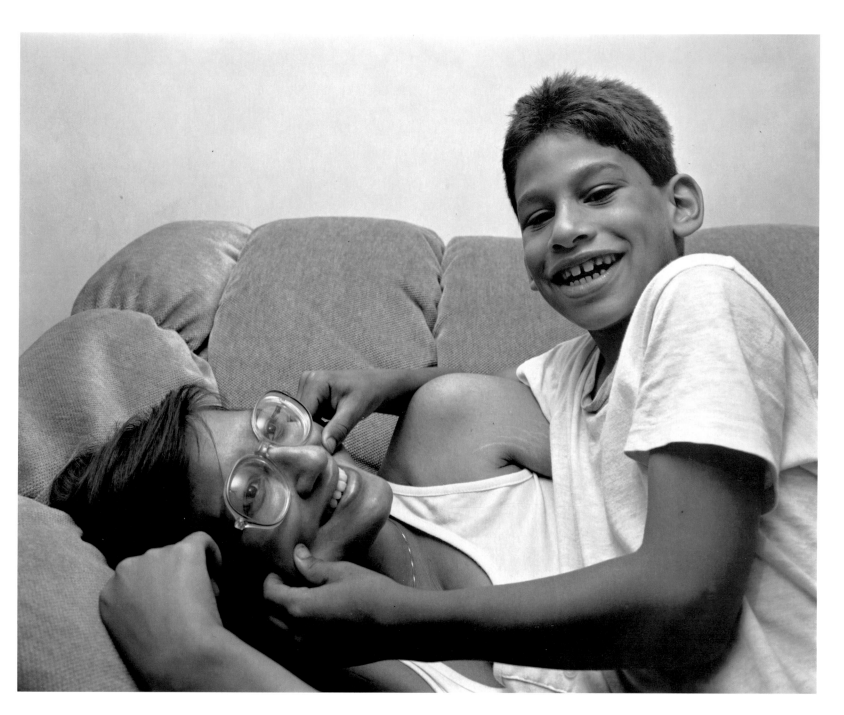

Elizabeth and Chris Ramos, Cambridge, Massachusetts, July 1987

AIDS is one of the facts of life now, like the birds and the bees. We just have to add it on to everything else.

I'm an ordinary person. I got AIDS. It can happen to anyone. Anyone at all. If people know that, if they see me and really know that, then I will have made a difference. That's my goal. I know about people and places that a lot of the organized outreach can't reach out to. I know about drug users. I know about teenage girls in the projects. I know how they tell you anything they think you want to hear, and then go do exactly as they please. It takes a special kind of knowing, a having been there, to talk to them so they *listen*.

The teenagers I talk to, they're mostly girls. And usually by the time they come to hear me, they've already had some sexual experience. That's why they come. They're scared. And I tell them, "You make sure that guy puts a condom *on* before he puts that thing *in*. You just make him. It won't be easy, because a lot of them are goin' to say, 'Bye, baby,' if you make them. But it comes down to this: are you willing to *die* for this dude? Because if he has the virus, and he won't wear a condom, that's just what you'll do. Is it worth it?" They listen.

My kids are afraid that when they come home from school, they'll find me gone. Gone to the hospital, gone to heaven, just gone. It's hard to prepare them for my death. They hate this illness. Christopher once told me he wanted to be back inside my stomach. I asked him, "Why?" He said, "So I could fight the virus from inside you." They know, even my Chris, and he's only eight years old, they know there's no cure. They are very scared.

When I die, I want everyone to know why I died. And I want people to know that I tried very hard to get them to understand.

In January 1988 a jury awarded Elizabeth $750,000 in her lawsuit against the doctor who had misdiagnosed her illness. Her greatest satisfaction was in knowing that her children could be taken care of after her death, that they would not be a financial burden to anyone.

She also had two dreams that could now come true. One was to buy a real house for her and the boys to live in. After much searching, she found one that she thought was just right for her, and she bought it, even though the price was way too high. She was ready to move in, but there was something she wanted to do first: Her other dream was to take the boys to Disney World. The trip was a prize she'd been given by the top fundraiser in the AAC's annual Walk for Life in June. With much fanfare and a great public send-off, Elizabeth, Matthew, and Christopher all went to Florida in mid-October. They did everything at Disney World; the boys went on every ride. But Elizabeth was exhausted by it, and she was getting sick again. After five days in Florida, she came home.

By this time, she had been hospitalized more than a dozen times. The disease was wearing her down. The day after she came back to Boston, she went into the hospital again. Within three days she had slipped into a coma. Less than ten days later, on November 4, 1988, Elizabeth Ramos died. She never spent a single night in her new house.

The boys now live in New York with their Aunt Lucy. The dream house is on the market.

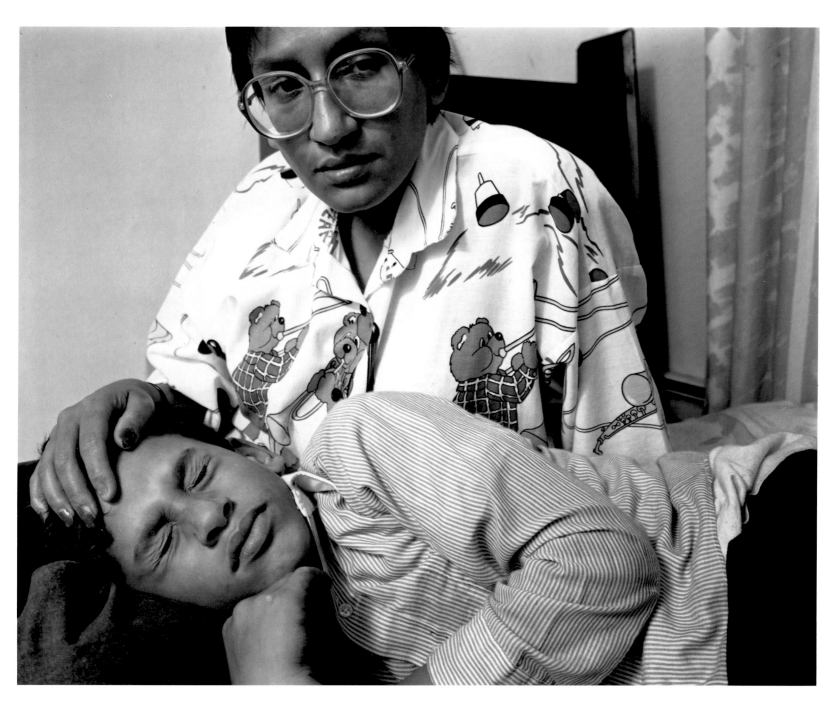

Elizabeth and Chris Ramos, Cambridge, Massachusetts, August 1988

Mark Pfetsch

Mark was a former champion swimmer, a mathematician, a Quaker. He loved the wilderness of the Adirondacks, and had a deep and genuine respect for the wisdom and insights of children. He had been, by his own description, an unhappy heterosexual for many years. His "coming out" was a relief, but a source of enormous confusion for him. He became estranged from his family, and they stayed remote until he became ill.

When he was diagnosed with AIDS, shock and disbelief numbed him. He never could quite accept, or make his peace with, the reality of what had "happened" to him. He spent much of his time arranging his own memorial service. He wrote and rewrote the eulogy, made careful selections of poetry, music, and readings from Scriptures. He kept list upon list of information he thought he, or someone, might need for his memorial. He sent massive files of documents containing the names, addresses, and telephone numbers of all the important people in his life to those same important people. He became a public speaker for the AAC, railing venomously against the culture that had served him so badly, urging compassion for those afflicted with AIDS, pleading for funding for research and care.

JANUARY 1987

Ah yes. My diagnosis. Well, it was a shock. During the summer of 1986, I had flu, or flulike conditions. I lost weight. But I've lost weight before . . . lost it, gained it, five pounds here, five pounds there. I developed a fever. It was a low-grade fever, and it stayed with me a few days, then it developed into a higher fever.

I decided it was time for me to see a doctor. I remember getting ready to go to the Harvard 350th anniversary celebration, and I thought, "Oh, I'd best see the doctor first, and put off the celebration until tomorrow." The doctor told me I had pneumonia, and that it was advisable that I should be admitted into the hospital. I went to the hospital thinking, "Oh, bother, I have pneumonia. This puts a damper on things. It will slow me up." I did not consider that it could possibly be AIDS.

I was admitted into the hospital, and I went into the lab, and when the lab technician came in with a mask on and gloves, my heart sank to the floor. And I thought, "Could I possibly have AIDS?"

I never thought it would happen to me. I had few sex partners. I have practiced safe sex. I was an advocate of safe sex. But I have AIDS.

Mark was so angry at the injustice of his illness, that he seemed to want to die. But because he was so physically strong, his body responded well and quickly to the drugs he was given, and, almost against his will, he recovererd from numerous attacks of PCP.

SEPTEMBER 1987

I think it is appalling, the failures of our medical system, our educational system, our religious institutions, our government. Why did people not speak out? Think about it. If people had spoken out back when this disease started surfacing, my life could have been saved. *My life could have been saved.* But I have AIDS. I am trying to live with it the best I can and

Mark Pfetsch, Cambridge, Massachusetts, September 1987

95

it's been a most difficult and interesting time. I can't tell you what it is like, to be in my mid-thirties, and to have a disease, where most likely I will not be alive two years down the pike.

AIDS is a natural phenomenon. It is a disease which is preventable through education, safer sex. Sexuality is a given. It is as natural as night and day, and it is your responsibility and my responsibility and everyone's responsibility to talk about sexuality. I think of the dilemma, and the contradiction, of wanting information, AIDS information, but not wanting to talk about sex. You can't separate them out. And it is oh, so foolhardy, so blind, so wrong, to try.

I pray, I hope, there will be a cure to this cruel illness. In time, I believe that there will be. It probably will not be within my lifetime. Not within my lifetime.

In October of 1988, Mark contracted another case of PCP. He chose not to have treatment for the pneumonia, but to have only oxygen, to keep him breathing as long as possible, and morphine, to keep him free of pain. Mark Pfetsch died three weeks later, on November 23, 1988, at the New England Deaconness Hospital. It was the day before Thanksgiving. He was thirty-five years old.

Mark Pfetsch, Cambridge, Massachusetts, August 1988

George Gannett

George lived in Providence, Rhode Island, where he was a full-time architecture student at the Rhode Island School of Design. While he studied the nuts and bolts of building codes and regulations, George restored several of Providence's beautiful but neglected old houses.

George's long-time friend and lover, Peter, died of AIDS in San Francisco in 1985. George had had ARC for three years when, during the summer of 1987, he became constantly tired. He lost twenty pounds. He developed several dark lesions. That fall, at the age of thirty-four, George was diagnosed with Kaposi's sarcoma. He had full-blown AIDS.

WINTER 1987–1988
PROVIDENCE

Just before Thanksgiving my parents were in a terrible car crash. They were coming out of a parking lot and this guy came around the corner too fast and plowed right into them. The car was totally crushed, and my father was trapped for a long time. They're okay now. It was the first time they ever had to deal with their own mortality. They're young and healthy, they make trips all over the world, and none of us had ever thought of them not being here. Somehow, they hadn't ever really thought they would die. Or we hadn't, my sister and brothers and I.

It made it a little easier, and also a lot harder, then, for me to face the fact of my own death. I had this diagnosis, I'd watched my dear friend Peter die of AIDS, and countless others, and part of me knew the hard truth. But only after the accident did it really hit home.

It's almost as if none of us can accept the fact of our own mortality until the generation before us has done that. Not died, necessarily, but dealt with it.

It's very important for me to live as if I am going to beat this, to live every day to the fullest, even if that does sound trite. It is also very hard to do.

I grew up around Boston, but I moved to California right after high school. I went to college in L.A., and as a fruit of that experience I had a chance to live in Japan for a year, which was wonderful. Then I came back and lived in San Francisco. I needed to be away from the East, from my family and my past. I had to work out a lot of things, in terms of my sexuality and everything else. It took me about twelve years to deal with all that stuff before I felt comfortable enough to come back.

By that time I'd told my parents I was gay, and that Peter was my lover, and that we were moving back East. It took them a while but in the end they were very accepting of our relationship, and very supportive when Peter got sick. He got sick here, in the East. Then we returned to San Francisco, where he died. Then I moved back here.

I really want to build a house in Rhode Island. I've been looking for land. My dream is having a few acres near the water somewhere. I may sell off half of my house in Providence, or the whole thing. I'd like to try to design a house that's small and much more efficient. I've never built anything from scratch, and I just want to see what I can design. And also, it

George Gannett, Providence, Rhode Island, October 1987

will stimulate me to get rid of a lot of stuff. Physical stuff. I think my mental baggage is pretty much sorted out, pared down to what it has to be.

But first, as soon as I finish school, I'm going to go back to California for a couple of months and just visit with friends out there. It will be interesting to go back to California now. I haven't been there since I was officially diagnosed. People ask if I'd ever move back to California. I don't know . . . there's a wonderful community here in Providence, people I've known for many years, that I'm really close to. A family with four children that I've sort of helped grow up. On the other hand, people say the support services and all are so much better out there. I'll be curious to see for myself. I have so many good friends there, a lot of whom are dealing with AIDS. They're all doing very well. There's definitely potential for a bicoastal support system. But, at this point, I feel that I want to stay here in the East. I've found that it's very important to my parents that I'm here. They try to see me once a week. Most of the time I find that very good. Being here, we hash through a lot of stuff. They need to do that as much as I do. I have a support group, and I have friends who I can call and talk to. But it's not so easy for them. There aren't many people for them to talk to.

My sister and one of my brothers are gay also. They have never talked about it with my parents. My parents pretend they don't know. My oldest brother is almost forty now, and he's lived with this guy for eight years. He believes if they want to know, they'll ask. For me it's been very positive having them know that I'm gay. Thank God they've had a few years to digest that, because now . . .

I have a serious love relationship now. Ron and I met at the march in Washington, back in October. We'd heard a lot about each other for years, had a lot of friends in common, but had never really connected, until then. I'd just been diagnosed, and we were talking about how to proceed with this relationship. And I said, "I hope AIDS doesn't keep us apart." And he said, "I really hope AIDS doesn't pull us together. You're obviously in a situation where you're needing some love and support. I'm already a buddy for AIDS Action Com-

mittee. I'm a nurse. I'm actively involved and supportive with AIDS issues. What could be more appropriate than to have a boyfriend with AIDS?"

I thought it was really good we could talk on that level from the word go. But I also thought, "Can't we just have a simple relationship where we just fall in love, and everything goes along?" It hasn't ever been able to be that way, of course.

So far, I haven't felt very sick from AIDS. I'm on AZT now, I have been for about four months. I really had a hard time going on it, not physically, but psychologically. I had been dealing with this disease all homeopathically, and holistically. I wanted to try the AZT, but was worried about the side effects. I'd thought that if I started having trouble with it, because it is so toxic, I could just go off it. But since I'm now in the care of traditional Western medical doctors, they say, "Oh no, we can't take you off it. If you have trouble, we'll cut your dose in half." It freaks me out. Now I am on a half dose, because my white count's dropping slowly. I hate feeling that I'm actually jeopardizing my health, because of the medicine that's supposed to help me. I talked about it with my homeopathic doctor, too. He said, "That's the thing about holistic medicine. You become your diagnosis. You become your medicine. And that's your identity, and it's a very hard thing to get out of. It's part of the therapy, part of the healing."

Lately, there have been studies coming out saying that AZT isn't effective after six months to a year. I thought maybe I could go off it now, while I'm feeling great, and then I might be able to go back on it later. But no doctor is willing to tell me that that's an okay way to play it. They all think it's one of those drugs you have to keep up. That kind of stuff makes me crazy.

I began going to the homeopathist with Peter, my lover, at the time when he was getting very sick. He was going, and we decided we'd start going together. By the time Peter got diagnosed with AIDS, he was so sick, there was no hope. I just realized that now. He was just so far gone, and he was so debilitated, they just "kept him alive" for six months.

When Peter was sick, about two or three years ago, attitudes were very different. There was more the feeling, "We can't discuss this in public." He deteriorated very quickly, and got lesions from head to toe. He was this emaciated being, covered with spots, the worst of the worst in terms of how he looked. There were lots of issues that came up for me then. At one time, he was in the hospital for a month, and I got to the point where I could only visit him for half an hour a day, and then I would freak out and I would have to leave. He would start screaming at me that I wasn't giving him enough support. I was trying to work full-time, and people were visiting, and I was trying to juggle all of them, and I thought I was going crazy. By the time he died, I was very much there, and I had worked through all the stuff that I needed to work through. I think I was as supportive as I could be, for him, but there are times when I think I could have done it better.

Recently, a friend and I were talking, and we were saying that Peter was trying to be the perfect AIDS patient and not be too much of a burden to me, while I was trying to be the perfect supportive lover. But he and I never really discussed our feelings of fear and anger and pain. I just don't want to duplicate that with Ron.

I'm learning so much about how little experience any of us has with compassion for the suffering of another person. There are so many issues that come boiling up when someone is so very sick. Issues like caretaking, and love, and debt, and gratitude, and what's expected of you by someone else, what you *think* is expected, feelings of guilt, responsibility, all these things that you somehow have to integrate into your everyday life. Because your life doesn't stop going. We as a culture just don't know how to do this. Dying just isn't part of living. Even being sick isn't part of living anymore. We fumble along in a kind of arrogance, or oblivion, thinking we're in control. It's such bullshit.

I do a lot of visualization and meditation. That has been very helpful to me, and also very unusual. I'm pretty much of a gregarious person, very social, and I've never, ever taken time to be by myself before. I've always found it very difficult to carve out time for myself, and sit in a room by myself. I'd much rather be with someone.

Last fall, I went to visit a friend in the Berkshires whose lover had died about a month before. I was doing my visualizations, and we were talking all day. It was very cathartic for him, and for me. I said something like, "I'd love to think I'll make forty, but I probably won't."

He just blew up. He said, "Here you are, doing visualization and meditation, and it's not gonna work, because you're not seeing yourself as living a long and productive life. If you really don't believe you're going to live to be a ripe old age, you're just thwarting your own efforts, wasting your time."

I got furious at him and said, "How can you say this to me? I've been working so hard on this. I'm the one who's sick, here. How can you dare to say what you said? You can't know what you've said." Then it really sunk in, what he meant. That I was sabotaging myself. And I was deeply shaken.

I talked to my therapist about it, and she said he was quite right. If you truly believe that your next step is death, then the visualization and meditation is going to hasten that. She told me that what I'm working on is stuff that I need to clear up in my life. And when it's cleared up, it will be fine, I can die. She also said that there's often a misunderstanding about visualization and meditations and trying to heal yourself. "Heal" doesn't necessarily mean "cure."

I've been feeling great, I've been doing very well. The doctors all are impressed that my lesions are going away, and my blood counts have been doing well, and everyone treats me like this model patient. Yet there are times . . . I went through a point this fall when I was terribly depressed. I just didn't care if I lived or died. And there is fear, especially when I feel shitty, like the last few days. I think, is this going to be the moment, what does it mean? Am I going to be lying in a hospital bed in a week, being given IV drugs? I just think, that can't become my image. It's so easy to plug into the fear aspect. And I find that is the hardest thing in the world to fight.

I used to read about these people who got AIDS, and who said that they thought it was a gift. And I'd think to myself, "How can you say that?" I didn't know what they were talking about. Now I understand that there's something about the shadow of a serious illness like this one that makes you see how truly wonderful reality is. Good and bad. You can have a great intensity for life when you're dealing with something that could bring you to death so easily. I feel I have a much better appreciation for life, and for what goes on. It puts a whole different set of priorities on your life. And that's a very positive thing. That's the thing that I have, that other AIDS patients have, to share with people close to us. You don't have to go through what we're going through, but you can still make the connection by being close to us who are going through it.

In the spring George took an extended trip to California, as he'd promised himself he would.

LETTER FROM SAN FRANCISCO

Dear Bebe and Nick,

It has been wonderful to be here: fantastic weather (if drought-causing) and lots of relaxing and seeing friends. . . . Ron just left, after a two-week visit. We spent time in LA, then we drove up the coast and spent a few days here in SF. It was his first trip to California, and I think he loved it. It was fun to have him here. . . .

There is naturally much talk about AIDS out here. Treatments, people sick and dealing with it. I have spent some time delivering food to PWAs (through "Open Hand," a worthwhile group—they deliver dinner and lunch daily to a number of PWAs). It is depressing to see the mostly horrible, solitary conditions these people are spending their last days in. I think it is important for me to see it, and cannot help but wonder if I am staring my own end in the face. . . .

I hope all goes well with you both, and that spring is in full bloom. It has been ninety degrees the last two days here. I

must say I love the heat. I have been feeling very well and quite rejuvenated. I will be back around 1 May, and will call you. Take care.

Love,
George

After his return from California, George was very tired. He'd had pneumocystis pneumonia, from which he recovered, but which left him deeply fatigued. He had been unable to sell his house in Providence, and he was concerned about his tenants. Still, he was more determined than ever to build his own house on a piece of land near the ocean. He searched for land that pleased him, that he could afford, but without luck. Then, during the summer, he found a tiny house with trees and a yard that sloped down to the water's edge, overlooking an estuary in Barrington, Rhode Island, about an hour south of Providence. He bought it, and in late October, he moved in.

FALL 1988
BARRINGTON

I like to see this as a whole new chapter in my life. I really don't interpret it as my final resting place, that I have created. A part of me thinks that that's what I *have* done: I've gotten rid of a lot of stuff, and made this very cozy small house to come and die in. There's part of me that thinks that's exactly what I've done. But there's another part of me that thinks, "No, I'm here because I want to have a yard, and be more involved with the earth, and have a nice place to live and not be a landlord." I think I can see it both ways. Maybe both things are true, I don't know. They're not incompatible.

It is very liberating to get in here. It is also strange. For part of me, it was a hard break. It's been crazy. I moved in here two weeks ago, and I've had friends visiting me up until yesterday, continuously. I'm feeling very tired, very overstimulated. The friends who visited were best friends from California, and I loved having them around. But now I'm glad that everyone has left. It's very hard to have people in your house all the time, no matter how close friends they are.

And no matter how big your house is. And mine is very petite. I haven't even really had a chance to just be here, by myself, and settle into the house. So, the novelty has not worn off yet.

I'm having a hard time with my stomach these days, so I'm wary of putting anything in it. I don't throw up, I just get nauseous, then get chills. It started a few months ago, and we thought it had to do with the medication I was on. I was taking erythromycin, and that can really do a number on your stomach. So I chalked it up to that. But it kept going even after I went off the antibiotics. Now they have found K S in my intestines, and that's what everyone thinks it probably is from.

It's a drag, because there isn't really much I can do about the K S in terms of treatment unless I want to get into chemotherapy. Which I don't want to do. I haven't decided *not* to do it, I'm still vacillating. The only way I can do it, is if I believe that in the long run it's really going to help me. Even though in the short run it's potentially going to make me feel shittier. But no one can predict that. And I don't know enough now to make that decision. I've done a lot of calling around, and talking to people who are in the same kind of regimen. Some people have had no side effects, feel great, their lesions have disappeared. And others have said that it's a hard thing to go through, and when you're done, nothing seems to have changed.

There's also a part of me that doesn't want to do something that is potentially my only option, and then find out it won't work. I'd never really verbalized that before, but all of a sudden that was a thought that came to me. And I think it's true. The longer I can put it off, the more potentially I have the hope of making it work.

All I'm doing now is taking Bactrim, the antibiotic, which I've been doing since I had pneumocystis. After being on it about two months, I developed this rash, which is fairly typical. It makes my face all blotchy and red. It itches like crazy. Except for that, I've tolerated it very well. It's one of those drugs that most people react to very violently. They feel sick, and their blood counts plummet, but I've done well on

that level, which is nice. The doctor wants me to continue on it indefinitely, if I can tolerate it, because he feels it's very important to have a prophylactic drug in place. If I stop, he says that within six months, at least fifty percent of people get another bout of pneumocystis. That's just a statistic, for me to make of what I want. He's also given me an antihistamine, which I take to stop the itching, so I can sleep at night. When I wake up it looks pretty good. But already this morning it looks pretty shitty. Everyone says, "Oh, you look so healthy, you have such a ruddy complexion." [Laughs] It's because my face is falling off once again.

I'm still doing homeopathic medicine; it has been very helpful to me. The doctor gives me remedies as my symptoms go along. He only treats what he can hear about or see. With traditional Western medicine, it's all blood counts and numbers. It doesn't mean anything, really, except intellectually. With homeopathy it's much more immediate. Your stomach hurts, use this remedy. Your foot is swollen, here's another remedy. If you're having trouble with your eyes, here's another remedy. It's more satisfying on certain levels, emotionally. Having grown up with Western medicine, it was hard for me to get the gist of homeopathy, because it's so much more subtle. I've been going to a homeopathic doctor for four or five years now, and I'm finally getting the picture. I've had enough remedies over the years now that have really worked for me. The thing is that if they *don't* work for you, there's never any toxicity, or side effects.

There's something very satisfying about dealing directly with your illness. There's something so nonlinear about Western medicine, it's almost anticipatory. Not that they're guessing, but they're anticipating based on information that they have, extrapolating, imagining or predicting what might happen, and trying to deal with that, rather than with what is going on, what's there.

I also get very annoyed with the drugs. I'm trying to stay away from as many drugs as I can. The Bactrim to me makes sense. If I can tolerate it, I'll stay on it. The homeopath would like to think I might not be on the Bactrim forever. At the

same time, he's willing to let me, if I think it seems to be helping. He's even pretty supportive if I want to do chemotherapy. He says he can understand why it might be a useful thing for me to do.

It's hard to be clear about a decision for my own treatment. The future of my health is in my hands, in a way. And it's very hard to decide. Chemotherapy or not? It's also hard, if I'm feeling basically pretty good, to decide to go with the chemotherapy, because if I do, I will be feeling very sick for a very long time. With AIDS, you just treasure the times when you do feel good, so it's very difficult to say, "I'm going to take the chemotherapy for the next six months and feel shitty," hoping that at the end of the treatment, you'll actually *be* much better. It's sort of a gamble. There isn't any rational way of making the decision. It just has to be done. Or not done. And then that has to be the decision. I don't want to feel like I'm not pursuing every avenue about this, so I certainly have considered it pretty strongly. But I still don't know.

WINTER 1988–89
BARRINGTON

George further postponed deciding about chemotherapy. In time, he became too weakened to undertake the treatment.

It's terrible when you see people chasing every imaginable cure, any treatment, any therapy. Some people are so obsessed with "doing something" that they can't see what's happening. Which is, that they're dying. And far better to deal with that than waste away in bed in some futile pursuit of cure. It's a shame to see people do that to themselves. They squander so much of the precious energy that's left to them. The medical profession, the whole medical mindset encourages that kind of thing. It's an outrage. Yet to stop, to really accept on some level the fact that you're probably going to die from what you're dealing with, is very hard to do. I think it's something that most people don't ever want to accept. Which I think is fine, in a way. Yet there is a certain acceptance I think it's

important to come to. I never see myself as a person who's dying from AIDS. That may be naive. But to see it that way wouldn't leave me the emotional energy to deal well with what there is. But I know there does come a point, with everyone I've known who's been sick with this, where they just do say, "This is it. It's time."

And then, there's the other side. I know another person with AIDS, who has wanted to die for over a year. But there's almost nothing wrong with him. His body just won't quit on him. Several times, he's called friends in the middle of the night and said, "Please come, I'm dying." And we'd go, and he'd be in bed at home, preparing to die, but he wasn't dying. He was just ready.

Now he's in the hospital with pneumocystis. And he is quite ill. With treatment, and antibiotics, and pentamadine, he could probably survive. But he's refused treatment. He'll only accept morphine, for the pain. And he's finally going to get his wish, I think. He's finally going to be able to die.

Is this suicide? I don't think so. But it makes you stop and think about the fine line between living and dying, and the difference will can make. This man had a fairly privileged but fairly troubled life. And I think the AIDS diagnosis, which he got two years ago, was such a profound shock to him, that he simply decided that it would be the end of his life. He's spent a lot of time preparing to die. It's been his work for the past two years. It's odd, because on a public level, he's been very activist, very visible for AIDS causes. But on a personal, private level, he's checked out. It's very hard for people close to him, both friends and supporters on one hand, and fellow AIDS patients on the other, to accept or tolerate what he's doing. He toys with people's emotions, yet I don't even think he knows he's doing it.

He wouldn't do anything so aggressive as ask someone to help him die. He's just waiting. It's quite chilling. And he won't talk about it. He's incapable of talking about what he feels. And in this case, I don't think he really even knows what he feels.

Since I moved down here, it's been very hard on Ron's and my relationship. It's hard to have any time together, because I'm here in Rhode Island, and he's up in Boston. And Barrington is even farther away than Providence was. Ron works at the hospital five days a week, so on the weekends I really want and expect to spend time together.

Having AIDS, and being in a relationship, it makes it so much more difficult. It has so much in it . . . it just is so potent. Our sexual relationship is fairly nonexistent at the moment, and that really bothers me. It's sort of by his choice. And I find that that's something that I really miss, that I was excited about having again.

I can't blame Ron. I know when Peter was sick, he was so sick that he wasn't particularly interested in anything sexual anyway. I was feeling nervous . . . I realize now, looking back, that I went through a lot of anger about his being sick, and a lot of feelings of physical repulsion as his body changed. I got to the point, before he died, when his body was just covered with lesions, and really thin and frail, and he had to use a cane. It really took some effort on my part to even go out in public with him. I don't think he ever knew that. But there was definitely part of me that felt, "Everyone's looking at us. Everyone knows." Four years ago, AIDS meant a lot more stigma than it does now.

But sex is so close to the center of it. And there's so much anger tied up with it, with feeling rejected. With AIDS, sex equals death in people's minds. It's a very hard thing to be feeling sort of passionate or sexual with someone who you know might, well, kill you. That's what it comes down to. I'm sort of amazed we had as good a sexual relationship as we did, for as long as we did. Small solace. But I do understand why it's become such a big issue. Now, we're trying to create ways we both feel comfortable about having sex, without it being a threatening experience. If we can give each other the freedom to do what we have to do, our relationship will be much easier.

Being in a heterosexual relationship that's sanctified by society, and having children, must make it a little easier to go through these kinds of problems. There is a built-in support system for the relationship, which is the whole culture at large. But for us, we're on our own. It's not bad. But it's lonely, sometimes. Especially when death is at the center, somewhere deep down.

By January 1989 George was in the hospital. AIDS was affecting his vision, his muscle control, his stomach, and his brain. Friends and family came from California, from Boston, and from Providence, and set up a shifting cordon of support and assistance. After several weeks George decided to stop treatment altogether, and return home. He arranged for a hospital bed to be moved into his living room, and there he stayed. Too weak to walk, eat, or talk, he withdrew from most of his family, and ceased taking most of his medicines. Visiting nurses came daily to the house, and his friends maintained their watchful, helpful presence. Ron spent every weekend, and many evenings, with George.

George Gannett died at home on February 27, 1989.

After George's death, Ron wrote:

Dear Bebe and Nick,

Thank you for sending the pictures to me. I do appreciate having them. As you can imagine they stirred up a lot of emotion that had only recently diminished somewhat.

The picture that affected me most was one of the last. Taken from the foot of the bed at George's. Bright winter outside, soft and warm inside. George's face emerging from a sea of blankets. His skin glows. He is beautiful again at the end. It reminds me importantly that for the most part, George's death was a peaceful one. Sad for me and so many others, but perhaps tolerable for him to bear.

It still seems to me a great waste, but I am I think beginning to heal, and the fact that I am able to look at the pictures and even like some of them in spite of the pain is testament to that fact.

Fondly,
Ron

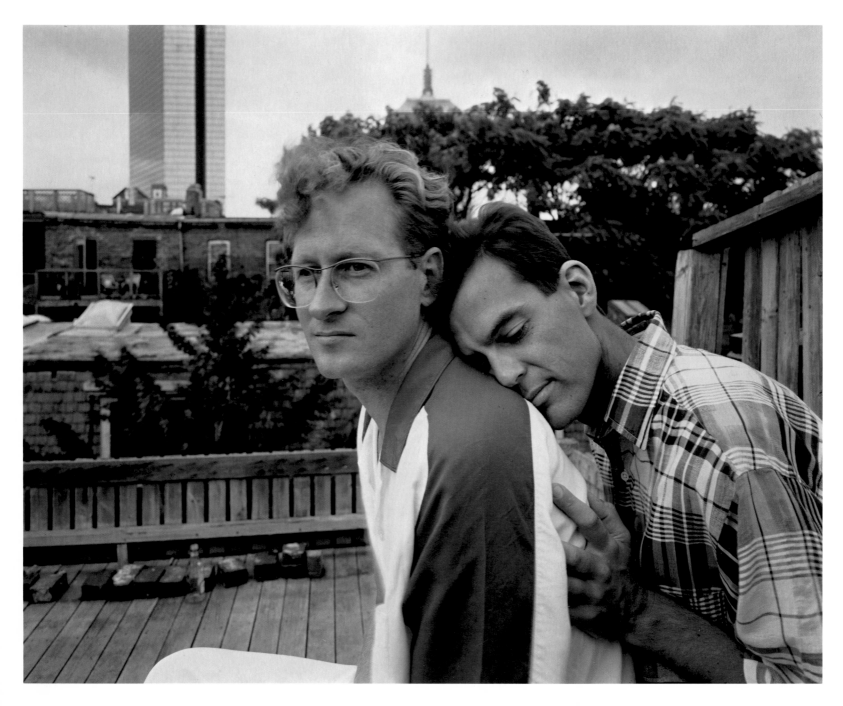

Ron McClelland and George Gannett, Boston, August 1988

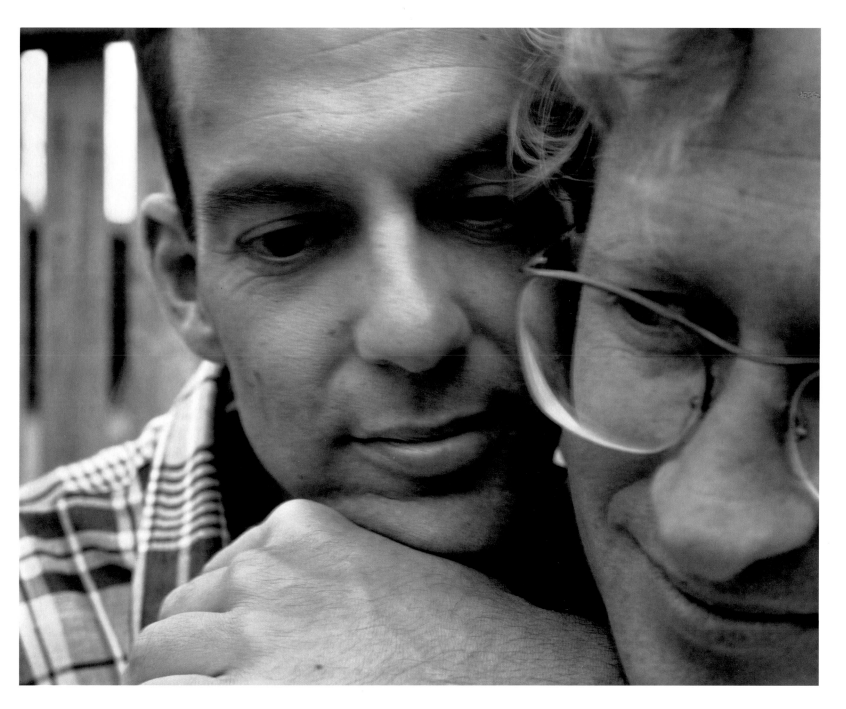

George Gannett and Ron McClelland, Boston, August 1988

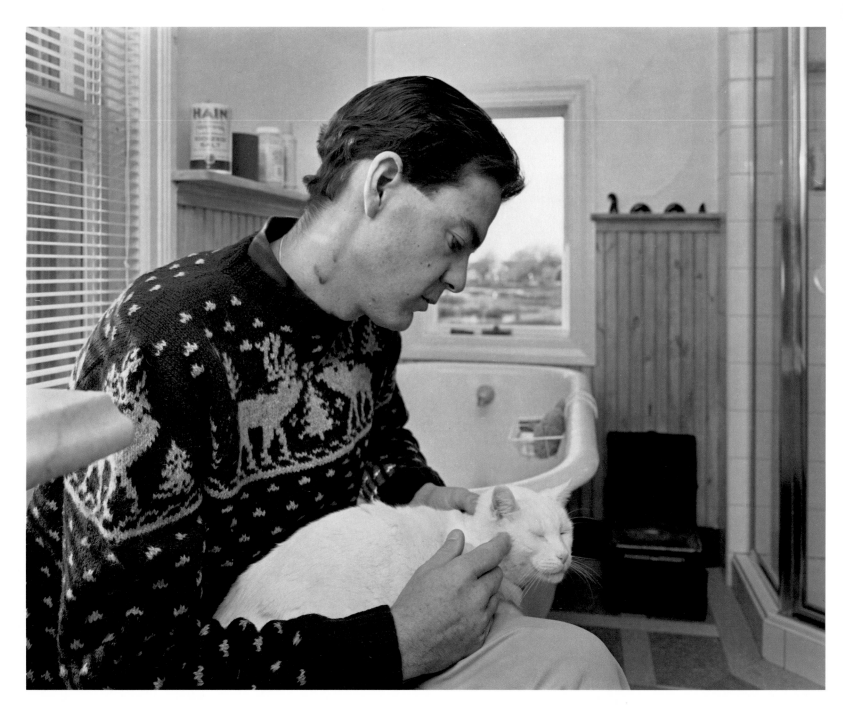

George Gannett, Barrington, Rhode Island, December 1988

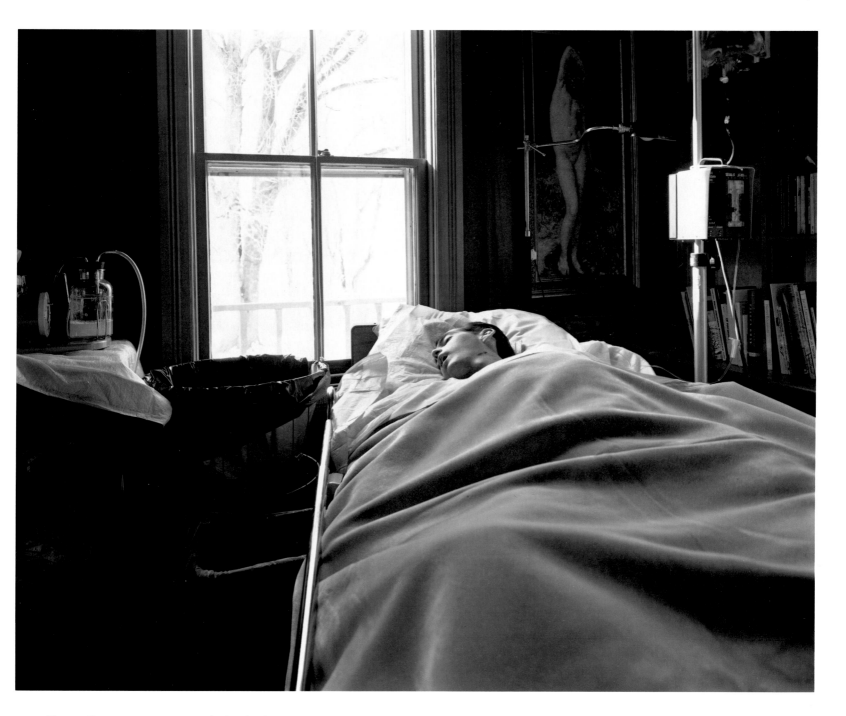

George Gannett, Barrington, Rhode Island, February 1989

Paul Fowler

Paul was a talented calligrapher amd an openly activist gay man. He was by turns a vain perfectionist, an incurable snob, an acerbic observer of the foibles of others, and a true and devoted friend. He dressed elegantly, shopped ceaselessly, and redecorated the houses of all his friends and relations with joyful flamboyance. He taught calligraphy in Boston's art community for many years, traveled and taught extensively in the People's Republic of China, and was the special projects designer for the EPA in Boston. A friend once described him as "a man who was never semi-anything, and who wrote the book on style." He gave elegant dinner parties, coaxed a recalcitrant garden into bloom, and reveled in music of all varieties, especially grand opera and the songs of Strauss.

Paul was the fourth of seven children. When Paul needed his family's support, he could count on it. He and his sisters and brother grew up in Cambridge, where, as Paul once said, they learned early on to value differences in other human beings. He was fiercely loyal to his friends and family, starkly honest, and quietly, selflessly courageous.

Paul's friends were many and far-flung. His correspondence was copious and almost old-fashioned in its regularity and style. Though he loved to talk on the telephone, he enjoyed the formality and texture of the written word. Paul's letters were elegant creations, thoughtfully conceived and carefully hand-lettered so that they were both satisfying to read and beautiful to look at. Even a simple thank-you note was filled with charm. Like Paul himself, his letters always hinted at something unexpected, the glimpse of a surprise.

In the late summer of 1986, he and his then live-in lover, Jeffrey, a musician, became ill with persistent bronchitis.

August 5

Dear Nancy,
[his sister, who lives in San Jose, California]

Greetings from your currently decrepit brother! The cough that Jeffrey has so thoroughly enjoyed—and I vicariously—is now settling nicely in my chest after five days of sniffling, achiness, and exhaustion. I'm beat. I guess I was weakened by the lack of sleep suffered while Jeff was at his worst. He's now finally getting better, but it's left me weakened to fight off the contamination. I've been making it to work, and ignore the stares of passersby as they shock to the sound of my tubercular cough. I'm up to three packs a day of Hall's menthol cough drops. Sure will be glad when *this* all passes. The embrace of our double affliction has seemed an endless travail. . . .

Not much else is news. I've canceled my trip to Paris. Will probably go in October instead . . . Peggy and Sam may come in October. Is *mid*-October best for foliage? What do I know, I only live here.

Love,
Paul

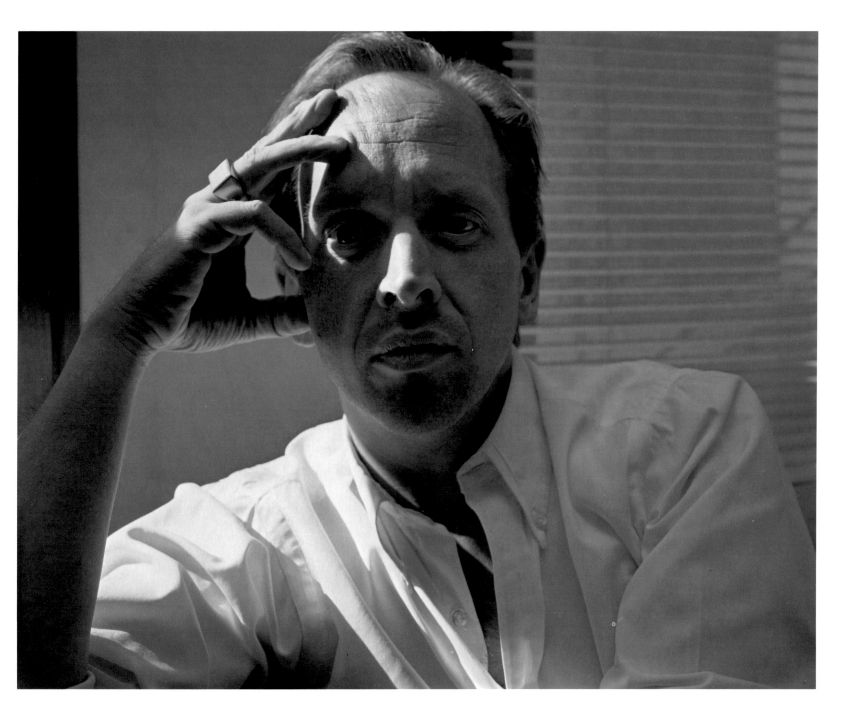

Paul Fowler, Cambridge, Massachusetts, July 1988

August 15, 1986

Dear Nancy,

Well, back to work today — obviously I'm not too into it — sitting here writing you a letter. I found out yesterday I'd run out of sick leave, so the last two days of my absence will be unpaid. . . . I must admit that life could be beautiful without work, if only we could afford it.

I'm finally feeling a little more normal. My lungs are clearing up, the frequency and severity of my cough has diminished. I'm not on top of the world, but with a bit more rest and relaxation this weekend, I hope to improve. This thing had really knocked me for a loop. . . .

Ev and Cindy [two of their sisters] came over on Sunday with soup "like Ma used to make — in a can!"

. . . Mom has of course offered her live-in nursing services, which I refused. Partially 'cause it's not necessary, partly 'cause I wouldn't want her to catch this.

I have of course *not* gone out, nor have I made any plans. I'm still really tired, so plan to take things slow for a while. It's tough to get old and feel your body deteriorate. Hope all is well.

Love,
Paul

August 15, 1986

Dear Lao Chen,
[a friend in China, from Paul's teaching days there]

Many months have passed since I last wrote to you and much has happened. Each day my job seems to hold new challenges, many of which I feel unprepared to handle. At times I feel "in over my head." My boss is very confident of my ability — sometimes more so than I am — so often, she will just give me a problem to solve with no instruction. I always manage to struggle through even the most difficult ones. I generally work long hours, and I am exhausted by the time I return home in the evening. I sometimes miss the quieter, slower-paced life of the academic, but the job is still a stimulating challenge, so I'll stay here for another year.

This has been a terrible summer here in Boston. The weather has been cloudy and overcast and almost every weekend we have had rain, rain, rain . . . I had planted some flowers in my yard in the spring, and the foliage — and weeds — have grown large and green, but lack of sunshine has prevented any flowers from developing. I, and my flowers, could use a strong dose of sunshine about now. I have been battling a serious lung infection which has been bothering me all summer and which completely overpowered me ten days ago. Today is the first day I have been back to work in a week. I am on two medications — antibiotics and fever reducers — and must drink a lot of liquid and rest as much as possible. I am finally feeling better again and hope to be back to normal soon. I am a terrible patient — I don't know how to be sick, and I tend to rush back into things too soon for my own good.

This fall I am looking forward to some happy events. In early September we will have a large party to celebrate my mother's seventieth birthday. We have invited sixty-five cousins, aunts, uncles, etc., as well as some old family friends and neighbors. The party will be a surprise. . . . My sisters and I will go down to my parents' house the day before to set up and prepare the house for all the guests. It will be the first time in a long time for a big family reunion, and I'm sure my mother will be very happy! As a gift we will send both Mom and Dad to the South (Florida) for a warm-weather vacation during the cold winter months. . . .

I imagine you are busy preparing for the upcoming semester in September. Summers always seem to rush by! . . . I wish you the best of health and success in the upcoming year, and hope to hear from you when you have a moment or two to drop me a line. Please send my regards to your wife and family — and to all my friends in Hefei. Take care of yourself.

Fondly,
Paul

August 25, 1986

Dear Nancy, Jack, and Joe,
[in San Diego]

Greetings, "N," you'll be here before you know it! I imagine your weekend here will fly by — we'll be pretty busy putting it all together. I figure by then I'll be back in ace condition and will be able to participate fully in the preparations. It should be quite the party!

. . . My illness is in the "slow fade" phase, and I must admit to being completely tired of the whole thing. This morning I *forced* myself on a little run — could only run a few blocks, walk, run a few blocks, walk, etc. My body is still weak, but it feels like it's getting better. I'm anxious to get back to life and tackle all my summer projects which fell by the wayside. I'm a bit overwhelmed at the thought of all I have to do. This weekend's a long one, which should be a help.

Love,
Paul

August 26, 1986

Cheri Terry,
[a friend in China]

Ni hao and Greetings from Boston. If you are reading this you are, or must be close to, getting settled in Qingdao.

What an awful summer this has been. Jeff and I have both been sick. He started with a cough in early July. I caught it in mid-July and it developed into a full-force viral bronchitis . . . I had to return to work, but I barely make it through a day, and am unable to do anything after work but eat and retire early. . . . I don't think my lungs have ever been the same since China [Paul had been hospitalized for pneumonia while he was there], but you know, I think this sickness has been far more devastating and has lasted longer to boot! I've been in an unhealthy state of mind as I contemplate the breakdown of my physical well-being. I was convinced I had a terminal disease — which my doctor repudiated — until the last

couple of days I really wondered if I would *ever* get better. I'm beginning to crawl out of that "sick mode," and I hope to be better soon. My doctor assures me I will. . . .

I have a vacation trip to Paris planned for October. I'll be there about twelve days, which is long enough to plan a couple of "side trips," perhaps to Northern Italy, or Mont-Saint-Michel.

I hope this letter doesn't sound too depressing. I'm actually okay and looking forward to the next few months. Hope all is well with you, Comrade Cherry. You're almost a Chinese you've been there so long.

Lots of love,
Paul

October 28, 1986

Dear Everyone,

First off, please forgive me for this generic "letter." I have been overwhelmed with the volume of mail, phone calls, messages, flowers, books and tapes, etc. that have flooded my house, hospital room, mailbox, and phone machine since the news of my diagnosis "went public." This outpouring of love and support has been a source of great strength over the last two months, and will be the sustenance I need in the months ahead to both survive and thrive. I feel very rich indeed to know the love of so many people.

For the benefit of faraway friends I offer this brief synopsis of the events of the last few months. After several weeks of treatment for bronchitis, a bout with food poisoning, and then several days of diminished breathing capacity I was told by my Mt. Auburn Hospital doctors that PCP was among the possible pneumonias they suspected as the true ailment. To make a long story short, they referred me to the Deaconess Hospital, which has a special AIDS clinic, and is in the forefront of AIDS research programs including the new drug AZT. I had the conclusive broncoscopy — an ordeal with tubes down the throat into the lungs — and a few hours later my beloved Dr. Paula Pinkston gave me the news. Sisters Nancy,

Evelyn, and Cynthia were there (Ev had been at Mt. Auburn the day of the first suspicion), and they took me home where Jeffrey joined them and a stream of friends who paraded through the house and kept vigil through what seemed like the longest few nights of my life. I was taking antibiotics, but after several days Dr. Pinkston felt I needed to be hospitalized since the oxygen levels in my body tissues were severely lowered.

Within a few days of admission to the Deaconess, with the help of continuous oxygen, I began to feel better, stop coughing, and breathe more normally. My appetite returned — I'd lost twenty pounds, and even hospital food looked good after days of not eating. Once I began eating, my strength returned quickly — *and* my taste — Jeff brought me a sumptuous lunch of chicken tarragon, and all the fixings, and my second week in the hospital I dined midday on meals prepared or purchased (in elegant bistros of course) by Steve Hatch, Connie Griffin, Chris Jendras, sister Cindy (delicious home-made lasagna!), and by my three younger sisters Evie, Cindy, and Beth who visited Saturday with nieces Diana and Jessica in tow.

The care at the Deaconess was fabulous. I was given a private room on the eleventh floor, a not-much-used "VIP" floor, which is half-filled with noted doctors, socialites, wealthy Middle Easterners, etc. — and — AIDS patients. Weird combo. The room was pleasant, had view, adequate seating for a multitude of visitors, private bath. The nurses were wonderful, residents Drs. Hernandez and Conlon attentive, I could not complain about the care. My treatment consisted of IV-bottled antibiotics — then constant blood tests, arterial (ouch!) blood gases (for oxygen levels in tissues), and the usual vital signs. The food was awful, but my "supplementary" meals helped.

After five or six days I began to turn pink and my fever soared to 103 degrees — an allergic reaction to the drug Bactrim. It took several days to get back to normal, and scared the bejesus out of me since there was obvious concern by doctors and nurses concerning this turn of events. Later they told me that most Bactrim patients react this way. The new drug

— pentamadine — needed only once daily administration (four times a day: Bactrim) so that was a relief. The latter "crystallizes" less — so my IV clogged and required replacement far less often. These drugs soon had me on my feet, got me walking around, then had me climbing stairs (for exercise). Of course I remained "tasteful" and spent each morning after breakfast freshening flower arrangements, bathing, etc. and reading my cards and letters before the onslaught of guests began arriving at noon each day. I began my daily walks in the long corridors, and by the end of my stay had begun walking up four or five flights of stairs, to *really* stretch my legs.

My final treatment was completed after five days' outpatient care when I received a bottle of IV each day to complete the recommended twenty-one days' treatment. Schlepping back and forth to the hospital daily was more of an ordeal than I'd guessed it would be, so I was glad that I'd told friends *not* to drop by the first week. Elaine (oldest sister) stayed with me the first few days, followed by Mom and Dad who despite getting the "double whammy" — gay *and* AIDS — have been incredible in their support of me and their acceptance of Jeffrey. All the family has been exceptionally supportive . . .

I am now feeling well enough to get to work *out* of the house. I'm not up to hosting dinner parties yet, but have enjoyed a few evenings of Chinese take-out served to small groups of visiting friends.

Next Monday I start work back at the Environmental Protection Agency. They've agreed to give me two days a week — one home, one in the office to resume work on designing the new employees' orientation program. . . . It'll be good to work again. Two days will give me time to tackle my artwork and a few other projects I have in mind to complete. There's a lot I want to get accomplished. . . .

All in all I am feeling great. I'm slated to begin participating in the AZT Research / Treatment Program — all the applications and consent forms are signed and submitted, now we wait a week or two (???). My outlook remains positive no matter what, but I confess to a 90 percent commitment to this

coupled with 10 percent doubt. I'm back to running again—as often if not as far as before—so I guess I feel a bit hesitant to risk the side effects of a drug which is being administered to me and my brothers and sisters with AIDS quite like guinea pigs. It's a little scary, so wish me luck.

I plan to survive, but in the meantime I treasure each day.

I send love . . .
Paul

November 5, 1986

Dear Nancy, Jack, & Joe,

. . . Today was my triumphant return to work. . . . *everyone* has been popping over to say "welcome back." The more adventurous ladies have planted kisses and hugs on me and this has *really* rankled one of our office "Romeos." When my friend Connie and I kissed and hugged, he about fainted!

It feels good to be back. I actually worked a couple of hours this morning! I realized just how long I had gone without exercising my brain! . . .

Paul

November 19, 1986

Dear Tom,
[an old friend]

. . . I'm feeling good and so far have experienced *no* side effects from the AZT. I'm leading a busy life with work, tutoring, as well as running around the social circle. Many days I almost forget my diagnosis. It's weird.

I saw a stellar production of *Porgy and Bess* on Sunday, in concert presentation. The performance brought down the house. I went out to dinner (Thai) afterward, then dropped by a friend's cocktail party later. Dashed home by cab to take my medicine at 10 P.M. . . . I'm having nineteen to sit-down dinner at Thanksgiving.

Paul

November 19, 1986

Dear Everyone,

I continue to stay healthy—though wealthy and wise have somehow escaped me. Alas! I'm slowly, but *very* surely pulling out of the "sick mode" I've been in for two months, and find I'm occupied more productively these days than I had been. I don't anticipate that life will ever return to "normal," but then that was not an adjective I've ever aspired to use to describe my life's endeavors.

I am back at work two days per week. . . . My boss has been most helpful and encouraging and this has been a great consolation. There are still many special projects the office wants me to accomplish in the next year (at least!), which I feel completely capable of completing. Actually I *like* working less time—and don't even mind a little less money—because it gives me more time for my calligraphy studies, and a return to the Lettering Arts Guild.

My strength has returned, though my endurance is still a little bit weakened. I have gained weight (*yuk!*) so I'm no longer the svelte modellike figure who was dismissed—oops—discharged from the hospital in September. I am running again and have been consistently making it around the two-and-a-half mile track at Fresh Pond for a couple of weeks now. It was difficult to start up running again, and believe me, there were days when I just *didn't* want to even bother, but I struggled along. I'm feeling much less strain at motivating myself to put on my shoes and actually go out and hit the pavement.

The latest medical development is the introduction of the new drug AZT to my daily routine. I take two capsules every four hours, a schedule which unfortunately means at least one wake-up in the middle of the night. So far I have had no side effects other than tiredness, which I'd guess is [more] the result of the mid-night administration than the drug itself. The pill bottle says "For Investigative Use ONLY" so I'm more or less a guinea pig. My doctor must submit weekly reports, so every Monday I get a physical and blood tests. I know the *names* of the technicians in the blood lab. I'm sur-

prised there's anything left in my veins. I'm hopeful that the AZT will prevent my affliction with one of those tasteful parasitic diseases which could do me in. I remain positive. I did see the first positive depiction of an AIDS patient by the electronic media last week. I turned the TV on and heard "the latest news on the treatment of AIDS . . ." The featured woman had been on AZT for about a year and was going on with her life, hopeful that she'd live long enough for a real cure. I guess we'll *all* cross our fingers.

I have had a few bad (real bad) days lately. Returning from work one evening I found two messages, the first that a friend's lover had finally died after a "long illness" — guess which one — and that the AZT was in. Two major things to think about — put me in a *real* black mood for two days. I snapped out of it with a good run and a day later I was okay. My spirits somehow stay high!

Love to all,
Paul

April 10, 1987

Dear Nancy, Jack, and Joe,

Greetings from Greyland. Despite rosy predictions for a sunny day the skies are clouded over, and there's still a chill in the air.

. . . Yesterday's transfusion went well. Each of the three units took the expected one to one-and-a-half hours to be absorbed. I brought a bunch of flowers for the day care nurses, so I was tended to even more than usual. The IV insertion, however, was the most painful I've *ever* experienced. The nurse said it would be okay to say "ouch." Permission was *not* granted for what I actually blurted out. The headaches ended midway, then I went home and stripped paint and cleaned house. It's good to feel alive again. My crit was the lowest ever.

We saw *Madame Butterfly* on Sunday — it was nice, but I like a more dramatic opera — you know — more screaming and wailing, and passionate, heated lovers' duets. There were

a couple of scenes, however, which were just beautifully staged.

Love to all,
Paul

October 30, 1987

Dear Nancy,

Speaking of extravagant, I began shopping for rings today. Jeffrey and I have decided to buy each other rings for our anniversary and Christmas.

I started out with Chris just to see how homophobic the jeweler's building is. I'm happy to report that with Chris by my side I experienced absolutely *no* homophobia! Next we'll try it with Jeff!

I've beefed up my wardrobe this week. Bought a pair of Italian loafers at Jordan's, 75 percent off for twenty-five bucks. I also bought several sweater vests at Decelle's for $7.99 each — they're great in an unpredictably heated office building. I also splurged and bought a beautiful royal blue v-neck which reminded me of the turtleneck you brought me from Scotland which the moths got in Shanghai in '84. That was thirty bucks, but worth it, I think.

I've moved from the garden into the house and yesterday I tackled the upstairs den. I dusted all the books, then went through all the baskets of letters, cards, papers, etc., sorted, filed, and threw out *tons* of stuff. I have some final touches to do, but I could actually use the desk and drawing table now if I were inclined to do so.

Love,
Paul

November 2, 1987

Dear Everyone,

I should be severely punished for my recent deficiency in my correspondence skills. The months of September and October

were two I'd just as soon forget. My posthospital recovery was not aided by hassles with our tenants upstairs.

Anyway, thanks to some help from my social worker, Judy Babcock, and the sheer unshakable bond of our family (or its inevitable "noose," depending on our mood!), everyone is speaking and back to as normal as normal can get in *this* family.

My health is good and I'm back on one-half dosage of AZT. I'm hoping this will lengthen the time before my next pneumonia, since there were only two months between this last one and the one in May. So far I've had no side effects. The doctor suggested possibly returning to full dosage but I'm unwilling. Last spring I felt more dead than alive on full dosage, and I was needing blood transfusions every other week. We're hoping one-half dosage is enough to keep me healthy, but leave me feeling strong enough to work and exercise. I've got my fingers crossed.

Since I got out of the hospital and returned to work (two to three days per week) I've been spending most of my time in the garden. I have cut down several old shrubs and trees which had never grown very well or interestingly, moved other shrubs which had overgrown their location, planted new shrubs, bulbs of iris and tulips for next spring, and dug up and divided hundreds of violets, and dozens of hostas. I've also planted a continuation of my front hedge and gathered a truckload or two (using the trunk of a friend's Datsun) of used discarded red brick from a nearby construction site to lay out about 175 feet of brick borders along various planting areas, as well as for a small four-by-six-foot area I paved to accommodate some big planters I'll use next season for tomatoes and herbs.

The garden has been a source of great solace for me. There's something elemental, basic about digging in the soil, planting, weeding, watching your labor bear fruit. These last few weeks have been less immediately satisfying, but rife with symbolism, since all the bulbs I planted will lie dormant until next spring, and many of the shrubs and ornamental plants I either moved or planted immediately began dying — or hibernating — with the onslaught of the cold weather. Satur-

day when I dug up my geraniums and vinca to bring inside for the winter, the soil in the flower boxes on the north side of the front porch was actually frozen. Alas we must endure winter before we can enjoy the spring! My rewards for the back-breaking toil I've invested will hopefully be armloads of flowers and thriving shrubbery and greens.

At work this month we had performance reviews by our supervisors and I got an "Outstanding" rating which makes me eligible for a cash reward which could be anywhere from five hundred to one thousand dollars, and I'm recognized at next spring's Annual Awards Ceremony. I was very surprised at all this since I don't think I've been a particularly diligent employee this last year. I think the rating and award are probably more the result of previous years of unrecognized super-performance with perhaps a trace of sympathy for my current "plight." My boss did say that she's been impressed by my continuing high degree of professionalism despite my "personal needs." Whatever the reason behind the award *this* year I feel I deserve it — the recognition and the money — because in the past I have gone far beyond what was expected of me. The money will be a great help given my reduced income.

We've been to a few concerts and recitals including the opening night of the Boston Symphony. Jessye Norman was the special guest and she sang the Strauss "Four Last Songs," favorites of Jeff's and mine. Only once before in my life have I been moved to tears by a performer, but our entire row was wiping eyes and sniffling through the third song, "Beius Schlafengehan." Norman was *stupendous* — floated out on stage like some unearthly presence, folded her hands in front of her, opened her mouth to begin singing and *devastated* us all. We were high for *days* afterward. Months of anticipation of this performance were thoroughly rewarded.

All in all life is going well. I struggle to keep myself rested since my tendency is to fill up my schedule with work and other activities. I've never been one to sit on my hands and even though I know I must take things slowly — or at least more slowly than I used to — it's a constant battle deciding between what I *want* to do and what I reasonably *can* do and retain my health and strength. I'm luckier than many

AIDS patients that my health is good during the periods between my bouts with pneumonia.

Oh — I almost forgot — I've begun speaking — as an AIDS patient — to various assembled groups. I've done two speeches so far, both to groups of about thirty mental health professionals and Thursday I give one to two hundred (gulp) doctors and nurses at the Joslin Clinic. Basically I relate the story of my illness, both the physical and psychological ramifications — but it's also a chance for me to express some of my own opinions — both good and bad — to people who work with or anticipate working with AIDS patients. After years of teaching, the people don't bother or unnerve me, but the subject matter is a bit close to hand and at times it seems strange to share the intimacy of one's life with a large group of strangers.

Love to all,
Paul

APRIL 2, 1988
CONVERSATION WITH BEBE

I don't blame myself for being sick. I do accept responsibility for my illness . . . Something in my past, or some sexual encounter, brought me in contact with the disease. But the AIDS virus is an organism that exists, and if my behavior five or ten or fifteen years ago, as a young gay man, led to this disease, hey, I didn't know. From the time I've had any awareness at all of AIDS, I've practiced safe sex. I'm a responsible person.

I have two friends who have abandoned me since I had AIDS. AIDS is like any other disease, and some people just don't deal with sickness very well. I don't think these two friends have abandoned me because I have AIDS. I think they just can't cope with illness of any sort . . . And as for other negative experiences, I haven't had any. Because I won't allow it. If people can't deal with my having AIDS, that's their problem, not mine.

. . . Jeffrey thought that one of my previous lovers was

probably responsible for "giving me" AIDS. When I first was diagnosed and in the hospital, this former lover came to visit me, while Jeff was with me. He became rigid and angry and nasty to him. This was only a week into my diagnosis. At that point I just said to him and to myself, "I do not have time to sit down and figure out where I got it or who to blame, and I am not ever going to do that. It simply has no meaning." I have tried since then to *live* my life.

The worst thing about having AIDS is the stress. You have to do something to relieve it, and face up to the real link between your mental and physical health. I used to run, but I can't anymore. The side effects of AZT can be devastating. For all the benefits, it's not much, I suppose. But I find it exhausts me. If I know I'm going to do a lot of physical work, I won't take the AZT. If I do, I can't sustain muscle use. My muscles cramp up. In general, my health's been pretty good, other than a few bouts with pneumonia. My doctor tends to take a nonintrusive approach. So, if a blood count is crazy one week, we'll watch it for several weeks. Usually what happens if you're patient enough is that things go back to normal, at least in my case. So far.

I take my life day to day. Just day to day. My hope is that I will not be sick for a long time. My hope is that I will get pneumonia one of these times, and I will die.

To say tht I'm completely well adjusted to the fact that at thirty-five I could die tomorrow isn't really true. I'm not happy about it. But I've had a life. I've lived a very interesting life. I've done a lot of things I wanted to do. I don't sit around thinking about broken dreams and shattered expectations.

Last fall I did plant two hundred various and sundry bulbs in my garden. Most of which are coming up this year. You take your chances. And you hope. You do hope. And, in fact, I've planted my bulbs for later this summer. You do the best you can. And you go on. I think that's what human beings do. Some of us unfortunately have been given a few extra factors to struggle with. AIDS is an extra factor to struggle with.

All the people I've known who've had AIDS have had to

reassess. You have to say, "If my time is limited, how do I live it?" My friends have done whatever they can to make the time they have very high quality. To really accomplish some of the things they can reasonably hope to accomplish. The ones who have died, died with a sense of peace that they had lived what time they had with quality. A lot of people live eighty years. But I look at their lives and say, "So what? They didn't do anything with it. They wasted every goddamn minute of it." And then there are the heroes of my youth. The great rock stars who died young. But they lived fabulously for the years that they had.

April 5, 1988

Dear Nancy,

This weekend I bought five hundred pounds of manure which Jendras and I applied to all my flower beds and shrubs until 9 P.M. Saturday. The last few hours I was working in the dark, but wanted to get it all in before the rain we expected on Sunday which didn't come until Monday. Next weekend I'll have to do some planting since I also purchased one hundred gladiola bulbs, some freesia, calla lilies, dahlias (all bulbs), two climbing rose bushes, two coreopsis plants, and some climbing ivy for the churchside fence. My calla, by the way, is doing fabulously on the front porch. With all the beds raked and fertilized I can now see sprouts of green popping out, so I'm feeling more confident that last autumn's huge gardening efforts were not in vain.

The upcoming week will be busy. Tomorrow the award ceremony, support group in the evening, tonight Lettering Arts Guild meeting, Thursday evening "Neighbors" meeting, Friday evening: David Mone's opening at Simmons, Saturday evening a Calligraphy / Dance performance (by a visiting Californian calligrapher of course!). I also started my Chinese calligraphy class last Saturday morning. Busy, busy me. I seem to be surviving my schedule, thankfully.

Love,
Paul

By late summer 1988, Paul's relationship with Jeffrey had deteriorated under the stress of the illness, and the pressure of unlike personalities. Paul asked him to move out.

In September Paul took a trip to California, to visit friends and his sister Nancy. In San Francisco, he went to a show of Nick's photographs of people with AIDS at the Fraenkel Gallery. He was one of the subjects, of course, and during his stay, he became friends with the gallery staff. Although Nick was giving him prints of the pictures, Paul wanted to buy one of himself from the gallery. It was a grand gesture of support and affection that Paul couldn't really afford. He bought the print "on time," and agreed to pay what he owed in several chunks, over the next few months. He wouldn't receive the photograph until he'd paid in full. Nancy wanted Paul to have the picture while he could still enjoy it, so she paid the balance to the Gallery, and made them swear they wouldn't tell him that she was involved. Much to his surprise and delight, they gave him the print before he'd paid off his debt. When he sent in his monthly payments, the Gallery sent the money on to Nancy.

When Paul returned to Boston in September, he went back into the hospital with PCP. He was out in October, but back in once more in November.

[Letter to Fraenkel Gallery, San Francisco]

December 9, 1988
Hi Gang!

Enclosed is my check for my picture. Sorry it's so late, but I haven't been too chipper of late. I've been in treatment for pneumocystis number seven for over a month now and two weeks ago there was talk of switching to new experimental drugs since the conventional ones were not working. On Monday, however, the X-ray showed significant improvement — much to the surprise of my doctor, so I'm on the mend. Tuesday I (and my brother-in-law) were food-poisoned so I was out flat for a couple of days. But today, I'm feeling lots better. I'm trying to catch up on my correspondence.

Not much else is news here, it's been bitter cold; today the temp is sixteen degrees! Winter in Boston is gruesome, so

I'm hoping my health and finances will allow a January or February visit to California.

I wish you all my warmest holiday wishes, and much prosperity and peace in '89! I'll be in touch next month.

Warmly,
Paul

JANUARY 1, 1989
MESSAGE ON SISTER CINDY'S ANSWERING MACHINE

Hi Cindy, hi Bruce. It's Paul. It's 3:18, New Year's Day. I'm home, but I'm unplugging the phone. My plan is to go into seclusion for this week. And keep the phones unplugged. And I'm just letting people know so that they won't come and break down my door expecting to find me hanging or electrocuted or with my head in the oven or something. I need some time to . . . write a letter to Jeff, who just called, to wish me Happy New Year (groan). And . . . to get my will and some other papers in order . . . Plus, I'm just burnt out after the holiday so . . . I am unplugging the phone, so don't be shocked if you call for the next few days and don't get any answer.

I promised Ma I'd call her in a few days just to let her know that I'm still alive, so . . . If I do need anything, if I do start to feel sick, or something like that, I will get in touch with people. But otherwise I'd like to sort of pretend to myself that I'm not an invalid, and for a few days, poke around my house like I used to when I was healthy, and try to fool myself into a week of thinking that my life is normal, which of course, it really isn't anymore.

The stereo sounds great, Bruce. I really appreciate your coming over to hook it up. I've enjoyed it a lot. In fact, I'm going to start taping the Beethoven sonatas from the record that Chris bought. So I'll let you know how my first attempt at taping works out . . . I hope you guys had a happy new year. And I'll talk with you sometime, in a few days, or maybe tonight. I don't know. 'Bye.

JANUARY 3, 1989
TELEPHONE CONVERSATION WITH BEBE

I'm feeling very down, very confused. The holidays were difficult for me, the family was wonderful, but it was so hard. We all knew this would be my last Christmas. But no one talked about it. I guess part of the reason I need to hide out for a few days is just to find out where I am now. I really never thought I'd live until 1989, and now it's here, and I'm here, and I'm not ready for it.

I need to finish up some old business, my will, and a few letters. I can feel things changing, and I want to be ready.

January 7, 1989
Hi Gang!
[at Fraenkel Gallery]

Happy New Year. I had an enjoyable Christmas — a buffet here for fifty relatives and friends, including a couple of dear friends from LA. Took me three days to recover. I skipped medication for two days so I could sip a couple glasses of champagne — boy, were they great! My health is its usual see-saw, good days and bad days, but I roll along.

Hope all your holiday festivities and trips were enjoyable and that all of us will have a peaceful, prosperous '89.

I may be out in February, depending on strength. Final payment in person maybe?!? I'll let you know.

Affectionately,
Paul

In February Paul was faced with a difficult decision. His most recent infection with PCP, *his eighth, had not responded to the usual treatment. Even more troubling, he also learned he was infected with mycobacterium avium-intracellulare,* MAI, *a degenerative condition of brain, muscle and nerve tissue. There is no treatment for* MAI; *his doctors told him it would kill him in a rather slow and painful way within six to eight months.*

Paul had to choose between three alternatives: to remain in the

hospital for two weeks and undergo a new experimental therapy for the PCP, *which would be time-consuming, painful, and have questionable results; to continue with standard treatment for* PCP, *though it seemed not to be effective; or to discontinue all treatments and medications, and return home to die.*

FEBRUARY 3, 1989
DEACONNESS HOSPITAL
CONVERSATION WITH BEBE

Yesterday I was feeling pretty good. But today I listened to Mozart and cried. It's sad, kiddo. It's a sad thing. But afterward, after you cry, you do feel better. The crying makes you newer.

Deciding is hard. Being here is hard. I want there to be an answer. And I'm starting to think it's time to just give in to it. To let go. One of the doctors told me yesterday that I was the only one who could decide that. And I'm glad. But it's a hard choice.

Dr. Pinkston . . . she told me last week that dying from PCP was peaceful and calm. That the morphine drip keeps you drugged just enough to be comfortable, but you can hear, and say a few words. And you can still feel a hand on your arm, a kiss. It's a peaceful death, she said.

But now she says it's *not* a nice or easy way to die. "Thanks a lot," I said. Then I told her I think her professional judgment is getting clouded by her affection for me. She just doesn't want me to die. She doesn't want to lose me as a friend. This relationship just became more than it started out to be . . . and she wasn't prepared for that.

My ex-lover was here. He's a professor. He teaches writing to law students and has a wonderful voice. We went over my eulogy together. He's going to read it. Tomorrow he'll come in and we'll fix up the grammar and syntax. It'll knock 'em dead.

Judy, my social worker, is trying to find out about hospice care, or if it's practical for me to do this at home if I decide not to take the treatments. It's hard to think about it, but I think I'd like to die at home.

Jeff was here for a half hour today. He told me he'd come stay with me if I decide to do that. But I said, "No, I don't feel comfortable with that at all. I don't know what you are to me anymore. You were my lover. But we haven't worked out what we are now. And I don't think I'll live long enough for us to become friends. I still love you, Jeff, but I don't think you know what you feel. I don't hate you . . . we've made peace, but the treaty hasn't been signed yet. You abandoned me, you let me down. But I threw you out. You have to figure this out yourself. And I'm afraid you'll have to do it alone. Because I won't be here to help you."

The nurses here have been wonderful. They really listen. Doctors are all hung up with the success of their treatments. The nurses know how to heal in ways the doctors don't even know how to think about.

Mom and Dad have been here the past two days. We've cried a lot. This has been so hard on them. I think they're just about worn out. Dad doesn't know how to cry, but stands there with his hands folded across his chest looking strong and stoic for my mother. And for me. My Mom says when he cries, he cries alone. And he has shed many a tear.

This has taken its toll on them. They're beat. How much more can not only I, but also my family and friends, take? How much more can they see and watch me turn into a skeleton, and clean up BMs and diarrhea, and vomit and pee? Plus, the dignity of it. I can't write notes anymore. I feel so bad. Every New Year's I write long letters to friends who sent cards and notes at Christmas. But this year I couldn't even sit in the chair to write *one*. Besides not being able to climb a ladder, cook a meal . . . When all the power to do that goes, who wants to live? A friend came in and was trying to cheer me up, and said, "You're just you, and that's good enough for us." Well, it's *not* good enough for me.

I wouldn't kill myself. I'd go home and take no medication. I'd get hooked up to the morphine when I needed it, and wait to die. To commit suicide is an act of desperation, and I'm not desperate. I'm just through. To let death come . . . it would be peace. Suicide can be so messy. The other doesn't sound unpleasant. If it only goes on for days, or weeks . . .

not too many, please! And it does give everyone a chance to come and say good-bye, and pat my hand. Even now, I can rise to the occasion. Especially now, the people I see get me excited. I love people. I used to get on the phone and just talk, 7 P.M. to 3 A.M. . . . I'd start on the East Coast, and then when the rates changed I'd call the West Coast . . . I loved it. I'm too sick now. And it's the pills that *make* me sick. It's nuts.

I just don't know yet. I'm hoping a lightning bolt will help me decide. But I know better. I know it will come down to just me in the end.

FEBRUARY 3, 1989

Paul decided to go home, not to treat the pneumonia, to stop all medications. The doctors thought it would be four to six weeks. His family agreed to help him do what he wanted to do: to die at home, in peace. Paul's parents, who had been with him all along as he needed them, came up permanently from their house on Cape Cod to watch over Paul until he died. His sisters and brother made a schedule of friends and family members who could help out by staying with him. They coordinated the hiring of hospice workers to come in every day to give the family caretakers some relief, to give professional assistance, to administer medication, bathe Paul, and monitor his condition. His sister Nancy took a leave of absence from her job in California, and came East until "it was over." Beth came down often from New Hampshire with her children. Elaine came from her house on Cape Cod. Evie and Cindy, who had perhaps been closest to Paul throughout his illness, and who live in town, continued their loving care after Paul came home. Bill, who also lives nearby, became very close to his brother during his illness, and took on the responsibility for Paul's oxygen at all hours of the day and night.

Paul's father and brother went to the hospital to bring Paul home. It took him two-and-a-half hours to get ready. Although he had to ride in an ambulance, he wanted to be impeccably dressed, and he was: in a suit, topcoat, and scarf. He got out at the house, very weak and shaky, and insisted on walking from the ambulance into the house, over the icy path, by himself. Others wanted to help him, but his father said, "Leave him alone. It may be the last time he

ever does this. It may be the last time he ever walks outside again." Paul walked to the house alone, and up to the steps to his front porch. He never went outside again.

Paul wasn't willing to let his going home to die compromise the few pleasures that were still left to him. Even as AIDS took precious things away from him, he found something in almost every day to please and excite him. Freed of the medications which had for so long made him feel so ill, he enjoyed with great zest and appetite many old and new dishes, cooked by friends and family members, or brought in from exotic restaurants. His friends came often, bringing movies to share, flowers, stories, laughter. Paul kept up his interest in the outside world; he read the paper every morning and watched the television news each evening. He lived every day as fully as he was able, and found and shared pleasure with those he cared so deeply about, even though his body was so terribly weakened.

FEBRUARY 26, 1989

Paul, in his bedroom all the time now, lay awake one night.

I went to bed and left all the curtains open, and I waited in the dark for the snowstorm they promised us. I was disappointed that it wasn't bigger. There's something about the power of a snowstorm, the way that Nature can just come in and stop everything, that makes you stop and think. About everything. And where we fit in it all. To say nothing of the pleasure of having a whole city brought to its knees by snow. I've always loved it, how arrogant we mortals are, and how little we have learned. How little we have learned.

February 28, 1989

Dear Fraenkel Friends,

Sorry I've been so bad responding to notes and calls, and that this, the final check, is so late.

As Nick probably told you I'm in pretty bad shape. I am home, but hooked up to the oxygen machine and heavily medicated off and on. I am not in pain, but uncomfortable

more and more of the time. I won't be making another trip West at any rate.

I did want to convey to you my deepest appreciation for all your kindnesses since we all met some months ago.

It's rare to be embraced so quickly by strangers, as I was that day in the Gallery, and to then depart as friends. As mine winds down, I wish all of you the best in your lives, and I send my dearest affection to each of you.

Much love,
Paul

FEBRUARY 28, 1989
CONVERSATION WITH PAUL'S SISTER NANCY

Finding out that Paul was gay *and* had AIDS all at once, at my mother's birthday surprise party in 1986, was devastating to my parents. Since then, the only good thing is that they have both gotten to know Paul as he really is, to know who he is. That wouldn't have happened otherwise.

Paul isn't afraid, most of the time. When he comes closest to imagining his death, it seems quite unreal to him, and impossible — not unthinkable, you see, but impossible — to imagine no longer existing, which is what he thinks death is. So when he thinks most about it, it falls apart, like getting too close to a picture or to words on a page, and having them dissolve or blur into nonsense. It has no meaning, so it can't be frightening.

The family has gotten closer, has come to share more, since Paul's diagnosis. I can't understand my friends and colleagues who protest my coming to see Paul so often. They say, "But didn't you just see your brother last month?" And I say, "Sure. But I thought I'd be seeing him for the next forty years. And I won't."

MARCH 14, 1989 (TUESDAY)

Nancy called to say that Paul died last night.

All the family was here throughout the day — all seven kids were here all day long. Everyone took turns sitting with Paul, stroking his hands, his head, smoothing the sheets. After Friday, only the family was allowed to visit. The strain was too much for everyone, and the confusion was too much for Paul. You and Nick were his last visitors.

Sunday night had been a bad one, a night of painful breathing, high fevers, Paul's struggling against medication, help, comfort. He slipped into a coma. On Monday, Mom sat up with him all afternoon, and into the night. His death was close, and she knew it. By twelve-thirty Paul looked like he was at peace, and resting as comfortably as he could be. Mom needed a respite from her watching; like all the family, she had long since lost any sense of what it meant to be tired. So she went up to bed. At about ten minutes to one, my dad came downstairs, and put his hands on Paul, and said, "Is he peaceful?" I was sitting with him and said, "Yes, he is." So Dad went back upstairs.

I sat with Paul, holding his hand, talking to him as I'd done for the past hour, soothing him as he tried to speak, gently telling him that we knew he loved us all, that we all loved him, and we'd take care of Mom and Dad, that it was all right to let go.

For the whole previous two days, he hadn't shut his eyes. He'd just lain there, breathing, watching, murmuring. That night, after Dad left, he kept his eyes open for a few more minutes, then very peacefully his heart stopped, and his breathing stopped, and he closed his eyes. There was no struggle, no fight, no gasping for breath. His life was just over. He'd died as he wanted to, at home, with his family around him, without pain or frantic fear. If you can say such a thing, it was a perfect way to die.

My mother said she should have stayed with him, but I told her no, that if she'd stayed, Paul probably wouldn't have let himself die. He was ready, we were all ready, and it was

time. It had been a long struggle, from early February till then, six weeks of anguish for everyone, and now, a great sorrow, but a great release.

March 20, 1989

Dear, dear Paul,

It was just something like ten days ago that I sent my last letter to you, and when I opened my mailbox today and found the beautiful handwriting on the envelope greeting me from inside the box, I can't help it that my heart jumped happily in my breast and an utterance "Oh! My Dear Paul" escaped my mouth.

But as I hastily opened your letter and avidly devoured every stroke you wrote, my heart stopped, and shuddered, and shattered, and bled. Oh! No, no. Why should it be you? It is unjust. You are young, nice, original, and intellectual. You should have a glorious future. You should have all the best things that life has to offer.

If someone must die, let it not be you. I wish I could be in your place. Because I have known human joys and sorrows, and have achieved whatever work it was in me to do, and I would be content in the thought that what was possible has been done, and close my eyes placidly.

You asked me to sprinkle your ashes on a pretty place in China because China feels like a second home to you. But if you agree, I would like to keep them, put them into a beautiful China box and place them, together with your calligraphy, before your picture. So that whenever I think of you I could talk to you, tell you my joys and sorrows, tell you how I cherish the memory of you, read to you a poem from Whitman's or Dickinson's, entertain you with a delicious Chinese dish or share a cup of tea with you from time to time, and light a candle before you and sing a Christmas carol to you on the eve of Christmas. When I die I will be cremated too, and if you agree also, I would like to have part of my ashes mix with those of yours, and we can stay together forever, forever, forever. Of course I would like to do it as you wish me to do. My other ashes I have promised to be sent to Hong Kong where my parents' grave is. I hope they will fertilize the grass on the grave to enable them to grow high enough to protect my parents from heat in summer, from wind and cold in winter.

But we are talking too much about death. I believe that you are strong and the medical industry in the USA is the best and the most advanced and your dream of returning to China will be realized one day. This is the only thing I am looking forward to, and I believe it will come true.

Love, Lao Chen

March 24, 1989

Dear Bebe and Nick,

Thank you for giving Paul some purpose during the final months of his illness. He enjoyed and felt privileged to be part of your project, but also enjoyed the friendship which both of you extended to him. God Bless both of you for your compassion and sensitivity.

Fondly,
Edna Fowler

Paul's memorial service concluded with a recording of the "Four Last Songs" of Strauss, performed by Jessye Norman.

May 10, 1989

Dear Bebe and Nick,

. . . Some weeks before Paul died I'd written to Jessye Norman asking her to send Paul a note. She did, a lovely one and also included a copy of Joseph Campbell's book *The Power of Myth*. Unfortunately it arrived after he died. That was very sad. I sent her a thank you on his behalf and asked that sometime when she's singing she think of Paul. I'm sure she will and somehow I'm sure he will know.

With warmest regards,
Nancy

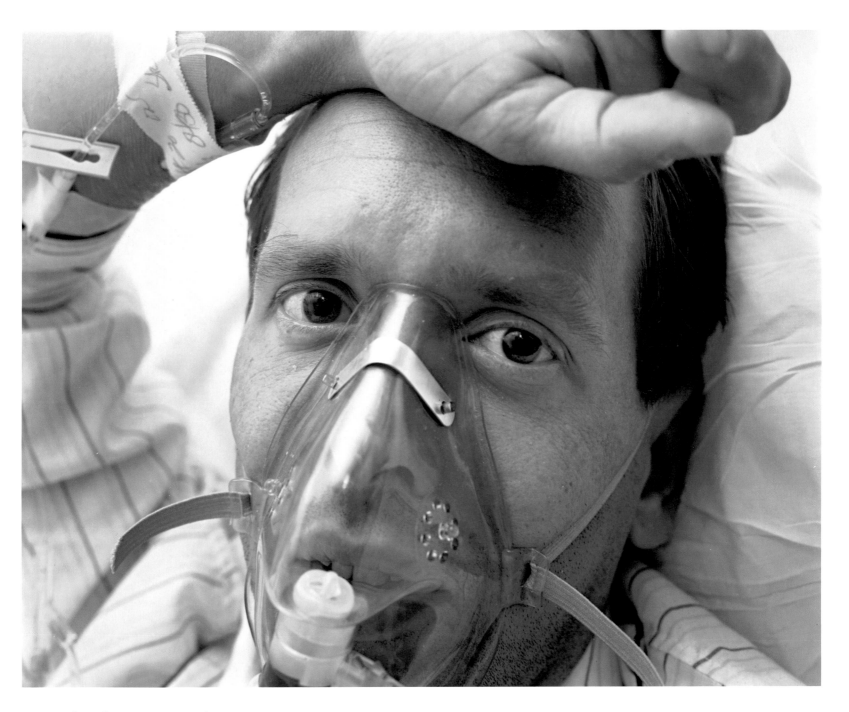

Paul Fowler, Boston, September 1987

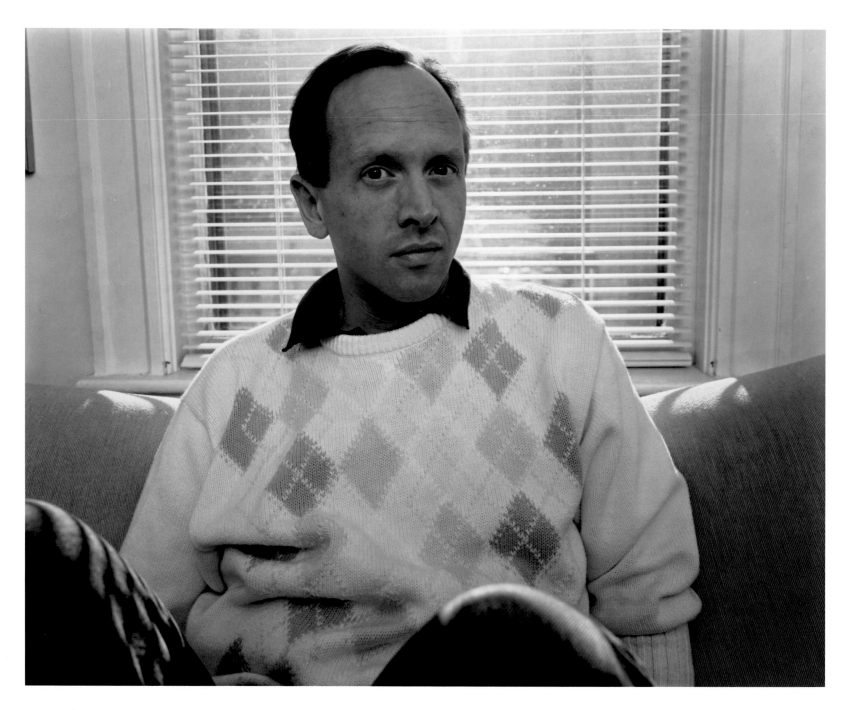

Paul Fowler, Cambridge, Massachusetts, September 1988

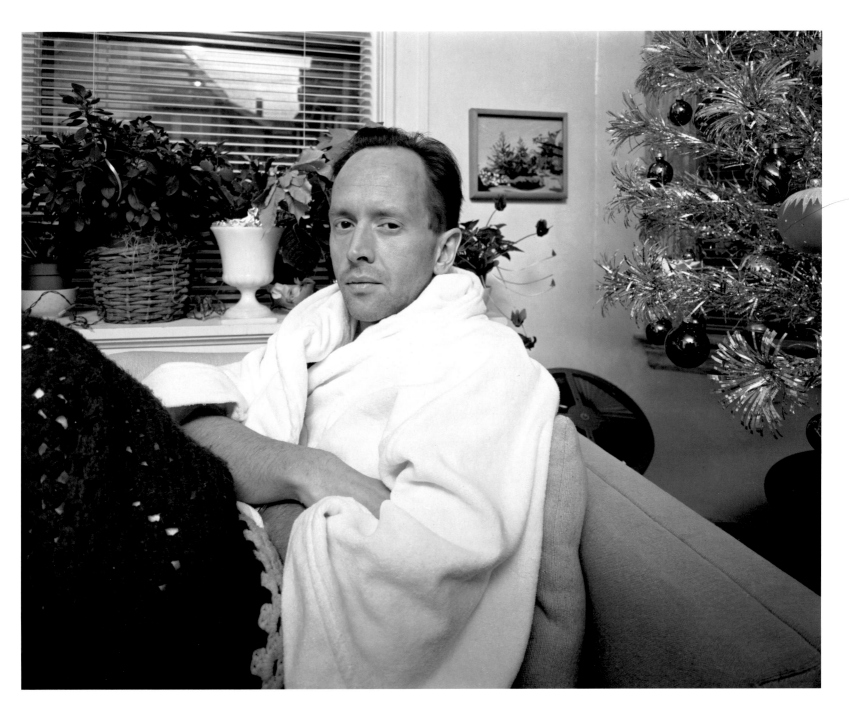

Paul Fowler, Cambridge, Massachusetts, December 1988

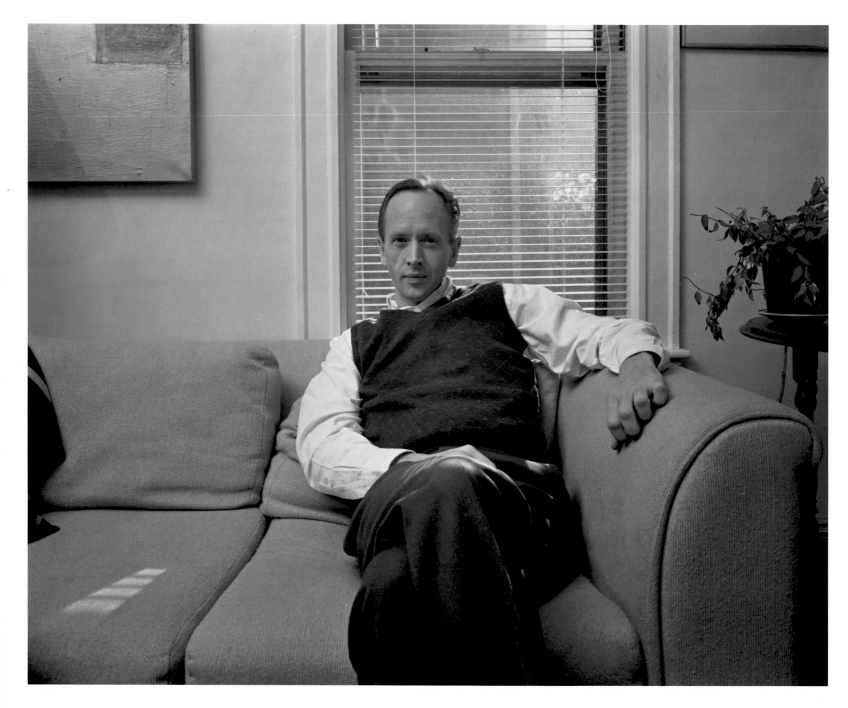

Paul Fowler, Cambridge, Massachusetts, December 1988

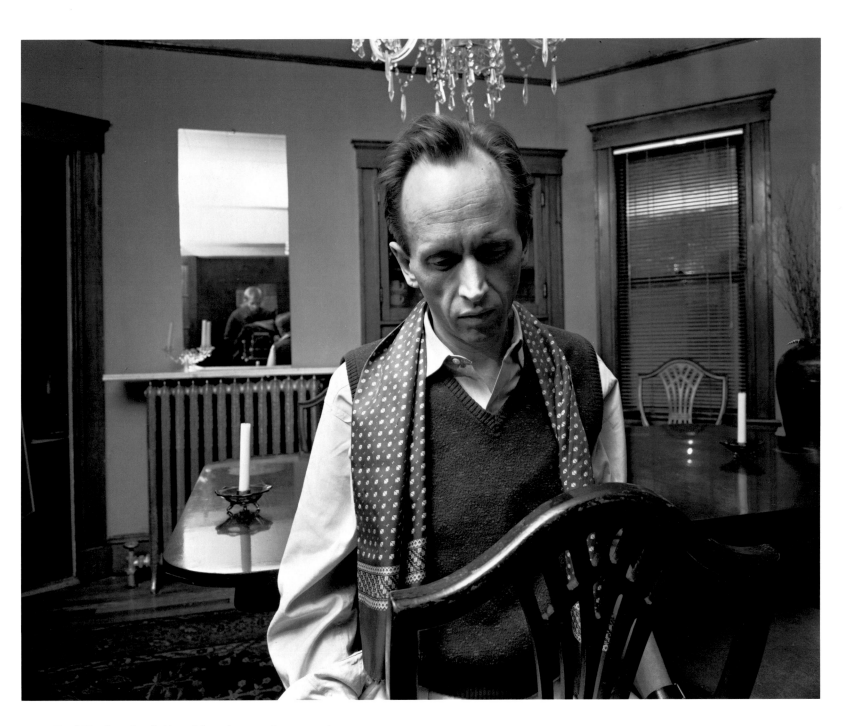

Paul Fowler, Cambridge, Massachusetts, January 1989

129

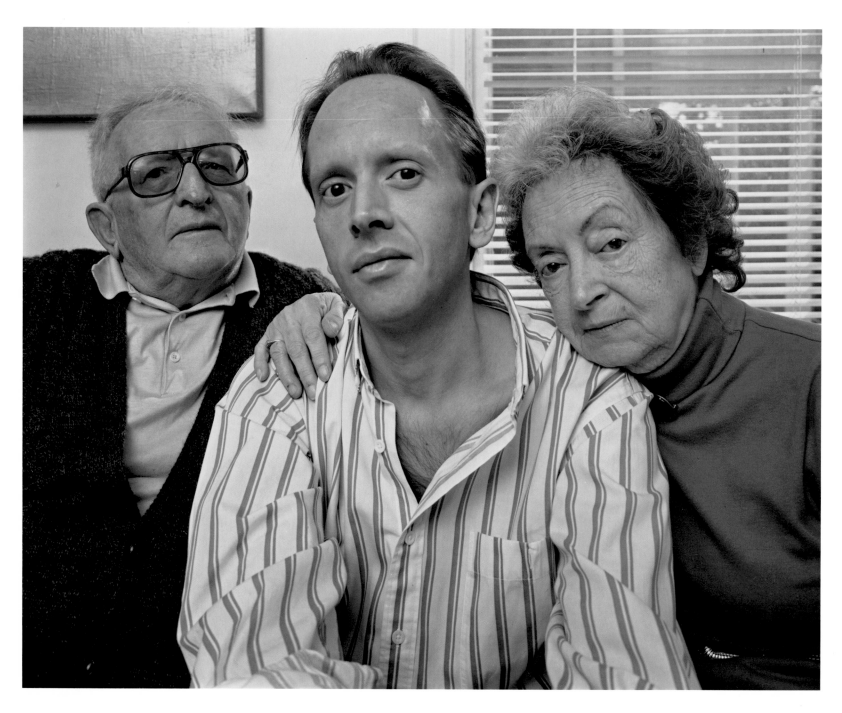

130 *Chick, Paul, and Edna Fowler, Cambridge, Massachusetts, January 1989*

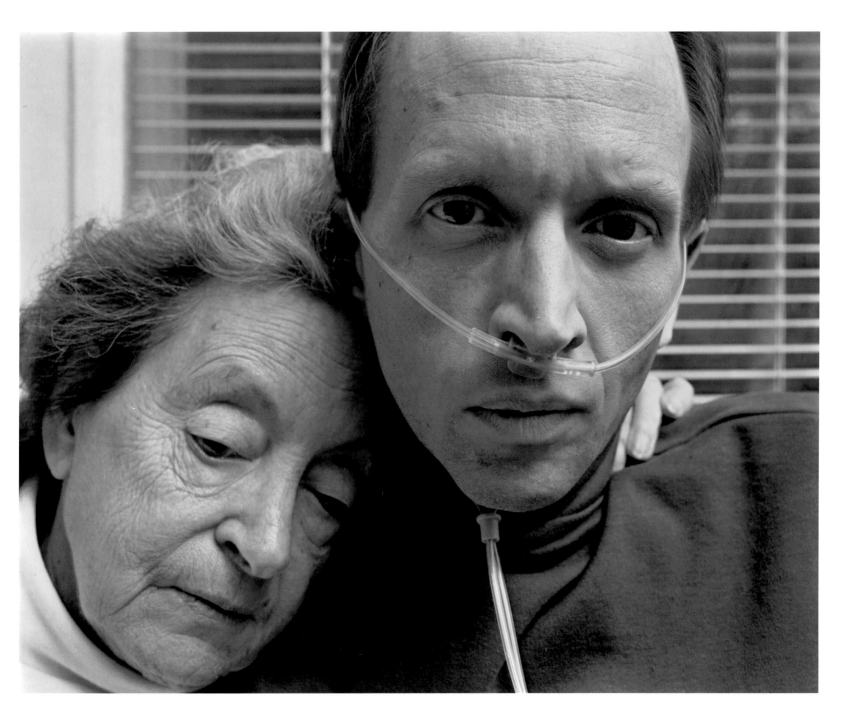

Edna and Paul Fowler, Cambridge, Massachusetts, February 1989

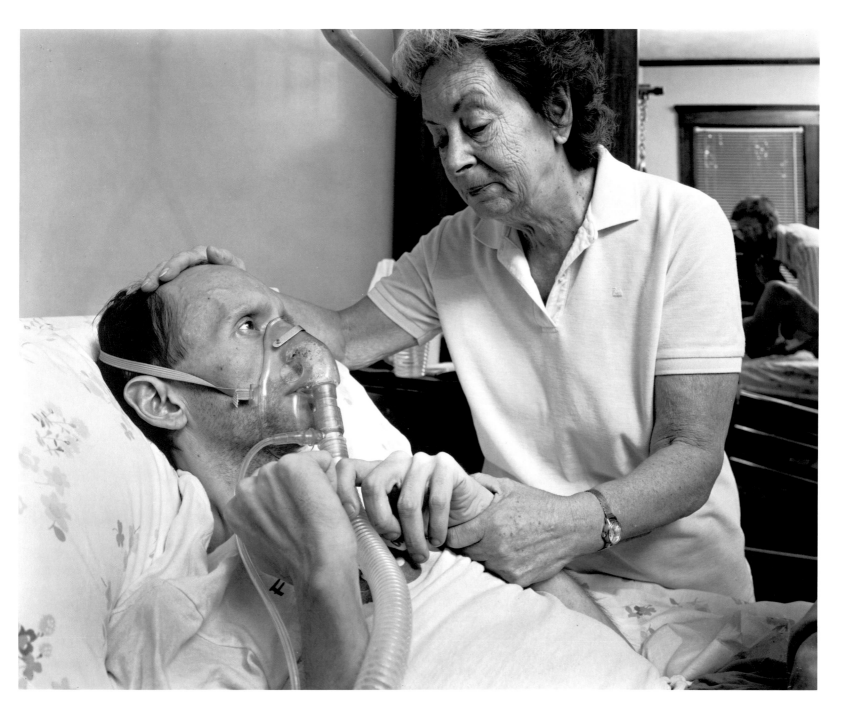

Paul and Edna Fowler, Cambridge, Massachusetts, March 1989

Laverne Colebut

Laverne Colebut loved to sing. Her idols were Billie Holiday and Diana Ross. She said shocking things with a sweet, knowing frankness, and then waited for the reaction: "La-verne!" She wore five-inch heels and stockings with seams, and tiny lace underpants in hot colors. She loved expensive perfume, fast, sleek cars, and men. She knew how to be alluring, and was proud of her body. She could be wickedly funny and raucous, and her sharp tongue could lash out more effectively at herself than at anyone else.

Laverne had always been on the outside, always "different." She grew up in a large, combative family in her mother's house in Providence. She watched a younger brother get killed by a car when she was only eight. She got involved with drugs and sex very early, and started turning tricks on the street before she was ten years old. When she was sixteen, her mother threw her out of the house, telling her she never wanted to see her again. Laverne ran away, lied about her age, and joined the Army. She was stationed in Germany, where she made a name for herself doing Diana Ross imitations in OCS nightclubs and stage shows, among other things.

After the Army, Laverne was still wild, but she wanted to make some changes. In 1979 she moved to Boston, had a nice apartment, found a good job in the computer industry, and spent the next few years trying to straighten herself out. She also tried very hard to make peace with her mother. But her mother wanted nothing to do with Laverne, and coldly rejected her. After several years of trying to settle things with her family, Laverne left Boston, and headed for Atlanta. She turned to the street once more, and worked as a dancer in the New South Bar. Once again, sex and drugs became the cornerstones of her life.

FALL 1988
PROVIDENCE

In Atlanta, I decided to have a little bit of surgery. They did the operation, then they told me, "Laverne, there's something wrong with your blood. You have the virus, the AIDS virus." I got real sick not long after that. I spent five weeks in an Atlanta hospital, being treated for PCP. I got scared after that, and I wanted to come home. I didn't know what would happen to me down there, so far from my family. Even if they *were* treating me so bad, they were still family, and I thought I needed them. I got the hospital to let me out, and I flew back to Providence, sick as a dog, but going home.

Just before Thanksgiving, this was. I got myself into Rhode Island Hospital, and that's where I stayed. I was still so weak, with that infection just working away on me. After a few weeks, my mother came to visit. That was something. We sort of made up. She called me her baby, said she was going to take me home and take care of me.

On my birthday, January 12, 1986, she took me home. But she wouldn't keep me. She freaked out, just lost it, just couldn't deal with having me there in her house. She told me over and over, she couldn't let me stay, couldn't let me stay. She followed me around the house, spraying Lysol on everything I touched. She split open big trash bags and laid them on the bed for me to sleep on. After one night, I was out of there.

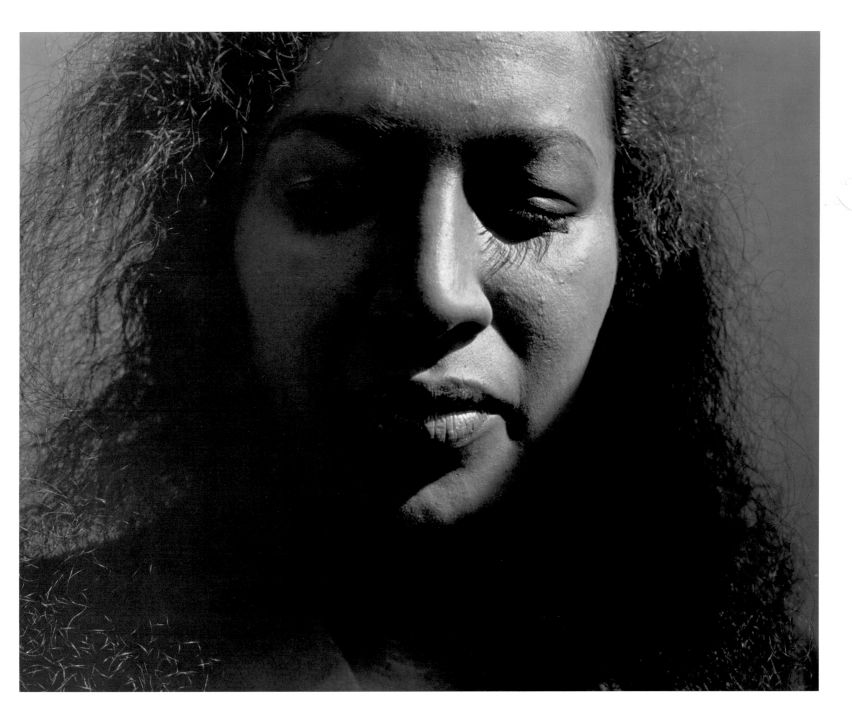

Laverne Colebut, Providence, Rhode Island, February 1988

I had no place to go, nowhere to live, and no job. And I was still sick. That's when I got my buddy Wanda, from Rhode Island Project AIDS. She went to my mother's house, she packed up all my stuff into big garbage bags, she called us a cab, and she took me over to the VA Hospital.

Wanda is real close to me. Like a sister. She got me all my benefits, got me into the VA Hospital, got Social Security. She did things for me that nobody else did. Nobody.

Wanda found me my place to live. The landlady's a scary old bitch. She's always yelling at somebody, sneaking around doorways, changing locks on you. But it's home. My benefits from the Army keep me all right. And I got most of my friends back now. At first, they were scared. Now they're better educated. And they missed me. At first no one came to the hospital. Now it's okay. They come see me, they bring me what I want. My own funky clothes, some soul food, a little reefer, my music, a little fun. Some *life*. And I got a boyfriend now. At first I was too scared of the virus. But I got to having that "hold me" feeling, and I just needed someone. We practice safe sex. It was his idea. I still do my turn out there, on the street, from time to time. It's where I get my life, you know?

The hospital's okay, if you have to be sick. It's full of these shaky old vets in wheelchairs, just drooling in their pajamas. I walk down the hall to get a little ice, or make a little call from the pay phone, and they just go wild. One of 'em told me, "Laverne, you just about give me a heart attack, wandering around here dressed like that." Well, *that* made me feel just fine.

SPRING 1989

I got to keep my spirits up, and I gotta keep goin' for this project, you know, so I look good for the pictures. I ain't gonna die of AIDS 'cause now I got a purpose in life. Life isn't either black or white. Life is grey. Look at me. I'm grey. Can you believe this skin? Is my lipstick all right? Sometimes I get so dizzy when I walk. But look, I got all these great new underpants. Hot pink, red, white, black. Lots of lace. Makes me feel better.

My mother did so many bad things to me. It's sad. I wish she could give up on the hate and just give in and show some love. But she can't. She has a meanness inside her. She's afraid. My family, all of 'em, they put up a great front, but it's a lot of bluff. They're not really there for me. Not really. I don't know why they bother. None of 'em tell the truth to my face. They'll be all sweet and nice to me, and behind my back, they just rip me to pieces. I've heard 'em, when they don't think I'm around. It's a real good show. Enough to make you sick.

Billie Holiday died in the hallway of a hospital, all alone. Did you know that?

We don't choose this life. God chooses for us. To test us, to make us strong. I started hustlin' when I was nine years old. It was hard. But nobody ever tried to hurt me. That was something. My life got to be a real mess. I was heading in the wrong direction. Men. Sex and drugs, all the time. I wasn't an addict, though. And God put the harness on me. Gave me AIDS. When I first got it, I thought I was being punished. I thought, "God did this to me." My social worker said, "My God doesn't do things like that." That made me change my thinking. I don't believe in church, though. I believe in God.

I'm more humble. I pray now. I always wanted to, but I thought I was too much of a hypocrite, wanting to get on my knees and pray, when I was being so bad. Yeah. I was doin' it all . . . real promiscuous, and drugs all the time. I did it because I could. It was what there was. It was *all* there was.

I think people sometimes can think themselves sick. Think themselves into dying. Some people think that AIDS means death, and that's the end of it. Now me, I think you can also think yourself well. And that's me. It's all attitude. At least, today I think so.

What scares me the most is that there's a limit on how far I can go. That I can't keep on getting sick and getting better. That I could die. Soon. I might *feel* 100 percent. But I'm not. That's scary. Makes me cold inside.

As the disease progressed, Laverne became increasingly weak and depressed. She spent more time in the hospital than out of it. When she was out, she withdrew into drugs and solitude. She stopped paying her bills, and her phone got disconnected, so no one knew where she was, or if she was in trouble, or dead. In late May she dropped out of sight completely. Finally, her buddy Wanda got the landlady to let her into Laverne's apartment. She found her nearly unconscious, lying wrapped in dirty sheets. Wanda had her taken to the hospital. Her mother came to see her there, but Laverne was too sick to know it. They never did make peace. On June 9, 1989, Laverne Colebut died, alone, at the VA Hospital in Providence. She was thirty-eight years old.

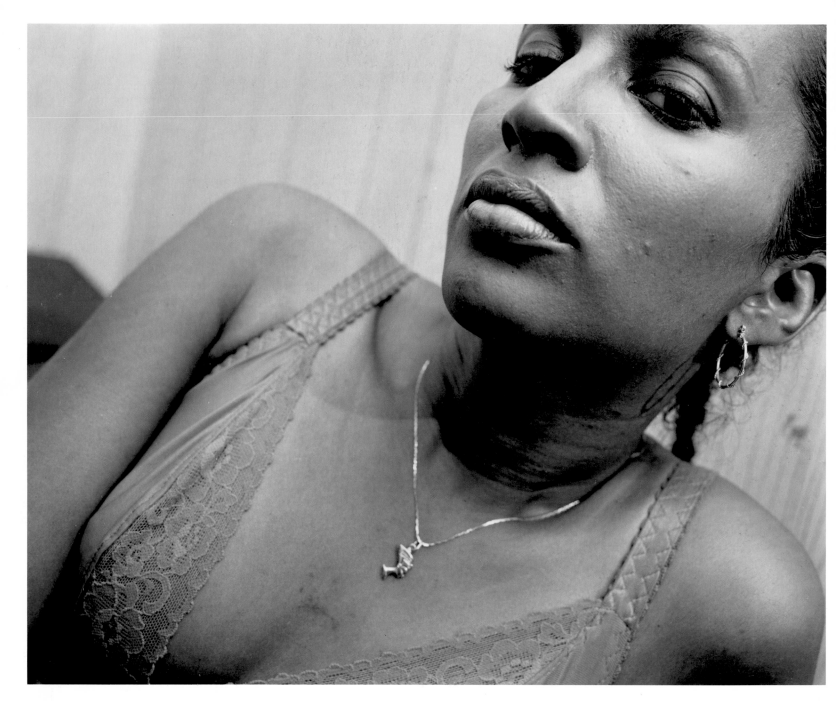

138 *Laverne Colebut, Providence, Rhode Island, April 1988*

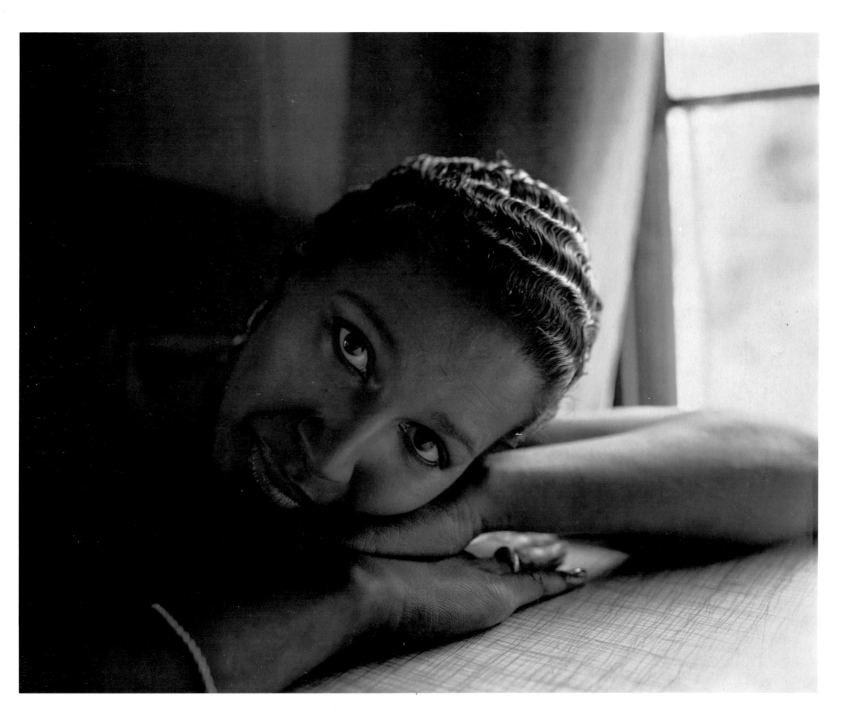

Laverne Colebut, Providence, Rhode Island, July 1988

139

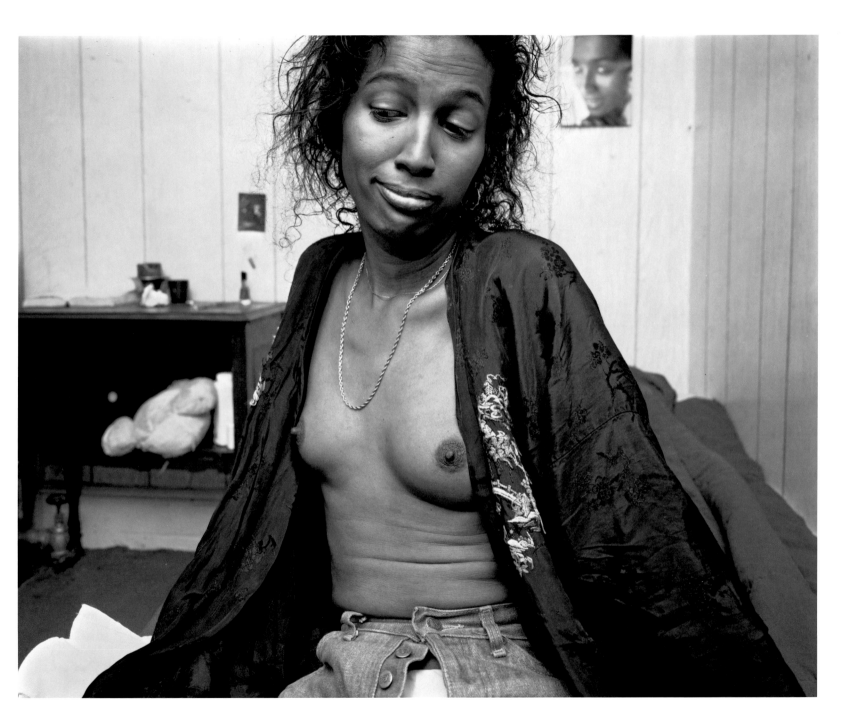

Laverne Colebut, Providence, Rhode Island, October 1988 *141*

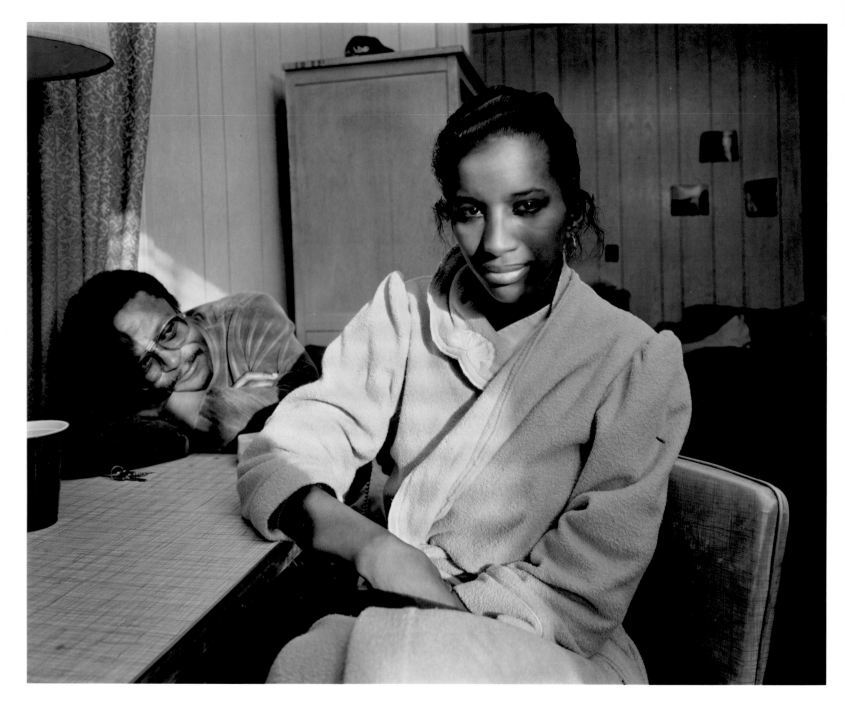

Manny Roberts and Laverne Colebut, December 1988

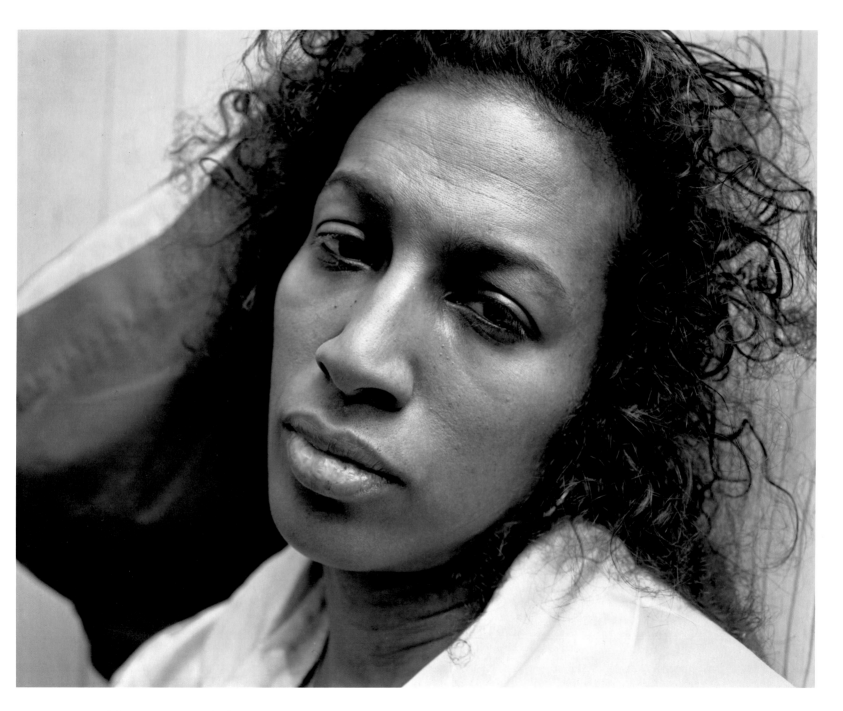

Laverne Colebut, Providence, Rhode Island, February 1989

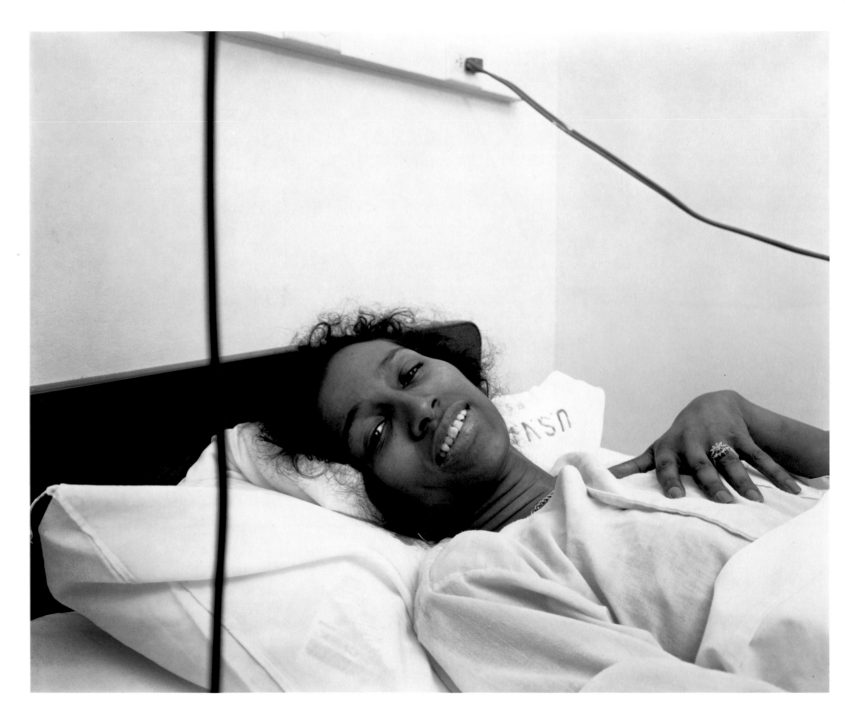

Laverne Colebut, Providence, Rhode Island, April 1989

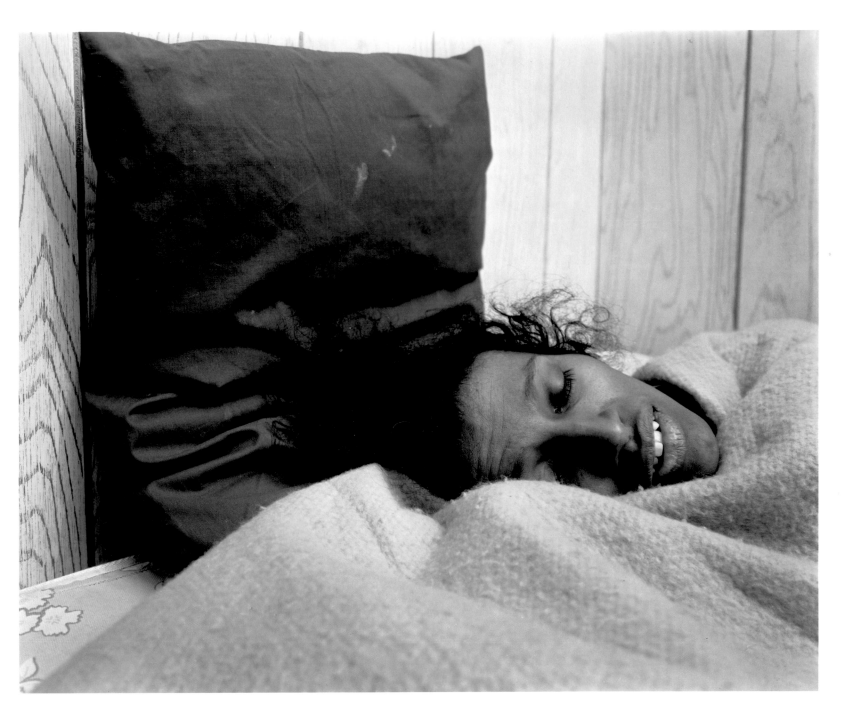

Laverne Colebut, Providence, Rhode Island, June 1989

Sara Paneto

Sara Paneto is thirty-nine years old, and lives in Providence, Rhode Island. She is a recovering addict, and the mother of five children, ages eight to twenty-one. She works as a counselor and intake specialist at one of the city's neighborhood detox centers. She was diagnosed with AIDS in 1984. Despite many serious AIDS-related illnesses, and several hospitalizations, Sara is exceptionally healthy. She belongs to the AIDS support group that once included Linda Black and Dean Madere. Sara is the group's longest survivor, and has outlived all of its original members.

At the center of Sara's childhood, in the Puerto Rican ghettos of New York City and Norwich, Connecticut, were violence, alcohol, and drugs.

I did drugs for a long, long time. I slept drugs, ate drugs, lived and almost died drugs. I had my kids, and I had my drugs. The kids got the worst part of me. I never physically abused them, not ever. But I ignored them. Growing up, I was programmed to feed kids, to cook and clean and look after them, send them to school, make sure their clothes looked okay. I still did all that, even though I was high. But that was all I did. I didn't pay attention to 'em at all. My life was drugs, and the kids didn't fit in. They didn't belong. I slept till noon, and God only knows how they got through it without more trouble than they had. It was brutal and ugly.

One morning I woke up, and I was just tired of the whole thing. I was disgusted. I was dirty, and I felt real bad. Next morning, the same. Morning after that, same thing again. I was sick of drugs. Something inside me just finally said, "No." I thought, "If there's a Power out there, please help me."

I detoxed on my own, cold turkey. I was hallucinating. Had diarrhea and was vomiting at the same time. Cold sweats and nightmares. I imagined there were horrible creatures crawling all over the floor and onto my body. It went on like that for weeks, I think. I don't really remember much of anything about that first year going off drugs. It was bad. My sisters were there for me. They helped with the kids, kept my spirits up.

After six months, I left where I was in Connecticut, and came to Providence. I went into Talbot House treatment cen-

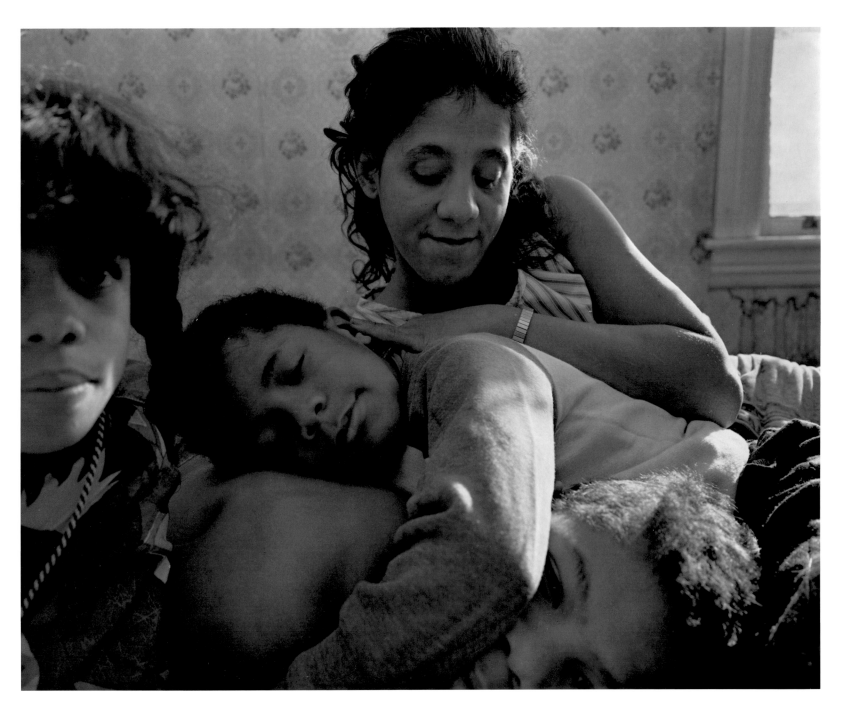

Tawana, Dwight, Sara, and June Bug Paneto, Providence, Rhode Island, November 1987

ter. I needed more help than I'd been getting on my own. I had to leave everything behind, kids, house, everything. That was five years ago. I got clean. I got free of drugs. I stayed away from my old habits, my old friends, even my old city. I'm afraid to go there even now. It's still full of that old life. And it scares me, how many of my old drug friends have died from overdoses, or from the virus. For five years now, out of thirty-nine, I've had a life. Before that, I didn't know who I was or where I was going.

But just as I was getting clean, I was getting sick. This was 1984. I'd heard about AIDS. Somehow, I knew it would come to me. When I was still in the treatment center, I had a blood test, and the doctor told me, "You have AIDS and you're going to die."

I was so down, I thought about doing drugs again, even after all I'd been through. I thought about suicide. I went to the top of the waterfall at the mill nearby, and I was thinking about jumping. Then a little kid came along, about five years old, and he said, "What are you doing here, lady?" I said, "Just thinking." And of course, I couldn't jump in front of a child, so I went back to Talbot House. He saved my life, that little kid. I went back, and then I got real sick. I had viral meningitis. I was in a coma in the hospital for weeks. My temperature was 106 degrees. I have always had bad kidneys . . . since before I was born. The doctors think it's from my father beating up my mother while she was pregnant with me. He kicked her in the back, and got me in the kidneys. Me and my sisters, we were physically, sexually, and psychologically abused from the day we first thought of life. It was a real family affair. Anyway, my kidneys started giving me trouble, too, in the hospital, and the doctors nearly lost me. I weighed sixty-nine pounds.

I got better, after a while. Mostly I was scared. I was afraid of dying right then, and I was afraid of dying that terrible alone sort of death. I was afraid of the virus, afraid of the future, for myself, for my children, for my boyfriend, John. They've all been tested, and they're all negative, thank God.

Something about all that, the fear for the children, the fear of dying and of being alone, made me decide to become a public person. I wanted people to know about AIDS. At first, I didn't want to do it. I was scared that people would reject me. But when I reach out to people, I feel better. Like with other recovering addicts. Or trying to help people who are addicts now get clean and sober. I wanted to do this AIDS thing as a kind of test, to see if there would be people in my life if they knew I had AIDS. Well, there are. Some of the best people I've ever known have come into my life because of AIDS.

Sara became an AIDS activist. Since 1985 she has been a fiery and popular speaker at universities, schools, and church groups. She has made several video specials, and is an outspoken, provocative participant in local radio, television, and cable programs about AIDS. She believes that part of her job now, her mission, is to "spread the word" about AIDS, especially among the drug community.

SPRING 1990

I don't ask too much of Project AIDS Rhode Island. There are some people with AIDS who just want to lie down and have other people come and take care of them. But I'm not like that. I'm on my own. I go to work and I'm trying to get myself stable. There have been times when I've gone down to the Project, like when I was in the hospital for three weeks in January, February. My bills weren't paid, and all my services got cut off: gas, lights, telephone, water. Project AIDS got them back on within twenty-four hours.

I like my work in detox. I go in there, some of the old timers are there, and they say, "I like coming here when you're here." Because I take care of them. They trust me. We talk a lot off the record, so I know a lot about their lives. The only scary thing is when they leave there, I know they're going back out on the street, drinking or doing drugs. These are real and important people in *my* life. And I worry about what will happen to them.

Most of the other counselors at the detox are also recovering addicts. But they're not as up front as me. They think if there's something I don't like, I should keep it to myself. *Why*

should I keep it to myself? I let people know what I don't like. I have that special thing that people say you need to be a counselor. Only thing is, I'm too honest. I don't beat around the bush. When you come to me for help, I let you know who I am. And that's what you're gonna get. You're gonna get *me*. And you can either take it or you can leave it. The social workers, they can't handle that. I'm me, and I'm always gonna be me. And I ain't gonna change for no one.

Years ago, I got a high school equivalency diploma. But it wasn't legal. I paid somebody a hundred and fifty bucks to take the test for me. I needed it to get jobs. But it was just wrong. Now I'm studying to take the test. I'm just doing it to clear my self-conscience. It's time to get honest with myself. I believe when I die, I'm gonna have as much conscience clear as I can. I don't want people to say, "Well, Sara did this, and Sara did that." I want them to know who I am, who I really really am. And if they like me or not, that's their problem, not mine.

My daughter Maria is sixteen. She has a baby now. My ex-husband took her and my oldest daughter, Rita, when they were babies. That was when I was doing drugs. The last time I saw her, she was four years old. She called me a few months ago. Said her father was beating her, and her stepmother was too. Landed in the hospital. She's got scars you wouldn't believe. She was in a mental institution. She just broke down completely. Her father had been raping her, too. So, I stepped in. A few weeks ago, I had her come to live with me, for a while at least. I'll see if I can handle it. She wants to keep the baby. My first grandchild.

The reason she says she got pregnant is that she wanted somebody to love her. I understand. I went through that. My parents were assholes. They were both drunks. To this day, I can't forget the beatings. I got beaten so bad. So bad, man. I mean, you get beaten with a belt, or with electric wires, those kind that are made in braids, you get bad scars. I've got scars. I can't ever remember my parents holding me and telling me that they loved me. My father was one of those men who had to have everything perfect. He'd check the housecleaning with

white gloves on. He made my mother wash and iron his suit by hand. The two of them were never sober. They're dead now. My father went into an alcoholic seizure, and he died. My mother and my daughter's father and my brother were driving, and they were drinking, and they got into an accident, and she died. I don't miss them. How could I?

My sisters and I, we've always looked after each other. They're my family. If something happens to me, with AIDS or anything else, I know I can count on them to take care of me, and my kids. When I get sick, they come to the hospital, they show me by being there that they love me and care about me. It works like medicine. Because sickness makes you so tired. So tired. It takes strength to get better. They come to the hospital and tell me they need me. More than once, they've given me strength I didn't have. They've saved my life.

And John. He has really stood by me. He's a recovering addict too. We met in detox five years ago. I've been hard on him sometimes, but he is always there for me. We live together now. He's fixing up the place, at night and on weekends. Plaster dust everywhere, but it will be real nice when he's through.

This last year, more people from my support group have started dropping. I saw my friend Bruce the other day, and I started crying. He's in a wheelchair and he's dying. Three weeks ago he was fine, walking around. He was as healthy as I was. My friend Roberto just died. And Dean. And Linda, of course. And Jerry, my dancing partner. He was gay, but he was such a loving person. We had a party for Jerry before he died. Twenty or thirty of us went to a gay bar. A lot of them had AIDS. I was the only straight person. Jerry looked okay. All along he looked okay. You could see some lesions, but you never could really see how sick he was. Because his sickness, it ate him from the inside out.

I've seen people die. I think Jerry was the most peacefullest one, I think because, when he died, he had accepted it. And there were people there *for* him. That's the way I want it to be. I don't want to die alone. Neither did he. He wanted

people around him twenty-four hours a day. When he died, he died with a smile on his face, and his eyes wide open. Because he didn't want to miss anything. I learned a lot from Jerry. He taught me to accept life, he taught me how to fight and how to love and appreciate what I had. He took away my fear of dying. But I still have my fear of pain.

I saw Linda just before she died. I think I was the last one to see her besides her family. It was horrible. She was choking, she couldn't breathe. I said, "Linda, let go. Don't try to keep going on like this. Just let go. Let yourself go peacefully." And I gave her a big hug and I told her I loved her very much. About an hour after I left, she died. I guess she just needed somebody to tell her to go. I mean, how long could she hold on?

SPRING 1991

Nick told me I'm the only survivor left, out of fifteen in the project. That's scary. I like this project. Pretty soon you're gonna have to start a new one, a survival one. It's scary though, to know that all these people . . . that I'm gonna be the end of the book.

It makes me sad to look at my scrapbook, at pictures of my friends. It's hard for me, looking at these people I was close to, knowing that they're dead, dead from the virus. Life is unbelievable. A close friend of mine who's real sick now is Bruce. He was a very strong man. A year ago, he said he was never gonna die. And he believed it. I could look to him and say to myself, "If he's gonna be around, I know I am." Now he's in a wheelchair. He used to be a very proud person. Now he can't even recognize people. I saw him the other day, and I went and said hello to him. And he just looked at me, and he looked at his mother, who was pushing the wheelchair. Just blank. She said, "He just doesn't know anybody anymore."

It's a horrible death. If you could just sit down and die, that would be all right. But you don't. You gotta suffer. Some people think God means it to be that way. I don't think so. I don't think God likes seeing people hurt.

I'm not a religious person, but I believe in God. I believe in miracles. And I have a purpose in life, to spread the message of miracles. I have come to respect life for what it is, and to stand up and be who I am. I am proud of what I have done in my life. I just refused to give up. I am proud to let other people know it. There aren't many like me: a survivor; a woman; a mother; an ex-druggie, who was abused as a child, who has AIDS. It isn't nothing, to do what I have done. I do a lot with my life. I have to have a full life, or I'm not satisfied. I want to be able to say, when I go to bed at night, "I had a great day." I'm so grateful when night comes, and I have survived another day.

I want to do my own book, the story of Sara. I even have the name already: *Memories of the Unknown Survivor*. I'll organize the book in chapters, about the people who have been around me in my life. I don't have an ending yet, because I don't know when I'll be finished. I just know, I'm not finished yet.

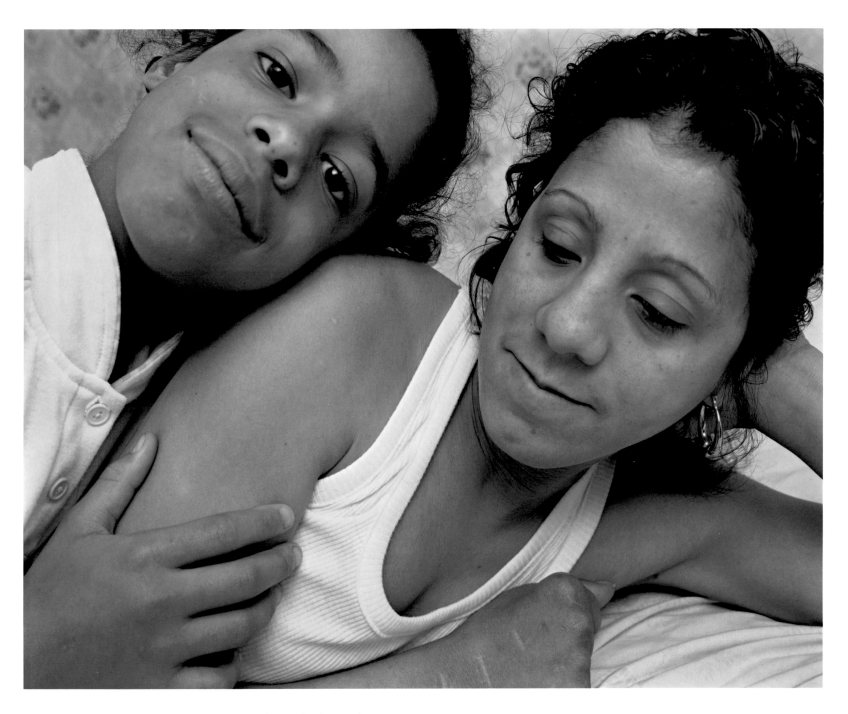

Tawana and Sara Paneto, Providence, Rhode Island, April 1988

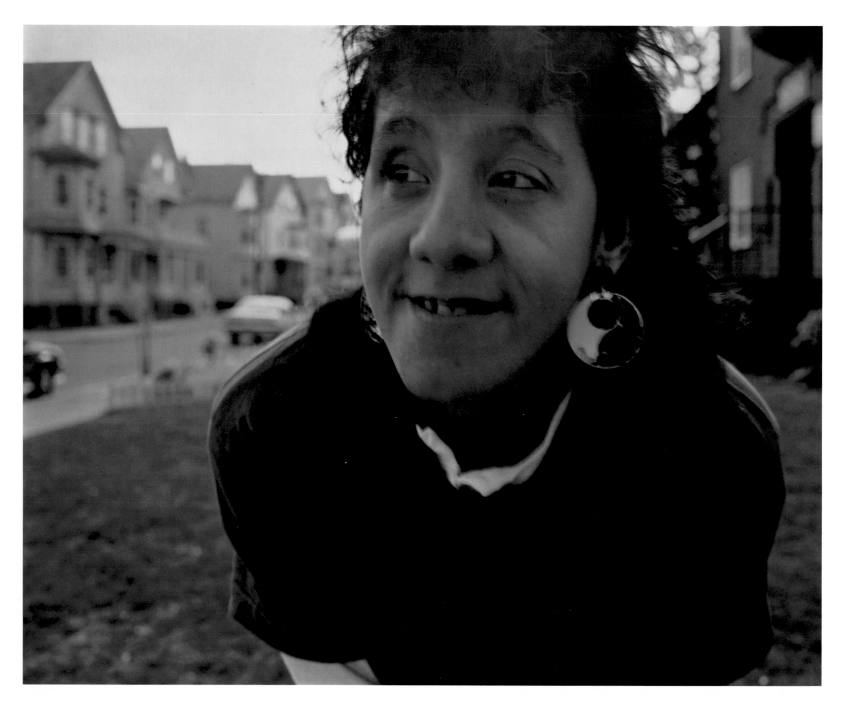

Sara Paneto, Providence, Rhode Island, April 1989

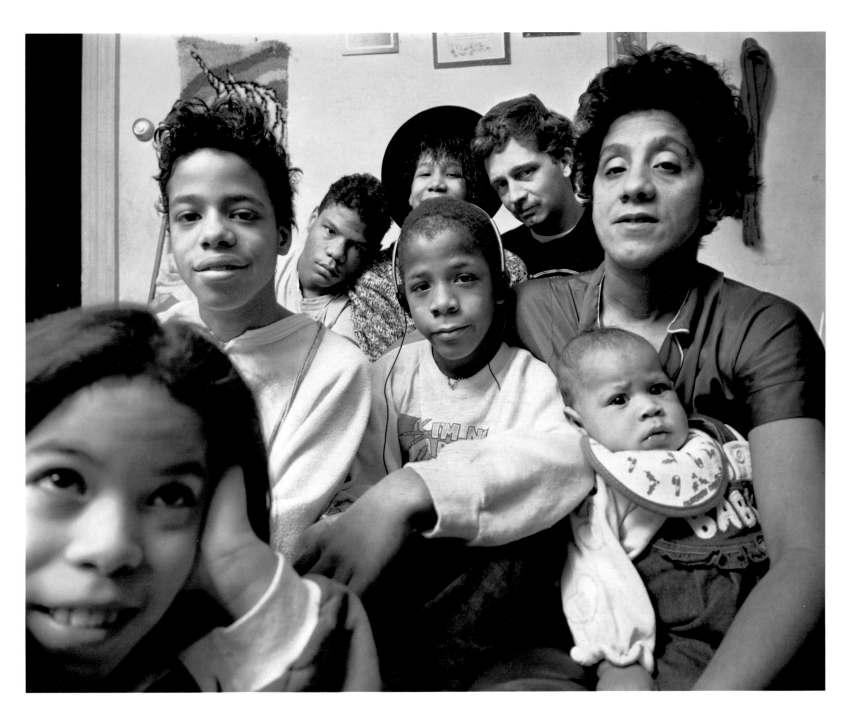

Sara Paneto with her family, Providence, Rhode Island, November 1989

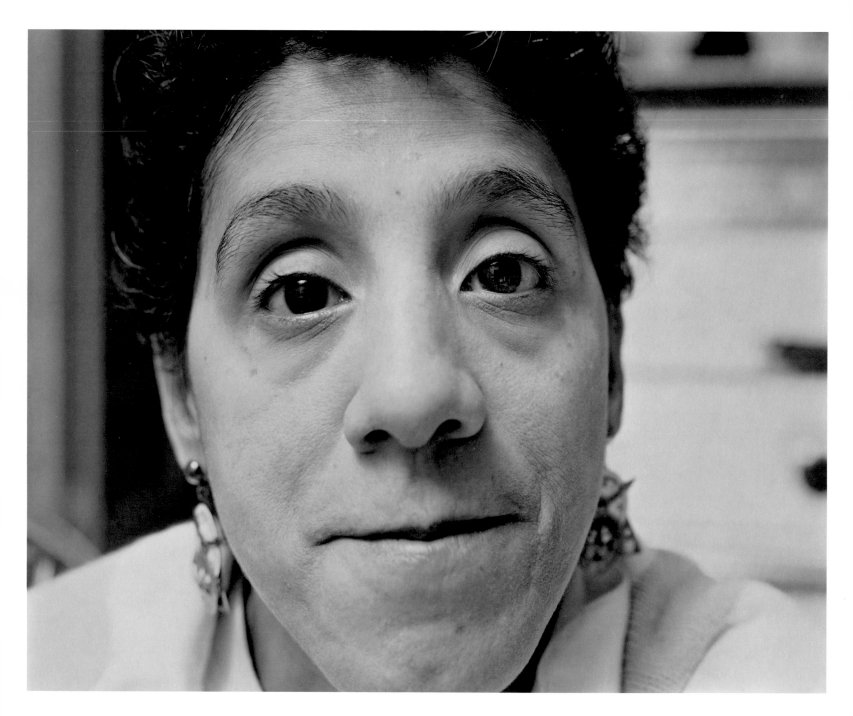

Sara Paneto, Providence, Rhode Island, April 1990

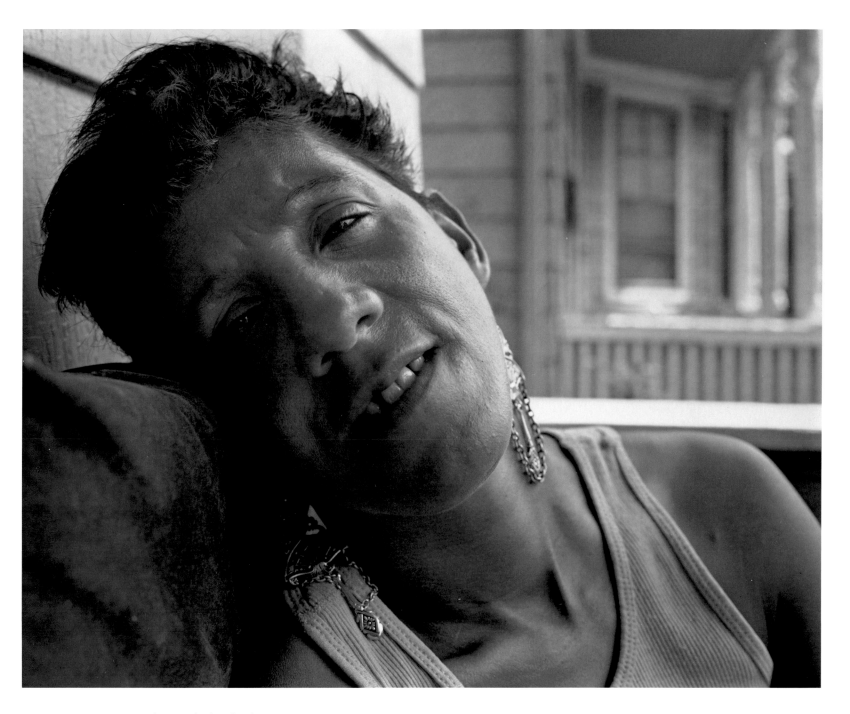

Sara Paneto, Providence, Rhode Island, August 1990

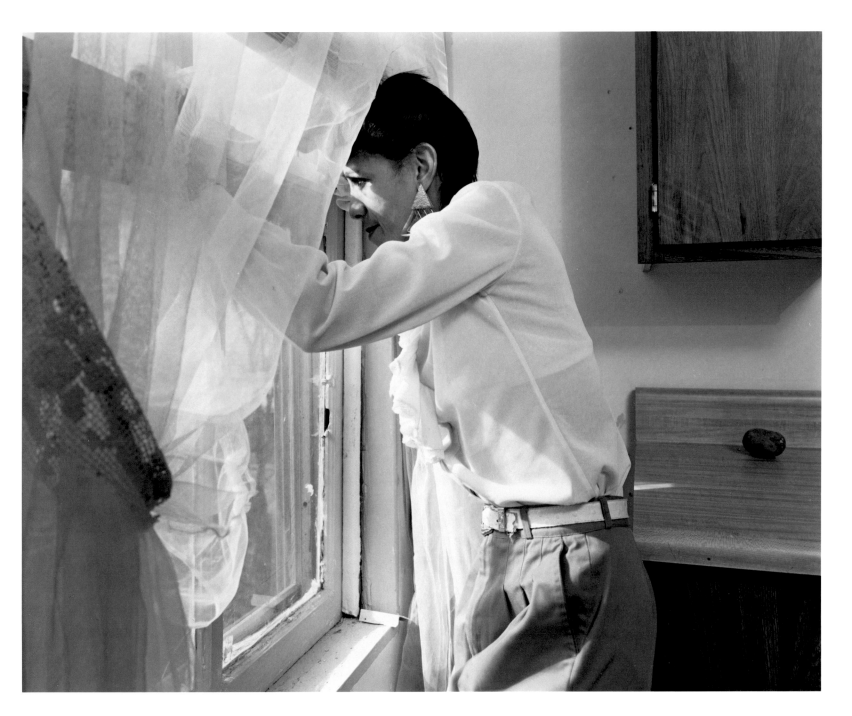

Sara Paneto, Pawtucket, Rhode Island, March 1991

Acknowledgments

Our first and deepest thanks go to the fifteen people who *are* this book. We hope that we have done what you trusted us to do.

To the families and closest friends of these fifteen, who tolerated, embraced, and befriended us, we are deeply grateful. Most of the time you welcomed us. Occasionally, it was agonizing for you to see us coming, to accept what we were doing and why, and to step aside and allow us to continue. Then, you did so because of your love and respect for the person we were there to see, who was committed to this project and wanted to see it through. We thank you, parents, siblings, lovers, and friends, for your generosity of spirit, for your patience, and for your dignity: Tom Petchkiss's brother, Anthony Petchkiss, and his mother, Jacqueline Petchkiss; Tom Moran's mother, Catherine Moran; Joey Brandon's parents, Everett and Zana Cloyd, and his lovers Barry and Mark; Linda Black's brother, Frank Black, and the entire extensive Black family; the Mastrorilli family and especially Tony's mother Anna; Keith McMahan's brother, Lance McMahan; Dean Madere's lover, B.C.; Donald Perham's son, Nathaniel Perham, and Donald's wife, Jane Perham; Bob Sappenfield's parents, Ginny and Robert Sappenfield, and Bob's friends Brian, Brenda, and Paige; Elizabeth Ramos' two sons, Matthew and Christopher Ramos, her aunt Lucy Rodriguez, and her buddy, Bob Haynes; Mark Pfetsch's buddy, Paul Wright; George Gannett's lover, Ron McClelland; Paul Fowler's parents, Chick and Edna Fowler, his brother Billy Fowler, and his sisters Nancy, Cindy, and Evie Fowler, Beth Chateauneuf, and Elaine Conners; Laverne Colebut's buddy, Wanda Schell; Sara Paneto's boyfriend, John Brady, and Sara's children and granddaughter. We could not have done this without you.

Many people who have been touched directly and irrevocably by AIDS and by other serious illness helped us shape this book. Some of them have died. Others still mourn. Their contributions, while indirect, were substantial and very real. To Bobby Schott, Rolf Svendsen, Denisce DiIanni, Steve Watson, Brent Sikkema, Chuck Smith, Eddie Benjamin, Paul Eaton, LeBaron Moseby, Martin Gaffney, John Palazza, Victor Rios, Mike Giovinco, "Joe," at MCI Walpole, Tea Cheney, Michael Macaluso, Jeff Barmeyer, the Reverend Emmet Watkins, Dave Dumas, Gerry Toupin, and the anonymous mother of a child with AIDS who telephoned in the middle of one winter's night to weep about her son's illness, we extend our humble thanks.

Dozens of kind and dedicated professionals involved with AIDS assisted us with this project, despite bureaucratic minefields, personal misgivings, and private sorrows. Most particularly, we wish to thank Liz Paige, Kurt Reynolds, and Laurie Bloom of the AIDS Action Committee, Geneva Woodruff of the Children With AIDS Foundation, Judy Babcock of New England Deaconness Hospital, Susan Marks of Shattuck Hospital, Marg Stark of Beth Israel Hospital, Elise Angelini and Marge Sterns, of the Providence VA Hospital, and the extraordinary staff of Hospice West.

The book itself was produced by highly talented artists, craftspeople, and artisans, who donated part or all of their valuable time and considerable ability. To each of them, we owe a debt of gratitude for their contribution, and an

acknowledgment of the pleasure we share at the result of their combined efforts. The half-tone reproduction negatives were made with exquisite precision and beauty by Thomas Palmer and Richard Benson, without whose great talent and consummate skill the images would have lost their magic. Designer Susan Marsh's passion for elegant bookmaking, and her sensitivity for the fine balance between words and images, ensured that the finished volume would look as good as we could make it. The staff at Franklin Graphics worked overtime — and then some — on the presses, to bring the book out on schedule. Within the organization of David R. Godine, Publishers, Thomas Frick devoted many meticulous hours to helping shape the edited text. Lucy Hitchcock had the inglorious responsibility of supervising the final weeks of loose ends, and Steve Dyer gallantly acted as overseer throughout. David Godine himself has earned our gratitude and admiration for daring to publish this book when no one else would touch it.

The financial and moral support of our contributors actually brought this book to life. To John and Mary Robinson, Jeffrey Fraenkel, Frisch Brandt, David Baltimore Alice Huang, and Agnes Gund, we once again offer our heartfelt thanks for your faith in us, and for your unshakeable belief that someday, this project would become a book. It has been a long time in the making.

Without our friends, we could never have begun this project; we certainly would never have completed it. From the very beginning, Peter Galassi has helped make this idealistic, formless, naive undertaking into something of substance. His wisdom, patience, and humor sustained us for many months, and gave us belief in ourselves and in the project, when we had begun to lose both. Genevieve Christy gave us continuous encouragement mixed with understated, thoughtful guidance, through one failure after another, until we finally got it right. Barbara and Chip Benson helped us through the rockiest times, when it seemed the pictures and the words would never become a book. Frank Gohlke and Lucy Flint gave immeasurable help with the photographs. Charles Hagen gave unexpected critical support when we particularly needed it. Jeanne Jordan listened and listened, with all her mind and heart, to the aimless ramblings of uncertainty, and then, without knowing she'd done it, lighted the fire that gave it form. To you all, for your expertise, insight, and unstinting support, there are not thanks enough.

Finally, Samuel and Clementine, we thank you for your patience and your boundless, unquestioning affection. During the months and the years that we talked with "the sick people" and made pictures of them, you were filled with sorrow for them, with sadness for their families, with confusion about what death was, with uncertainty about the future — your own and theirs. Your questions, to us and to them, were brave and honest; your hearts were strong. You gave us all strength and courage, and you helped us to understand that what this was really about, was love.

Bebe Nixon
Nicholas Nixon
Cambridge, Massachusetts

PEOPLE WITH AIDS

WAS SET IN BEMBO, A TYPEFACE BASED ON THE TYPES USED BY VENETIAN SCHOLAR-PUBLISHER ALDUS MANUTIUS IN THE PRINTING

OF *De Aetna,* WRITTEN BY PIETRO BEMBO AND PUBLISHED IN 1495. THE ORIGINAL CHARACTERS WERE CUT IN 1490

BY FRANCESCO GRIFFO WHO, AT ALDUS'S REQUEST, LATER CUT THE FIRST ITALIC TYPES. ORIGINALLY

ADAPTED BY THE ENGLISH MONOTYPE COMPANY, BEMBO IS ONE OF THE MOST

ELEGANT, READABLE, AND WIDELY USED OF ALL BOOK FACES.

THE TYPE WAS COMPOSED BY DEKR CORPORATION, WOBURN, MASSACHUSETTS.

THE DUOTONE PHOTOGRAPHY WAS DONE BY THOMAS PALMER AND RICHARD BENSON OF NEWPORT, RHODE ISLAND.

THE BOOK WAS PRINTED AT FRANKLIN GRAPHICS IN PROVIDENCE, RHODE ISLAND,

AND WAS DESIGNED BY SUSAN MARSH.